8-D

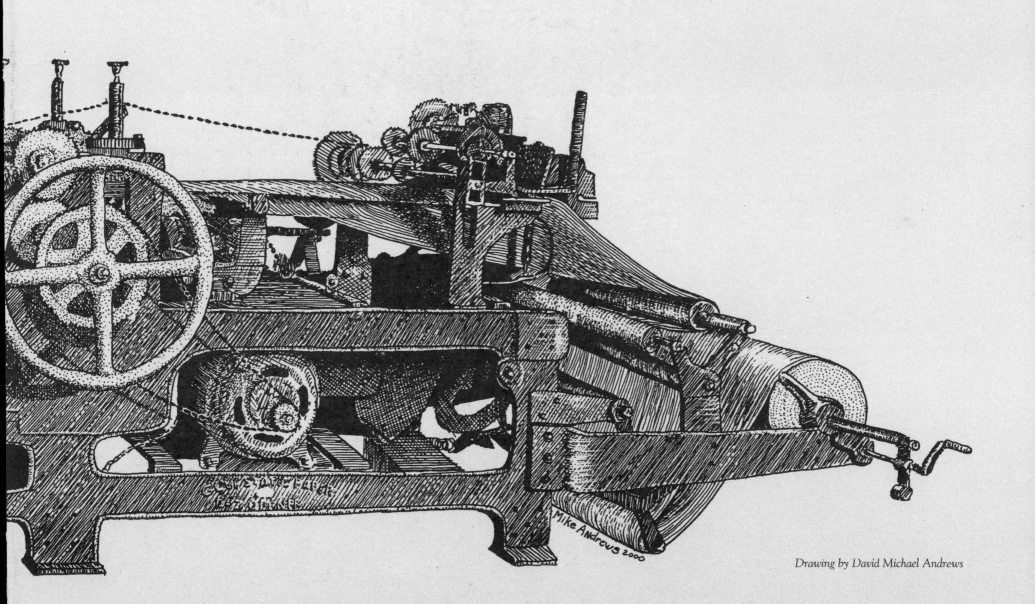

Drawing by David Michael Andrews

This book was contributed

to

CITY OF RANCHO MIRAGE
PUBLIC LIBRARY ©

by

Robert E. Armstrong

as part of the
Luce Fund for Scholarship
in American Art

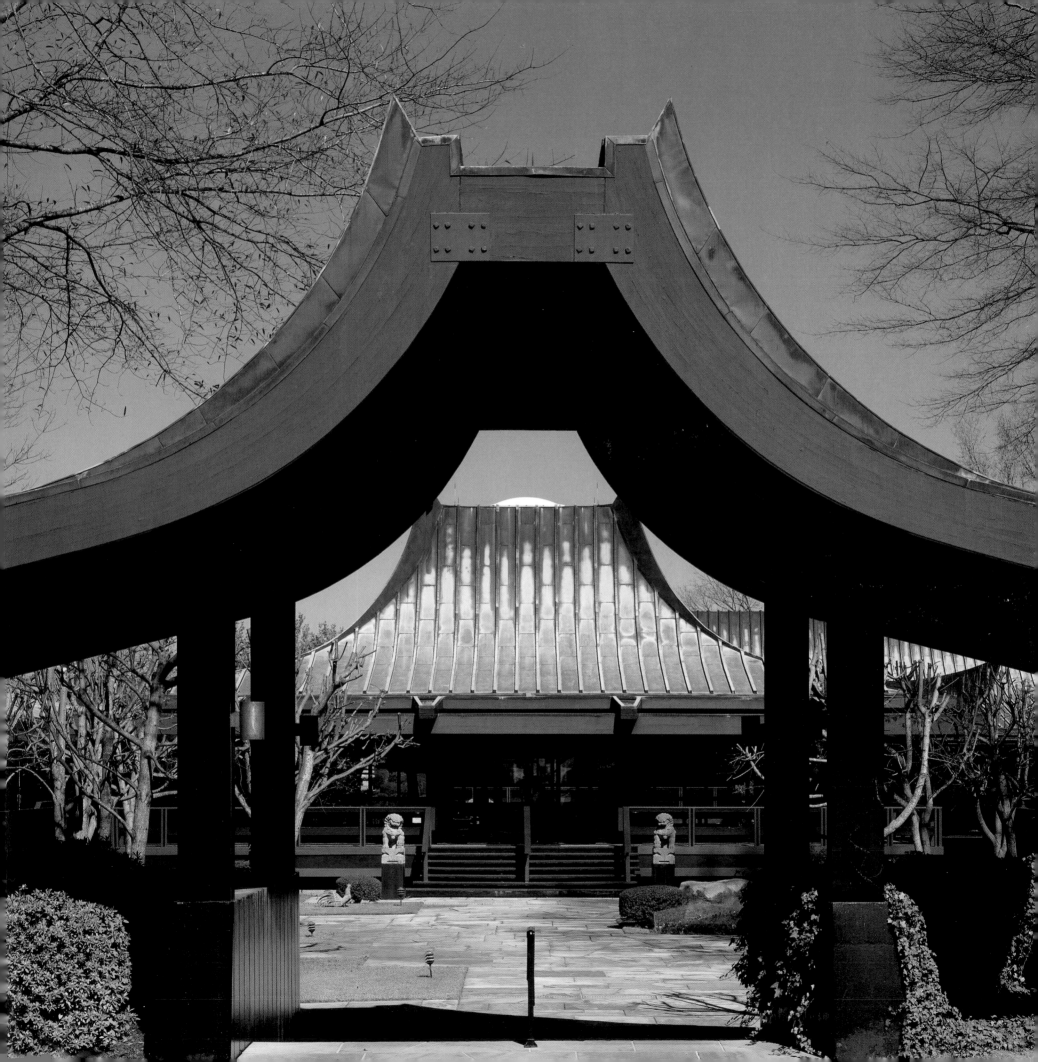

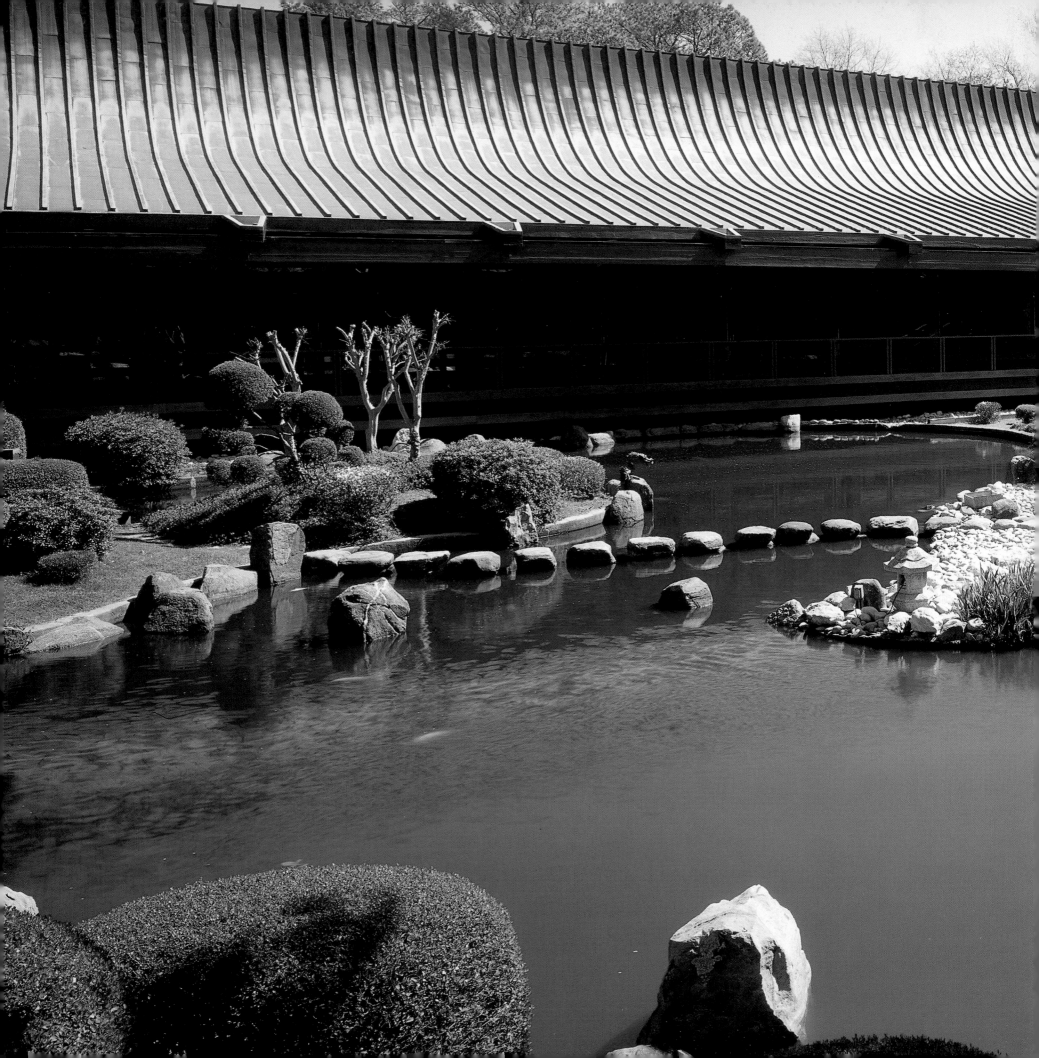

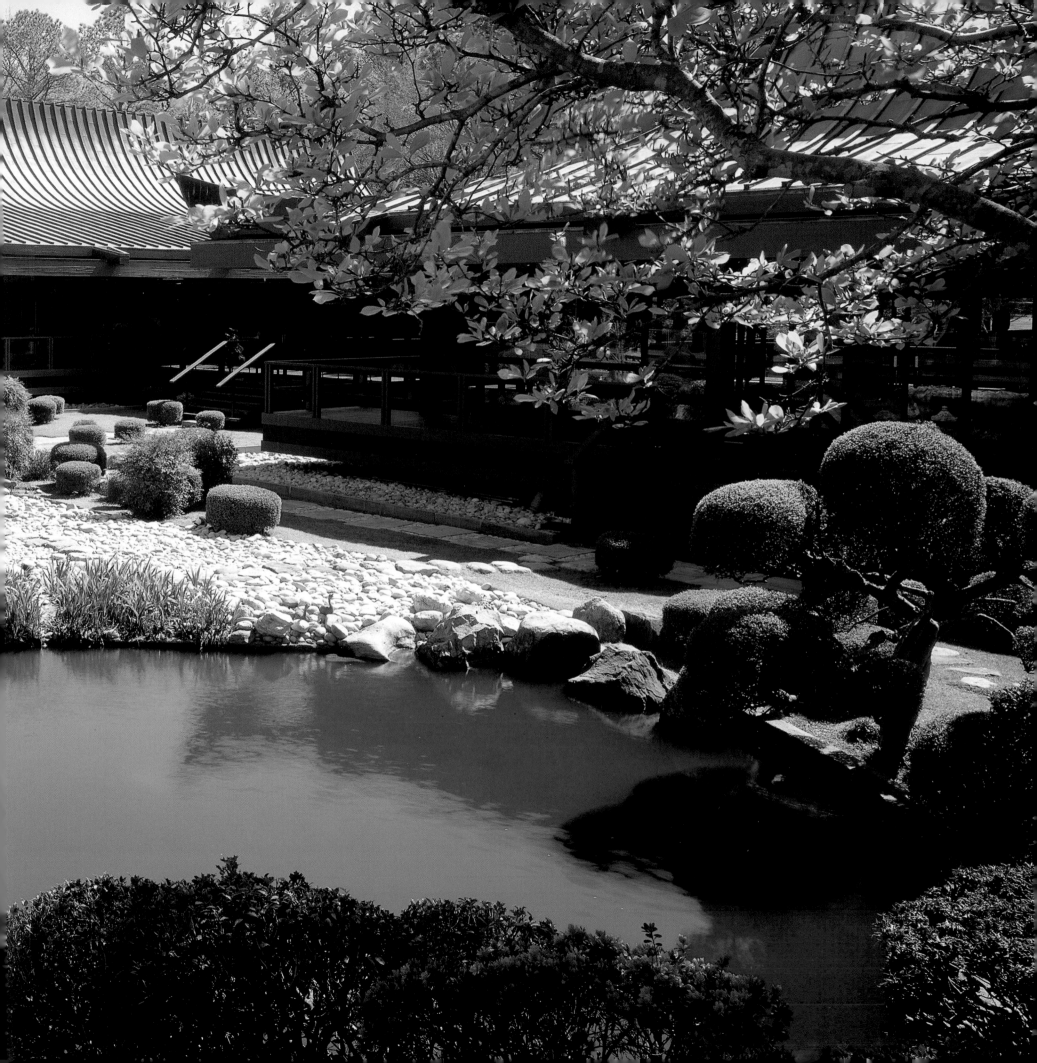

AN AMERICAN ODYSSEY

THE WARNER COLLECTION OF AMERICAN FINE AND DECORATIVE ARTS
GULF STATES PAPER CORPORATION, TUSCALOOSA, ALABAMA

TOM ARMSTRONG

Bob.
Happy Birthday, (belated)
It is a great pleasure
to become distinguished
together.
Tom
October, 2002.

ESSAYS BY
AMY COES, ELLA FOSHAY, AND WENDELL GARRETT

PHOTOGRAPHY BY
LYNN DIANE DEMARCO, BONNIE MORRISON, AND PAUL ROCHELEAU

THE MONACELLI PRESS

IN ASSOCIATION WITH

SOTHEBY'S

First published in the United States of America
in 2001 by
The Monacelli Press, Inc.
10 East 92nd Street, New York, New York 10128.

Copyright © 2001 The Monacelli Press, Inc.

Library of Congress Cataloging-in-Publication
Data
Armstrong, Tom, date.
An American odyssey : the Warner collection
of American fine and decorative arts, Gulf States
Paper Corporation, Tuscaloosa, Alabama / Tom
Armstrong ; essays by Amy Coes, Ella Foshay,
and Wendell Garrett ; photography by Lynn
Diane DeMarco . . . [et al.].
p. cm.
Includes index.
ISBN 1-58093-098-0
1. Art, American—Catalogs. 2. Warner, Jack
(Jonathan)—Art collections—Catalogs. 3. Art—
Private collections—Alabama—Tuscaloosa—
Catalogs. 4. Gulf States Paper Corporation
(U.S.)—Art collections—Catalogs. I. Title.
N6505.A66 2001
709'.73'07476184—dc21
2001044664

Printed and bound in Italy

Designed by Abigail Sturges

OPENING PAGES

**Gulf States Paper Corporation
Headquarters**
Tuscaloosa, Alabama

*The building, which opened in 1970, was
designed by Cecil Alexander of Finch
Alexander, Barnes, Rothschild and Paschal,
Architects, Atlanta, Georgia; the interior
Japanese garden was designed by David Harris
Engel, Landscape Architect, New York.*

FRONTISPIECE

WORTHINGTON WHITTREDGE (1820–1910)
Kentucky River near Dix River, circa
1865

Oil on board, 8 5/8 x 11 inches
Inscribed: T W Whitredge [*sic*]
Collection of Mr. and Mrs. Jack Warner,
Tuscaloosa, Alabama

CONTENTS PAGE

WILHELM SCHIMMEL (1817–90)
Eagle, circa 1850–75

Wood, gesso, and paint, 26 x 32 x 18 inches
(with base)

OVERLEAF

HENRY MERVIN SHRADY (1871–1922)
Bull Moose, 1900

Bronze, 20 x 20 x 11 inches
Inscribed base, right: H M Shrady
Inscribed base, rear: Copyright Theodore B Starr

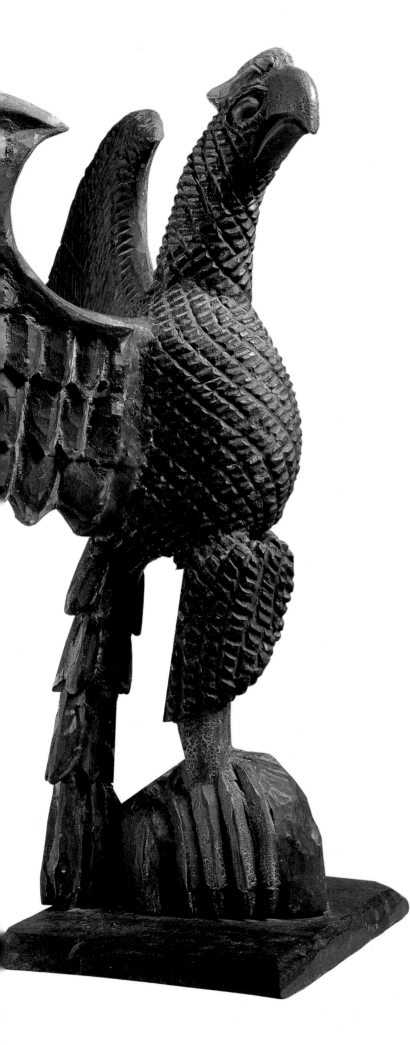

CONTENTS

An American Odyssey

The Warner Collection of American Fine and Decorative Arts
Gulf States Paper Corporation, Tuscaloosa, Alabama

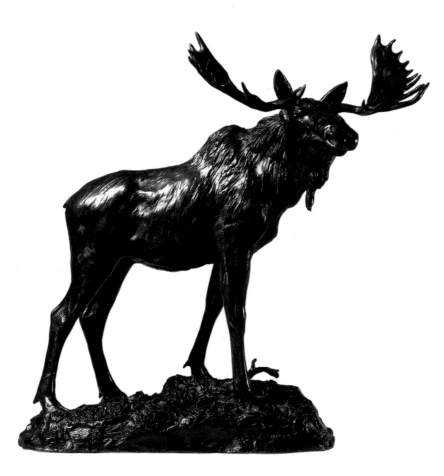

FROM WOODS TO GOODS

TOM ARMSTRONG

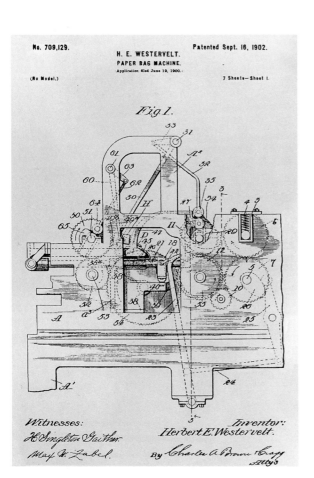

HERBERT EUGENE WESTERVELT, inventor
(1859–1938)
Paper Bag Machine
Patent no. 709,129, September 16, 1902
Sheet 1 of 7, application filed June 19, 1900

In 1876, the year the United States celebrated one hundred years of independence, an international event of unprecedented size and importance occurred in Philadelphia. The United States International Exhibition of 1876 introduced the American public to products and art from throughout the United States as well as from exotic, faraway countries. The scope was vast, with displays devoted to the past, present, and future. The centennial exhibition featured the most advanced achievements in technology and the sciences and had an immediate impact on cultural and economic development. A steam engine larger than any ever built provided power, and the emergence of machines as the means to create a new world was a preeminent theme. Perhaps no one went away from this experience with a more lasting impression than Herbert Eugene Westervelt, a teenage boy who traveled more than five hundred miles from Oberlin, Ohio, in a horse-drawn wagon with his parents and three older brothers to be among the ten million visitors who witnessed the spectacle of America entering the industrial age.

Herbert Westervelt was born in 1859 in Oskaloosa, Iowa, the son of a Congregationalist minister, William, and his wife, Lydia. Both had attended Oberlin College, the first coeducational college in the United States. William Westervelt's ministry and missionary work made it necessary for the family to move throughout the Midwest, but they returned to Ohio for the education of their four sons at Oberlin.

The wonders of the centennial celebration challenged the imagination of young Herbert Westervelt. A relatively short time after his journey to Philadelphia, his inventive genius began an American odyssey that resulted 125 years later in the Warner collection of Gulf States Paper Corporation assembled by his grandson, Jonathan Westervelt Warner.

As a young man, Herbert Westervelt was in the grocery business with one of his brothers in South Bend, Indiana. They made sheets of paper out of wheat straw to roll

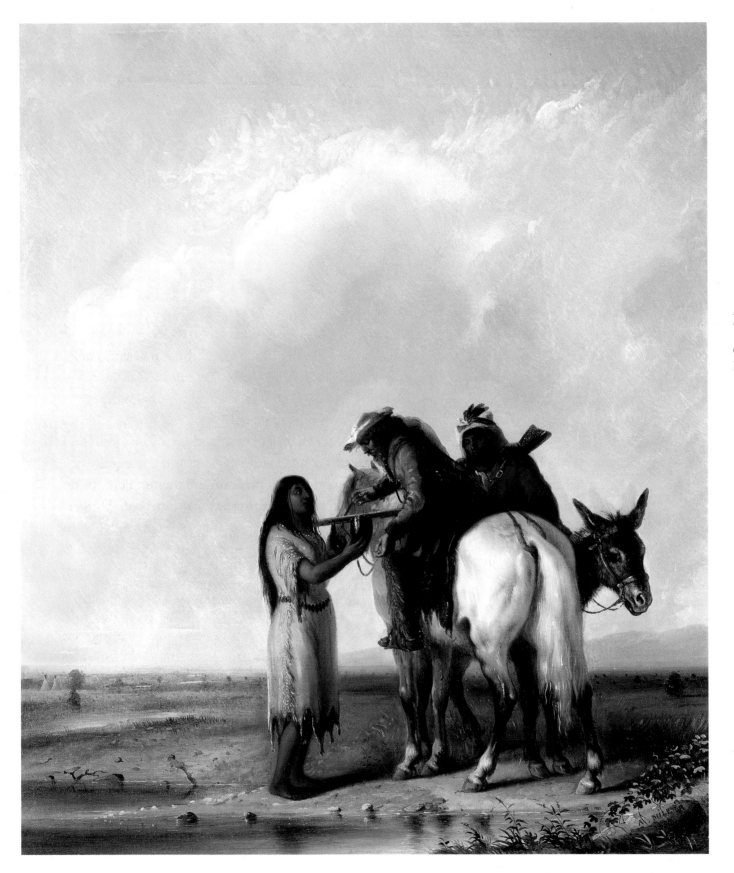

ALFRED JACOB MILLER (1810–74)
The Thirsty Trapper, 1850

Oil on canvas, 24 x 20 inches
Inscribed lower right: A Miller 1850

into cones to hold produce. Over the years Herbert developed expertise and proficiency in the paper production business. Then, in 1902 he patented a machine that made square-bottom, heavyweight paper bags that opened with a flick of the wrist and stood upright. His E-Z Opener bags revolutionized packaging and ultimately led to the formation in 1928 of Gulf States Paper Corporation, a private paper production and products company now directed by the fourth generation of Herbert's family. Gulf States has always maintained with pride an integrated operation that produces both paper pulp and consumer products—an accomplishment that allowed Herbert to proclaim that the company was involved "from woods to goods."

Herbert Westervelt passed the leadership of the company he created to his daughter Mildred, the first child of his 1891 marriage to Emma Mae Nielson, a schoolteacher from Marseilles, Illinois. Born on July 2, 1893, Mildred grew up in South Bend, Indiana. Because of illness as a young girl, which kept her from childhood activities, she spent a great deal of time with her father and became increasingly interested in his business and anxious to learn from him. After graduation from Lasell Seminary for Young Women near Boston, and a trip to the Far East, she met Herbert David Warner, a lawyer and city judge in her hometown. They became engaged within three weeks and married on July 17, 1915. By the time their second son, Jonathan Westervelt Warner, was born in Decatur, Illinois, on July 28, 1917, both Mildred and Herbert Warner were part of the management of her father's business, the E-Z Opener Bag Company.

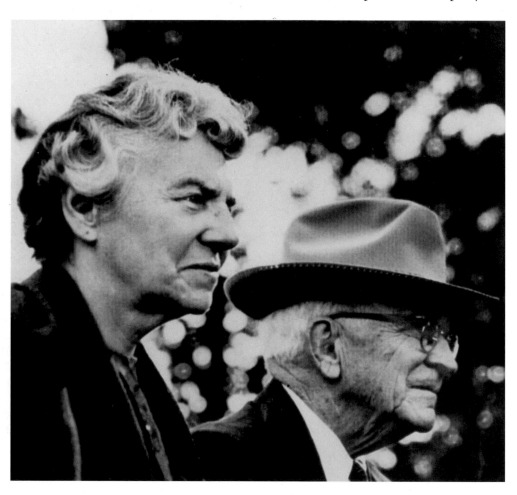

Mildred Westervelt Warner and her husband, Herbert David Warner

The recognition of his daughter's outstanding business ability led Herbert Westervelt to make her executive vice president in 1928 when the E-Z Opener Bag Company became incorporated as Gulf States Paper Corporation and moved the following year to Tuscaloosa, Alabama, to start operation. Fast-growing southern white pine, a source of water, and a labor force were necessary for the most rapidly growing private paper company in the country. Mildred Warner became president of Gulf States Paper Corporation in 1938, the year her father died. With her husband, Herbert, as secretary-treasurer, she managed the company until 1957, not only as president but also as a revered employer, esteemed colleague, and dedicated member of the Tuscaloosa community. It was unprecedented to have a woman running a company that was a prominent employer in a southern

city, yet she remains unrecognized by many seeking historic examples of women as business leaders.

Mildred Warner was committed to the proper management of natural resources and to historic preservation. She wanted children to understand the importance of conservation and sponsored essay contests on the subject throughout Alabama. With foresight and negotiating skills, she acquired large amounts of forest land and, in 1942, initiated a program of forest management that was widely recognized and commended by her peers in the paper industry. Advice on forestry conservation became a public service of Gulf States Paper Corporation; today the company's management professionals care for over four hundred thousand acres of Alabama woodlands.

Among all her good works in Tuscaloosa, perhaps Mildred Warner's most constant was her dedication as a member of the First Presbyterian Church. In 1952 the sanctuary was remodeled and redecorated under her guidance. In 1961 she, her husband, and their son Jonathan made possible the Westervelt-Warner Chapel in memory of their parents and grandparents. Herbert David Warner Jr., Mildred and Herbert's oldest son, who died in a swimming accident in 1931 at the age of fifteen, is memorialized with a prominent stained-glass window over an entrance to the church. Also in memory of their son, the Warners established the David Warner Foundation in 1936; many children in rural and urban areas throughout the South learn water safety in swimming pools donated by the foundation.

Mildred Warner was a wise and astute leader who wanted her son Jonathan, known to everyone as Jack, to match her courage and wits. Jack became president of Gulf States Paper Corporation in 1957 after learning the business through the diligent guidance and tutelage of his mother. Many of the finest works in Jack Warner's collection of American art are now installed in a historic house in Tuscaloosa named after his mother. The Mildred Warner House is the repository of American paintings, sculpture, furniture, and other decorative arts, primarily of the nineteenth century. It is a lasting tribute to the leader who preceded Jack as chief executive of Gulf States for more than twenty years and to the mother whose character, business acumen, and affection are so influential in his life.

Mildred Warner was also known as an extremely generous benefactor of the University of Alabama, located in Tuscaloosa since its founding in 1831. In 1946 she purchased the house that had been the home of the governor of Alabama before the capital moved to Montgomery; she donated the house to the University of Alabama

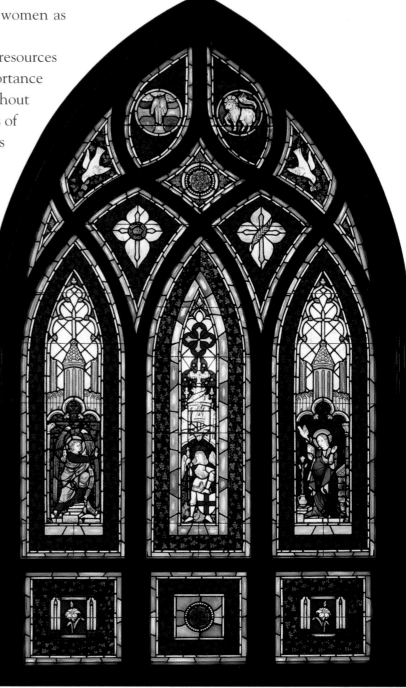

Warner Memorial Stained-Glass Window
First Presbyterian Church, Tuscaloosa, Alabama

Central panel: Winged Saint George, France, fifteenth century, from a church in Avignon
Side panels: Annunciation, South Germany, fifteenth century
Dedicated to the memory of Herbert David Warner Jr. (1916–31), gift of Mildred and Herbert Warner

and furnished it to serve as the University Club. Jack has continued to improve the furnishing of the club. His mother also gave her own home and the adjacent home of her parents in the nearby Pinehurst section of Tuscaloosa to the university. Jack has augmented this gift, making it three contiguous properties with the addition of his adjoining home, now used by the university as a guesthouse. Mildred Warner was particularly concerned that the president of the University of Alabama should have an appropriate setting for his official life. In 1950 she oversaw the restoration and decoration of the President's Mansion. Jack has again continued her efforts and placed major works of art in the rooms for entertaining. With his wife, Elizabeth, he has seen to it that the public rooms are representative of the finest interiors of the period of the house.

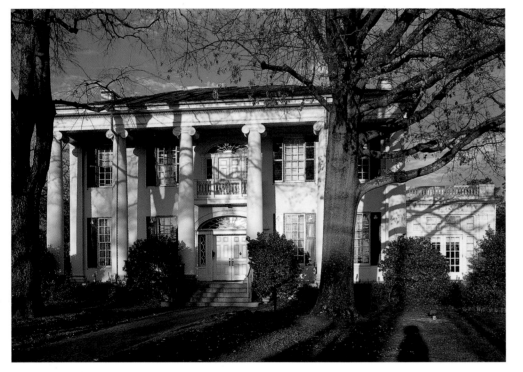

ABOVE

University Club, University of Alabama,
built 1834

When Tuscaloosa was the capital of Alabama, from 1826 to 1846, this building served as the governor's house. It was purchased in 1946 with funds from Mildred Warner, who also provided furnishings.

OPPOSITE

**President's Mansion,
University of Alabama**

*Venice, Bride of the Sea, 1856–66,
by Larkin Goldsmith Mead (1835–1910)
is on the Gothic Revival center table in the parlor.*

In addition to his mother, the other lasting influence from Jack Warner's youth is Washington and Lee University, where he received a degree in business administration in 1940. The university was founded in 1749 and financed by George Washington, who endowed it in 1796 with a gift of one hundred shares of James River Company Stock. Robert E. Lee became president of Washington College in 1865, and the name was officially changed to Washington and Lee University after his death in 1870.

The experience of being educated through the legacy of the first president of the United States has had lasting effect on Jack. His reverence for Washington—the man and the leader—is reflected in objects throughout his collection. In 1999 Jack encouraged a group of donors to celebrate the 250th anniversary of the founding of Washington and Lee with a gift to Mount Vernon of an amount equal to Washington's endowment gift. He has benefited his university, where he served as a trustee from 1970 to 1983, with the long-term loan of a portrait of Washington by James Peale, and the Jonathan Westervelt Warner Athletic Center was named in honor of his great generosity in 1977. Renovation of Lee Chapel and the redesign and reconstruction of Lee Chapel Museum was begun in 1996 through an anonymous one-million-dollar gift that was matched by Jack.

For over forty years, Jack Warner has increasingly looked to art as a way to formalize his respect for his American heritage and the resulting opportunities that have benefited him and his family. His collection has become his primary means of confirming and sharing his patriotic and aesthetic sensibilities. Above the desk

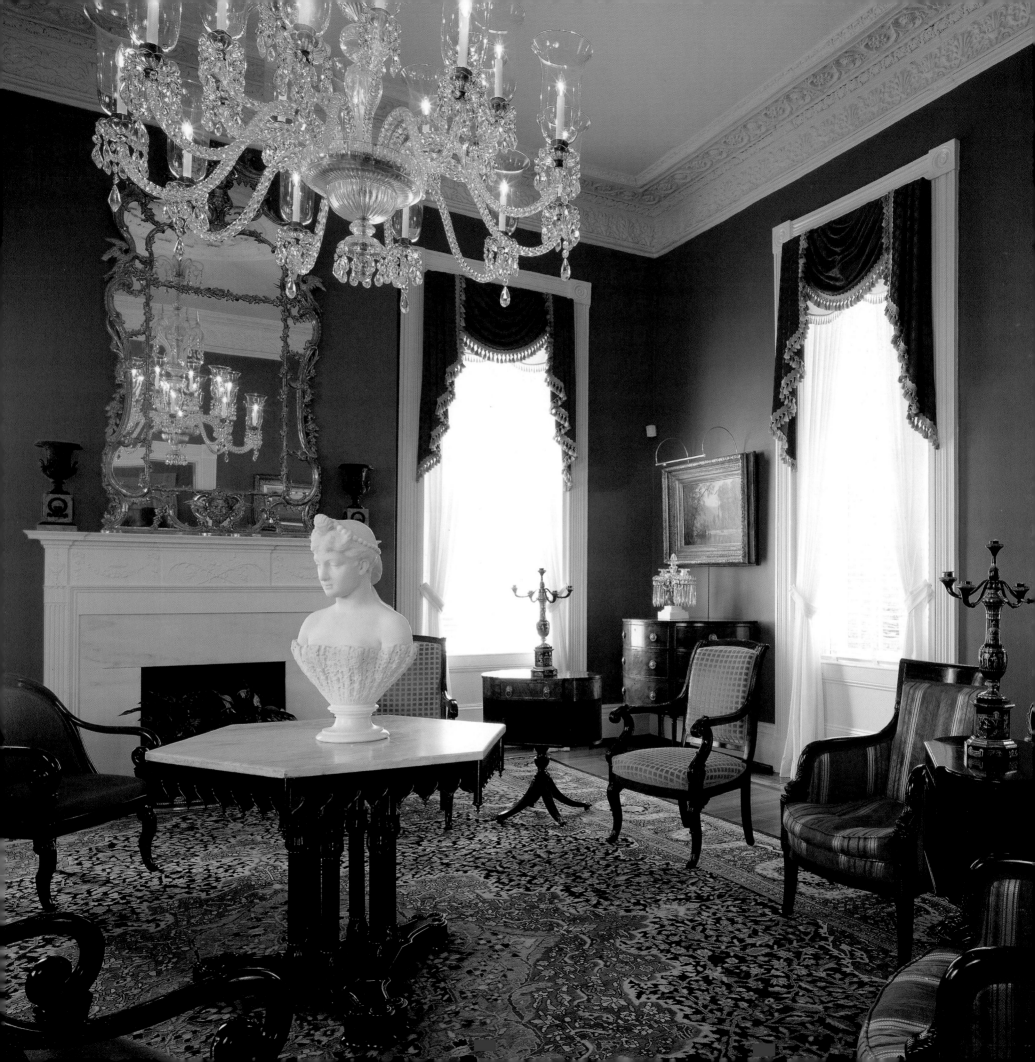

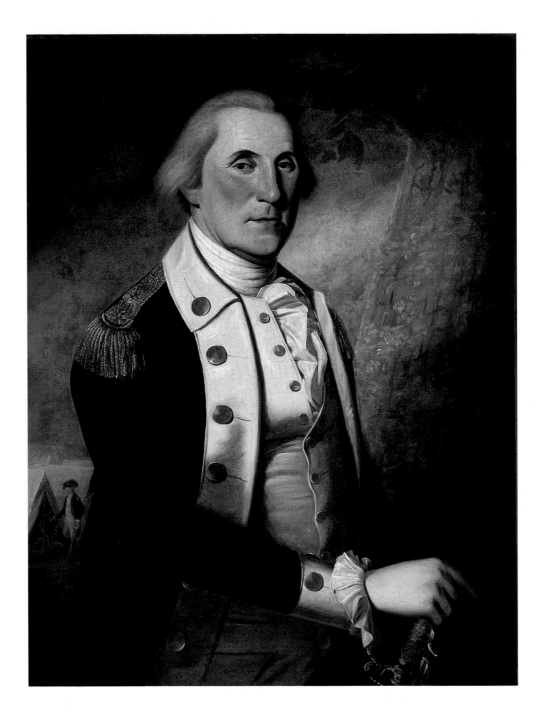

James Peale (1749–1831)
George Washington, circa 1780–86

Oil on canvas, 29 ¼ x 25 inches
On long-term loan to Washington and Lee University by
the Warner collection of Gulf States Paper Corporation,
Tuscaloosa, Alabama

in his office, Jack has chosen to install *The Thirsty Trapper,* 1850, by Alfred Jacob Miller. In many ways, the fur trapper receiving the gift of water from a Plains Indian expresses some of what Jack seems to respect: entrepreneurial skill and adventure, kindness among people, a sense of divine power suggested by the limitless landscape and the majesty of the sky. Artistic genius, respect for nature, the excitement of the frontier, love of family, and an abiding fascination with the talent for leadership, especially as expressed by George Washington, are predominant

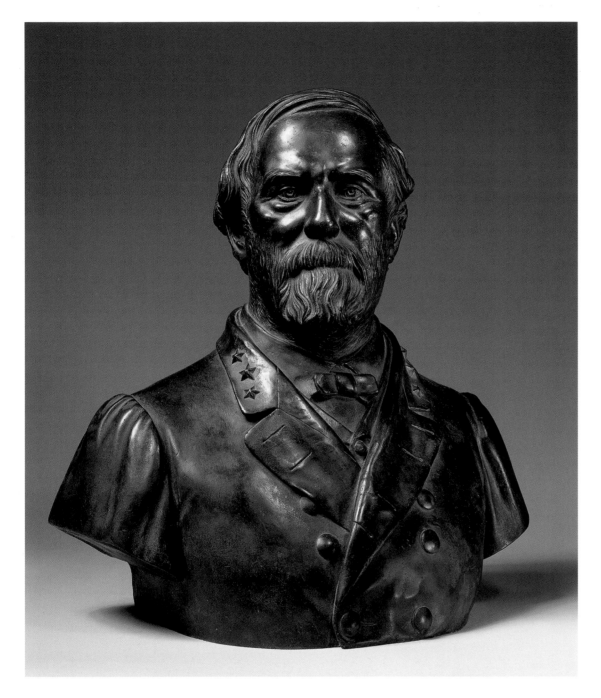

EDWARD VIRGINIUS VALENTINE (1838–1930)
General Robert E. Lee, 1870

Bronze, 22 ½ x 21 ½ x 10 ½ inches
Inscribed rear: Gen Robert E Lee
Edward V Valentine

Valentine worked primarily as a portrait sculptor in Richmond, Virginia. This portrait from life, begun four months before Lee died in October 1870, was a preparatory work for the full-length recumbent marble figure in Lee's burial place, Lee Chapel at Washington and Lee University.

Robert E. Lee was born in 1807, eight years after the death of George Washington. Throughout Lee's life, Washington was an exemplary figure and Lee would ultimately be forever associated with his fellow Virginian. Lee married the daughter of George Washington Parke Custis, the grandson of Martha Washington who was adopted by George Washington.

After graduation from West Point and an outstanding career as a model officer, Lee resigned from the U.S. Army in 1861 when Virginia voted for succession. He became general-in-chief of all Confederate armies and ultimately surrendered in defeat at Appomattox in 1865. Within months after the defeat of his army, he was asked to become president of Washington College, Lexington, Virginia, to rebuild the school. The dignity and forbearance he demonstrated contributed to reestablishing the economic, cultural and political stability of Virginia. When he died five years later, the trustees of Washington College with the General Assembly of Virginia joined for posterity the names of the two great leaders by renaming the college Washington and Lee University.

themes in the objects chosen by Jack for the Warner collection of Gulf States Paper Corporation.

Herbert Westervelt's expression that his business was "from woods to goods" can be rephrased in reference to his grandson. The natural resources of Alabama and the South, Herbert Westervelt's E-Z Opener bag machine, and a pioneering company led by a remarkable family have provided, through Jack Warner, the pleasure of an outstanding art collection. It is a privilege to enjoy the goods from the woods.

THE MILDRED WARNER HOUSE

The Mildred Warner House was known as the Washington Moody House when it was purchased and restored by the David Warner Foundation in 1976 under the direction of Jack Warner. Since then it has been a house museum named in honor of Warner's mother, Mildred Grace Westervelt Warner (1893–1974).

Built in 1822 by James Jenkins on land that he purchased from the United States government in 1820 for $120, the house was originally a two-room cabin. A four-story brick addition was built in 1832. In 1934 it became the first house in Tuscaloosa, Alabama, to be listed in the Historic American Buildings Survey. It is furnished with American art, furniture, and other decorative arts, primarily from the nineteenth century, assembled by Jack Warner.

ABOVE

Front facade, evening view

OPPOSITE

View from the west

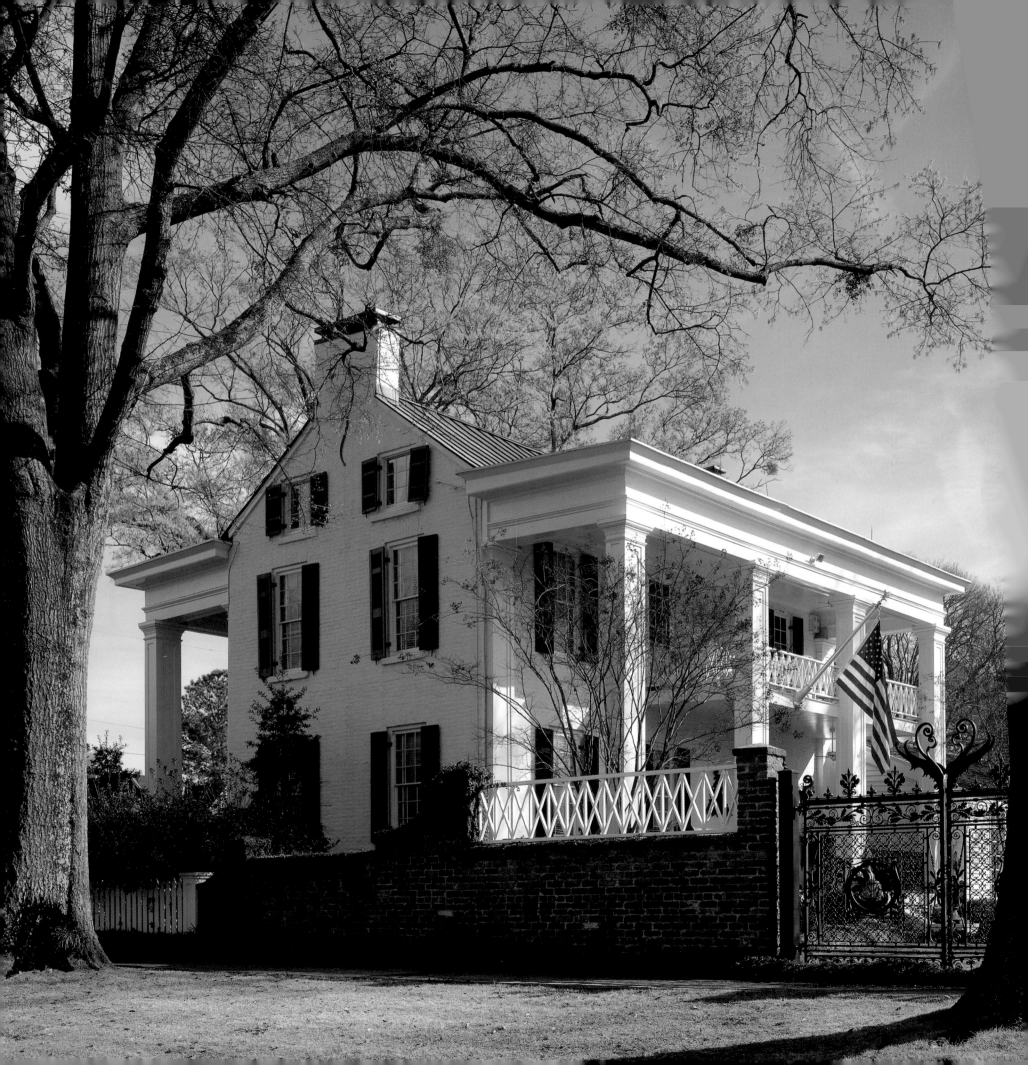

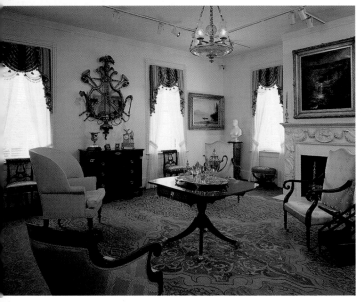

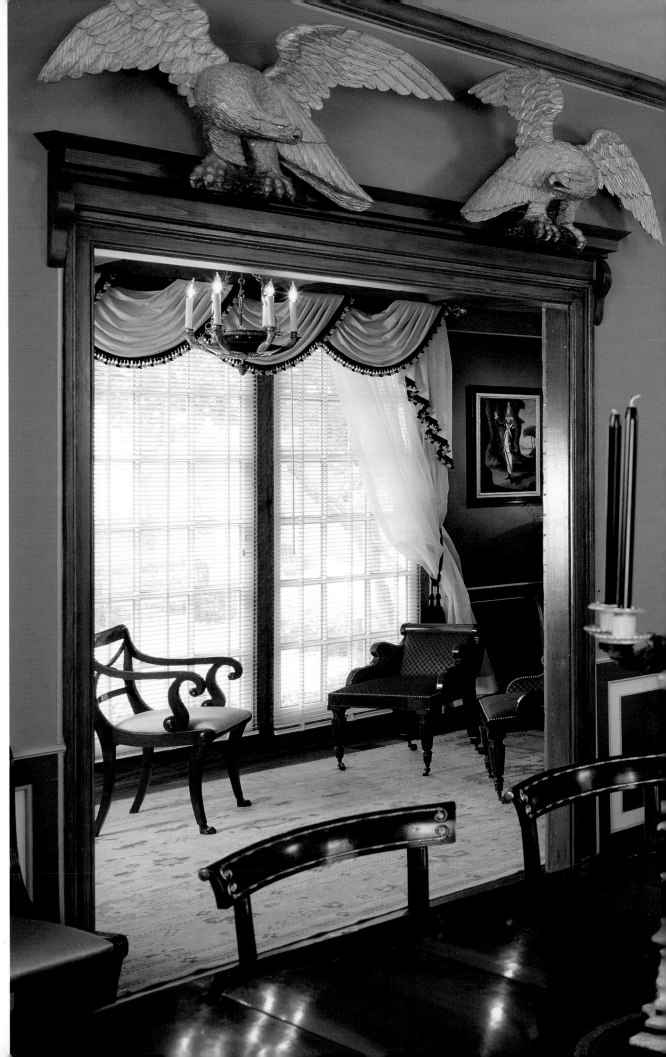

TOP

Foyer

ABOVE

Parlor

RIGHT

Dining room

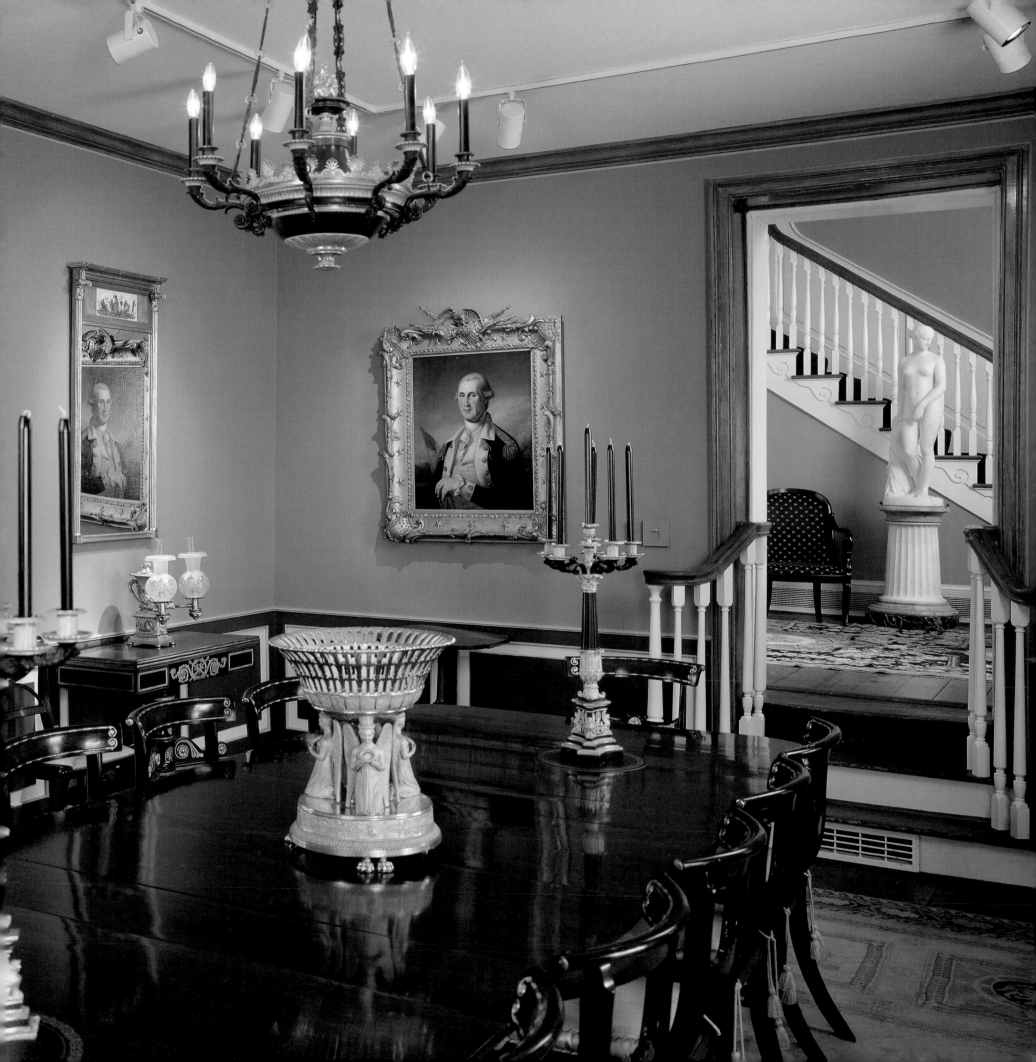

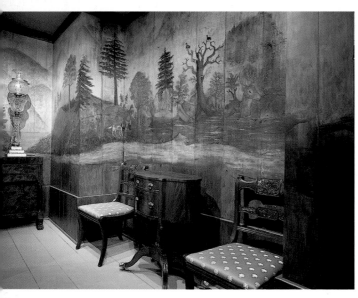

TOP

Sunroom

ABOVE

Breakfast room

RIGHT

Music room

Benjamin Franklin, *1854, by Richard Saltonstall Greenough (1819–1904) is on the table in the foreground.*

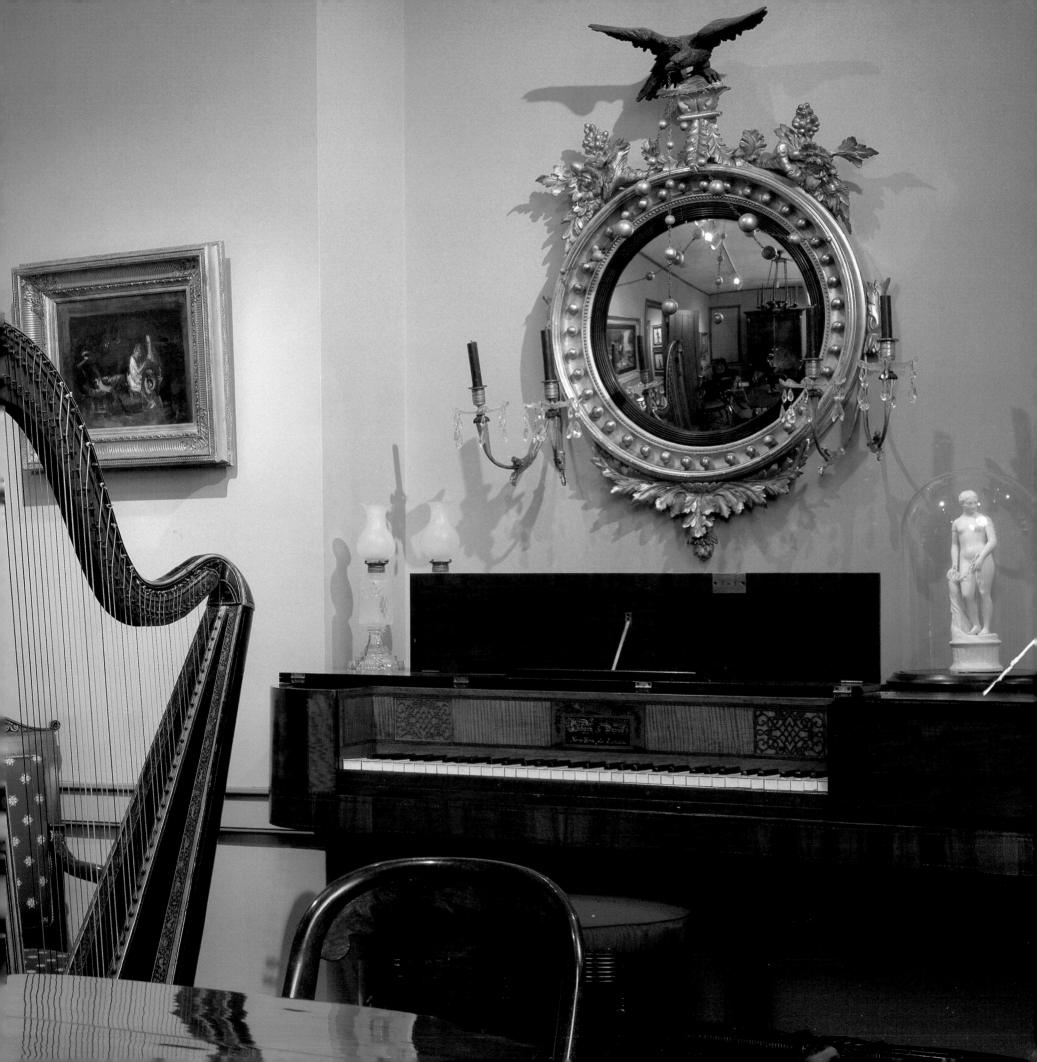

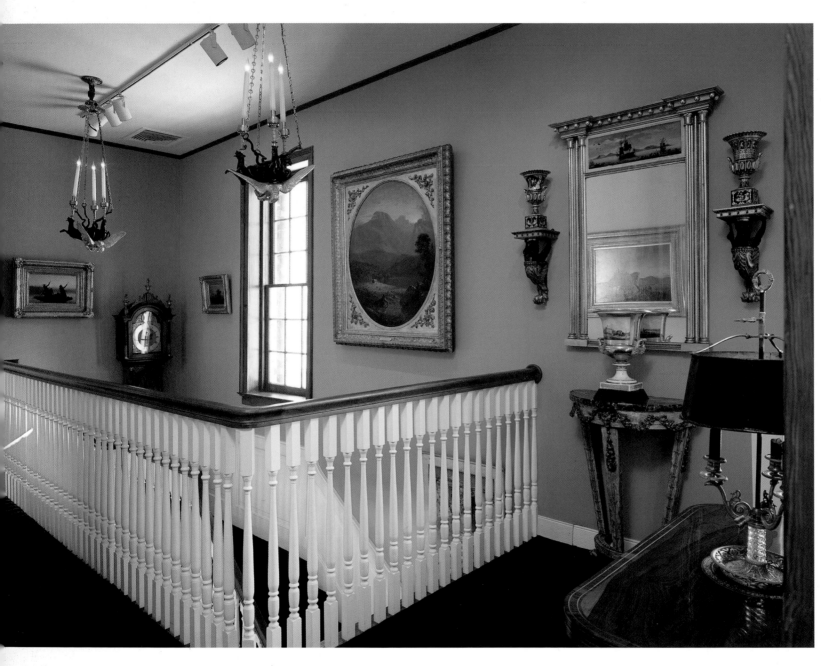

ABOVE

Upstairs hall

OPPOSITE

Bedroom

24

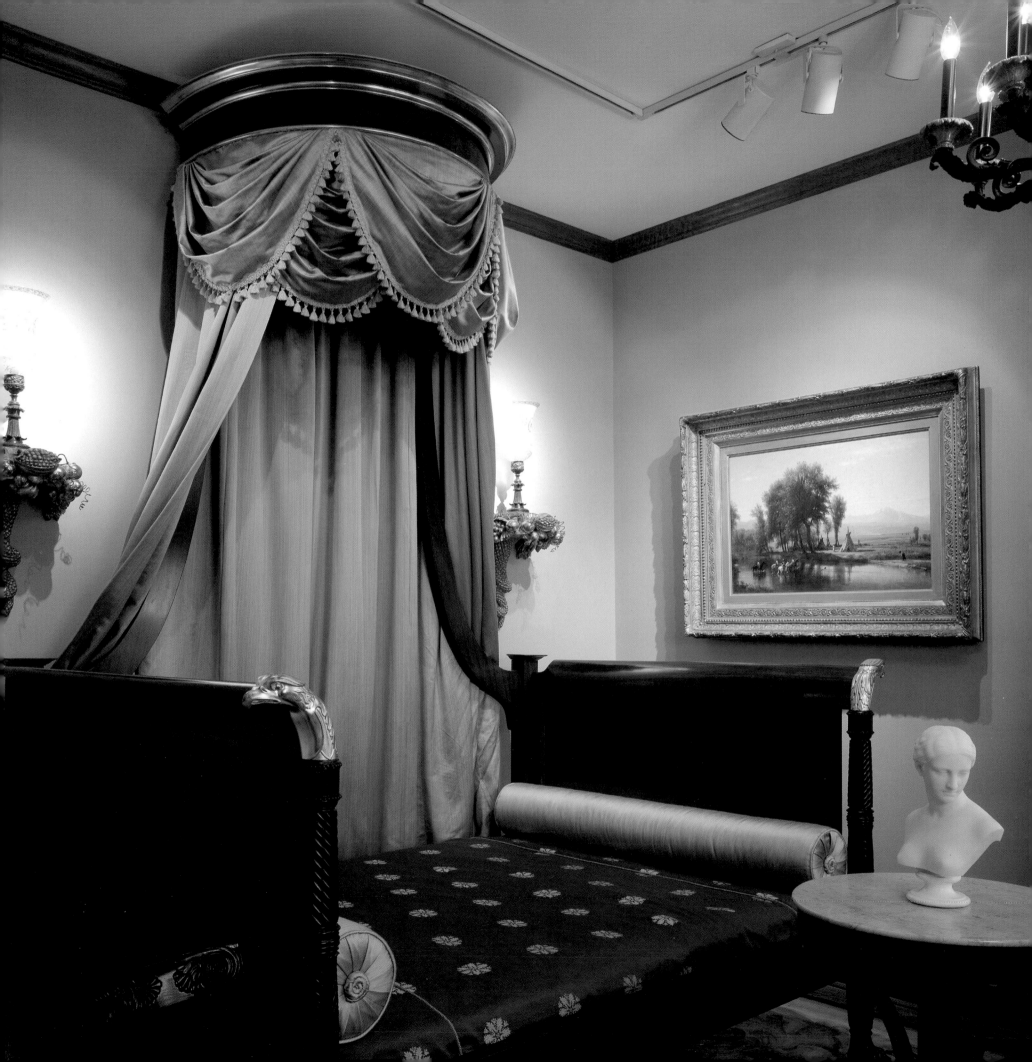

Sitting room

INTRODUCTION

PATER PATRIAE

WENDELL GARRETT

Through our great good fortune, in our youth our hearts were touched by fire.
It was given to us to learn at the outset that life is a proud and passionate thing.
—Justice Oliver Wendell Holmes Jr., *Memorial Day Address,* 1884

Every life is woven of intersecting strands. In Jack Warner's experience, one strand stands out: his unswerving devotion to the memory of George Washington, *pater patriae,* father of his people. A deep-dyed love of country underlies Jack's unflagging interest in America's heritage. He has devoted a long life and a superb intellect, a warm personality and a philosophic bent, to the collecting of American fine and decorative arts. Through a deluge of honors he remains perfectly and completely himself.

Washington was president before there was a presidency. He was president of the Constitutional Convention prior to becoming the nation's, and the world's, first popularly elected, constitutionally constrained chief executive. He exploited his role as presiding officer to ensure that the constitutional deliberation would produce a sufficiently strong union with a powerful chief executive at its head, and he placed his great prestige behind obtaining ratification. As chief executive, he remained faithful to the Constitution—yet the very sovereignty of the Constitution and the deference it came to acquire were largely his doing. He set critical precedents. He filled the gaps left by the document in ways that made the office strong while keeping it in check for a democratic republic. He launched the presidency on an appropriately democratic trajectory and is today invariably considered not only the first, but also one of the greatest, American presidents.

A fortuitous conjunction of character and destiny over two hundred years ago brought America a leadership of philosopher-statesmen unmatched in its history. These men, extraordinary by the standards of their own day as well as the present, faced the sternest test confronting the history of the United States—that of achiev-

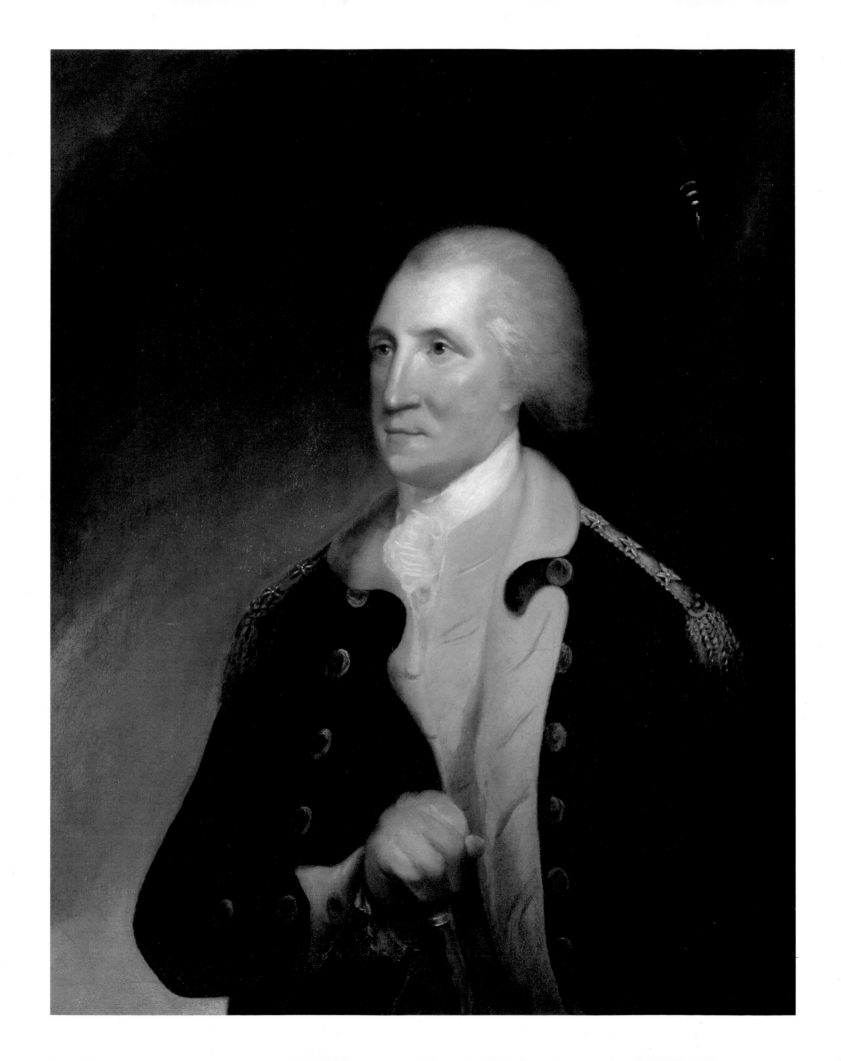

WILLIAM WILLIAMS, English (1727–91)
Portrait of Private McKinney, 1773

Oil on canvas, 23 ¹/₂ x 17 ¹/₈ inches
Inscribed lower left: W Williams Pinx 1773

*William Williams, an Englishman who painted in the
New York–Philadelphia area during extended periods
between 1747 and 1776, depicted his subject in the
uniform of a private in a New York City grenadier
company of British colonial troops. Composed primarily
of privileged young men, the New York grenadier
companies were separate from the militia until after the
beginning of the Revolutionary War, when they fought
with revolutionary troops. The painting is reportedly the
only portrait of an American colonial private in uniform.*

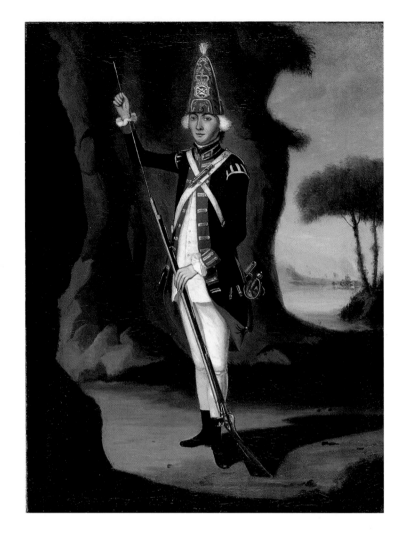

ing independence and building a durable nation. They thought of themselves, in Thomas Jefferson's words, as "the Argonauts" who lived in "the Heroic Age." And of them all, George Washington knew that he mattered most.

In portraiture and sculpture Washington never smiled; the magisterial Washington is stolid, serious, and unsmiling, intensely self-conscious of his role as hero-president, *pater patriae.* These were qualities of mind and spirit that later hagiographers and mythmakers described more often than bodily features. The fundamental element in Washington's character, according to Jefferson, was prudence, followed closely by integrity, honesty, and a stern sense of justice. He was described by contemporaries more in terms of character and intellect than physical appearance. The emphasis was on heroic virtues—self-restraint not self-expression, dignity not forcefulness, moderation not ambition, responsibility to accepted duty not making a mark on the world in novel ways. The occasional references to bodily features simply point to the qualities of mind and spirit. Writers

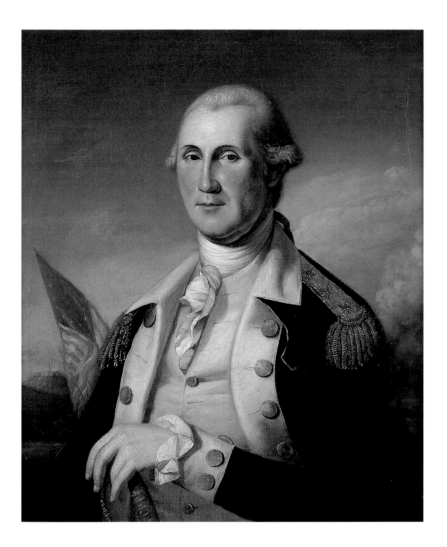

JAMES PEALE (1749–1831)
George Washington, 1780–86

Oil on canvas, 29 ³/₄ x 25 inches

James Peale and his older brother Charles Willson Peale (1741–1827) were the patriarchs of the first and greatest dynasty of American painters. Because the brothers shared a studio, James Peale's portraits of George Washington are related in composition and style to his brother's. James specialized in portraits and miniatures until the last decades of his life, when he and his nephew, Charles Willson Peale's son Raphaelle (1774–1825), established an American still life painting tradition.

Rembrandt Peale (1778–1860), the seventh of Charles Willson Peale's seventeen children, is also represented in the Warner collection. At the age of seventeen, Rembrandt Peale made a life portrait of Washington. He subsequently made many copies of not only his own but his father's and uncle's representations of Washington. Between 1822 and 1860, Rembrandt Peale made a series of seventy-nine idealized depictions of Washington, referred to as porthole portraits, as he strove to produce a definitive likeness to compete with Gilbert Stuart's iconic image, the "Athenaeum Head."

noted a countenance "strongly marked with the lines of thinking," or an eye that not only "kindled with intelligence" but also "spoke the language of an ardent and noble mind."

What gives the real Washington his special distinction, what in fact accounts for his towering greatness and peculiar appeal, is not so much intellectual achievement or book learning as character—an unflinching belief in principles and a stern devotion to virtue. In the course of a busy and active life, he found little time or inclination to read; he was a poor public speaker, slow in expression and halting in thought, and an awkward conversationalist, possessing, in the words of a contemporary, "neither copiousness of ideas nor fluency of words." But Washington had the good manners, dignified behavior, and supreme self-confidence of the well-bred, class-conscious, aristocratic gentry of Virginia. The classical Roman virtues of *gravitas, pietas, simplicitas, integritas,* and *gloria* fortified his sense of leadership, no matter how self-sacrificing, and sustained his feeling of responsibility, no matter how onerous.

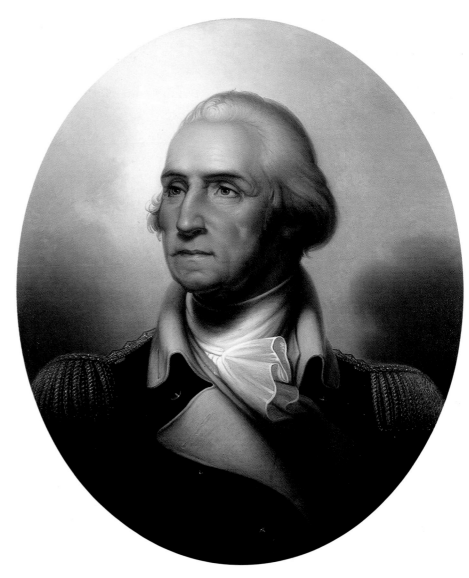

Fisher Ames, the Federalist orator, likened Washington to Epaminondas, the Theban patriot, whose nobility of character Plutarch eulogized. Washington himself seemed to prefer the role of Cincinnatus, the virtuous Roman and sensible farmer. "Agriculture has ever been the most favorite amusement of my life," he wrote after the Revolutionary campaigns were done. Sowing and reaping, planting and grafting, and riding along his fields of green tobacco and rippling grain were his chief delights.

Architecture was his favorite art, and in designing Mount Vernon he obeyed no guide but his own eye. Few historic houses in America so directly reflect the mind and character of their builder and occupant. Mount Vernon was a huge estate that stretched some ten miles along the Potomac River and penetrated inland about four miles at its widest point. Just as Washington—the living symbol of the Revolutionary cause—was much more than a country squire, Mount Vernon was much more than a country gentleman's residence. With no permanent national capital and no presi-

dent's house, Mount Vernon was one of the most prominent buildings in America and the scene of impressive entertaining for renowned visitors. It could be "compared to a well-resorted tavern," Washington wrote, "as scarcely any strangers who are going from north to south or from south to north do not spend a day or two at it." To intimates whom he invited for long visits he warned: "My manner of living is plain. I do not mean to be put out of it. A glass of wine and a bit of mutton are always ready, and such as will be content to partake of them are welcome. Those who expect more will be disappointed, but no change will be affected by it." The American Cincinnatus embraced the Horatian ideal of the good life: cultivation of the soil and tranquil repose by the hearth.

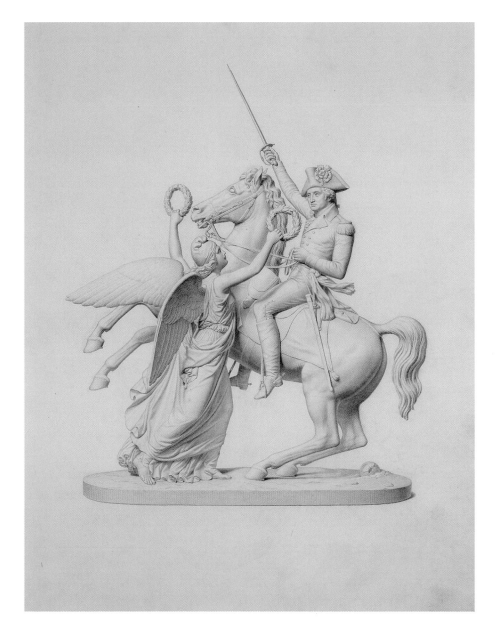

THOMAS CRAWFORD (1814–57)
Equestrian Washington with Figure of Victory,
circa 1845

Pencil on paper, 21 ¹³/₁₆ x 16 ¹/₈ inches
Study drawing of a proposed monument

In 1849 Thomas Crawford, the first American sculptor to settle permanently in Rome, was awarded the commission for a bronze monument to George Washington for Capitol Square, Richmond, Virginia. The commission is considered the first outdoor commemorative sculpture in America and was the first design for an American equestrian monument. Crawford's concept included Washington astride his horse on a pedestal surrounded by illustrious native sons of Virginia. By the time the monument was installed in 1857, two other equestrian monuments had been completed and unveiled.

Crawford died in 1857, the year his monument arrived in the United States from his studio in Rome. Only two of the six associated figures were completed by him— the others are by Randolf Rogers. The drawings in the Warner collection, which descended through the family of the artist, are precursors to Crawford's Washington monument.

Washington set his own terms for executive leadership, and a stiff public protocol suited his dignity. He fused the character of his office to the special qualities of his personality, and he lived the role of the hero-president with the profound awareness of a gentleman who was watching his every action as closely as he assumed others were. His stolidity provided a tableau of strength for the new government; just as he protected his own aloofness inside a sturdy case of formalities, so he expected the national executive to stand apart from the nation as a beacon of public order. And for a man of action unsustained by education and wide reading, he turned out in a correct and easy style an incredible amount of writing. Whether recording routine weather and farm data, or maintaining an extensive correspondence, he was a talented phrasemaker ("to bigotry no sanction, to persecution no assistance"), and he was capable of felicitous eloquence in his state papers. When he delivered his first inaugural address in Federal Hall in New York City in 1789, Fisher Ames, the most fluent member of the First Congress, confessed frankly that he had "sat entranced" in the face of this "allegory in which virtue was personified."

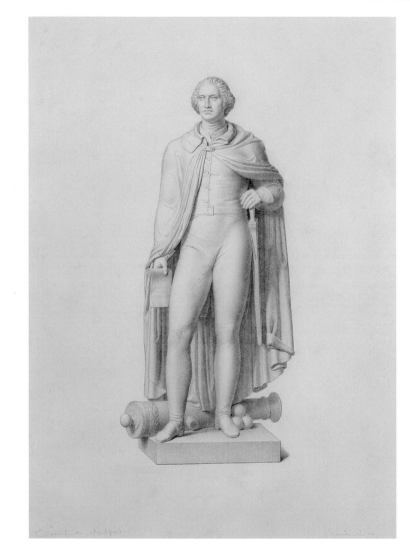

THOMAS CRAWFORD (1814–57)
George Washington Holding the Declaration of Independence, 1842

Pencil on paper, 17 ⁷/₈ x 12 ³/₈ inches
Inscribed lower left/center/right:
Crawford Sculp/Rome 1842/Camia Dis
Study drawing of a proposed monument

Washington is beyond question one of the greatest men in history, one of the noblest men who ever lived. He is the towering figure in the establishment of the United States, and did more than any other man to create and preserve the republic. When the Continental Congress took the thirteen colonies into war, George Washington was officially established not only as the commander in chief but also as the public symbol in the national Valhalla of the fight for popular sovereignty. While Congress, its membership ever shifting, wallowed in indecision, Washington became the power that held the cause together. His aloofness, his dignity, his reverence for God, his massiveness of character, his sense of destiny were proverbial in the public imagination: he was an abstraction of the aspirations of his countrymen. Following his presidency, he quit the life of power to go back to his farm in the role of Cincinnatus, who left the furrow to take up arms for his country and, duty fulfilled, returned to the plow—or in this case to his "villa," as Washington called Mount Vernon. He had become the father of his country.

It is questionable whether any other man in all of American history has ever been so venerated by his compatriots as the "godlike Washington," as Americans came to call him. A military man but never a militarist, it is not Washington the victor at Yorktown who stirs the deepest appeal; it is the legendary Washington on his knees in the snow at Valley Forge. He was great because he was good. Americans' desperate need for a dignified national hero arose from the fact that the nation sprang into being almost before it had time to acquire a history. With astonishing energy and ingenuity, Americans set about to provide both the institutions and the symbols of

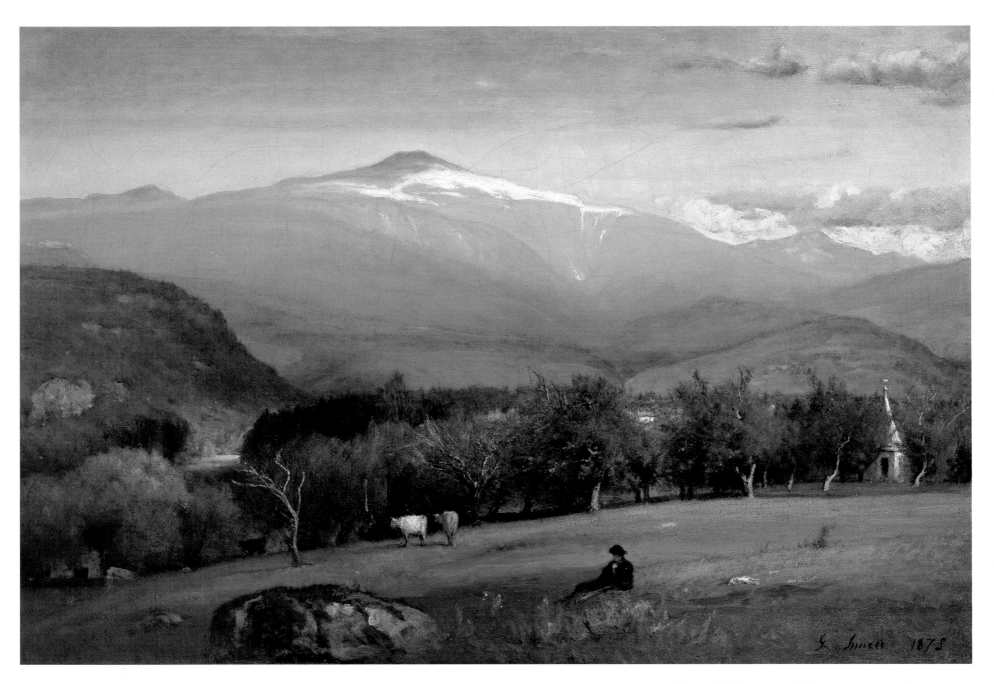

GEORGE INNESS (1825–94)
**Mt. Washington, North Conway,
New Hampshire,** 1875

Oil on canvas, 20 x 30 inches
Inscribed lower right: G Inness 1875

Mount Washington, the highest mountain in the
presidential range in New Hampshire, was named in
1784 by the historian Dr. Jeremy Belknap. At that time
George Washington was an esteemed Revolutionary War
general who would in 1789 become the first president
of the United States. It was not until 1820 that other
mountains in the range began to be named for American
presidents who followed Washington.

nationhood. The institutions—Constitution, federal government, judicial system, and political parties—they contrived with consummate skill. But what is most impressive is the speed and effectiveness with which they conjured up all of the symbols that go into the making of a nation: flag and national anthem, mottoes and myths, legends and traditions, capital city and Capitol. The same generation, indeed the same individuals, who figuratively laid the cornerstone of the nation literally laid the cornerstone of the new Capitol. And Washington was a symbol and driving force in both enterprises. The new capital city was to be across the river from Mount Vernon, and what is more, it was to bear his name.

Here indeed was a legend in the making: more than a military leader, he was the eagle, the standard, the flag, the living symbol of the cause. His contemporaries vied in their tributes—all intended to express the idea that there was something singular about George Washington. His surname, after death, became appropriate for one American state, seven mountains, eight streams, ten lakes, thirty-three counties, nine American colleges, one hundred and twenty-one American towns and villages. His birthday has long been a national holiday. His visage is on coins and banknotes and postage stamps; his portrait (usually the immensely grave "Athenaeum" version by Gilbert Stuart) hangs in countless schoolrooms and corridors and offices. His head—sixty feet from chin to scalp—has been carved out of a mountainside in South Dakota. There are statues of him all over the United States—and indeed, all over the world. Washington was in fact an exceptional man; with reason he became so merged with America that his is the most prominent name in the land.

When the dignified George Washington died on December 14, 1799, he became forever the lonely and immutable monument of American glory. As one eulogist said: "He created his own silence whilst the others were obliged to await the hand of time." The most famous summary of Washington's career was spoken by Henry ("Light-Horse Harry") Lee in a memorial address delivered two days after the former president died: "First in war, first in peace, first in the hearts of his countrymen, he was second to none in the humble and endearing scenes of private life . . . the purity of his private character gave effulgence to his public virtues." Sculptors froze him in the classical image of the patriot-statesman. Jean Antoine Houdon depicted him in a toga as Cincinnatus, Antonio Canova dressed him in Roman armor, and Horatio Greenough, in a colossal statue unveiled in the rotunda of the United States Capitol in 1841, presented Washington like Phidias's *Zeus*, seated on a throne and naked to the waist. During the period of national mourning for Washington—between December 14, 1799, and February 22, 1800—some 350 funeral eulogies were delivered from Maine to Georgia in which the "sainted Washington" was frequently compared to Plutarchian heroes. The man is the monument; the monument is America. *Si monumentum requiris, circumspice* (If you seek his monument, look about you).

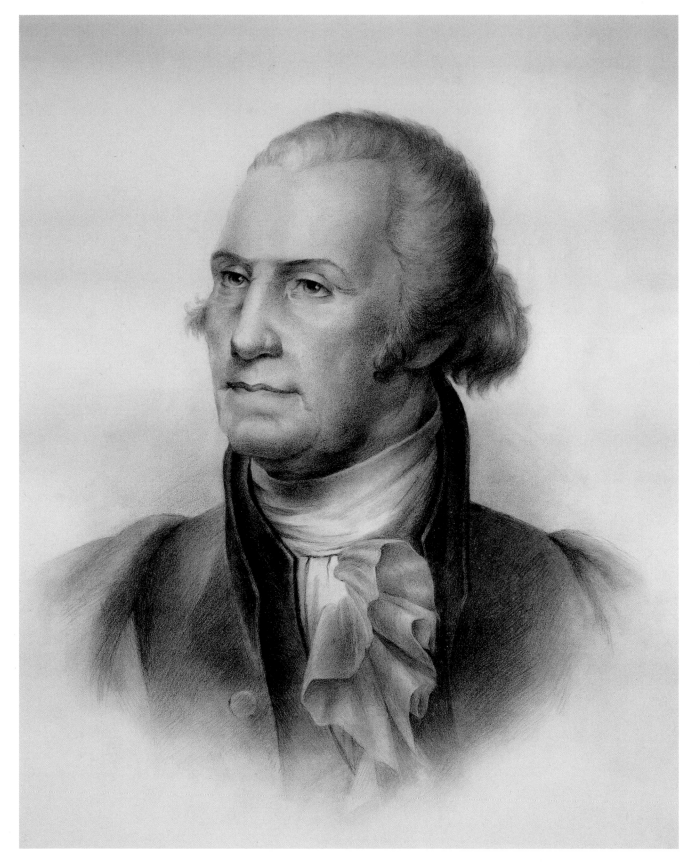

REMBRANDT PEALE (1778–1860)
George Washington, circa 1838

Conte crayon on paper, 20 x 16 inches
Inscribed lower left on original glass
mat: Rembrandt Peale Pinxt

GEORGE WASHINGTON

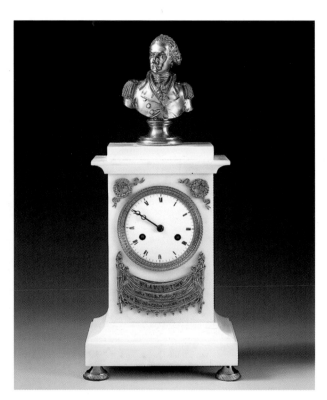

ANONYMOUS MAKER, French
Mantel clock with bust of George Washington,
circa 1815

Gilt-brass and marble, 17 inches high

For more than two hundred years, George Washington has been a superstar. No other American has been able to compete with Washington's accomplishments in so many areas of public life. Writers and artists continue to make him the subject of their books and pictures. Portrait and history painters originally depicted him in the neoclassical style; by the mid-nineteenth century, images of Washington showed him to be an ordinary man in whom ordinary people could see something of themselves. Nevertheless, the patrician image remained appealing through the nineteenth and into the early twentieth centuries. Thus, patrician and egalitarian traditions in the portrayal of George Washington—as ordinary mortal and as revered exemplar—coexisted, each articulating the concerns of a rapidly modernizing, imperfect society.

After his death, Washington was depicted as the man without faults, with all the nineteenth-century virtues—from courage to punctuality, from modesty to thrift—all within the human compass, all crowned with success. For America, he was originator and vindicator, patron saint and defender of the faith, in a timeless fashion—as if he were Charlemagne, Saint Joan, and Napoleon Bonaparte telescoped into one person. After him, only Abraham Lincoln rivaled his national glory. The conceptions of Washington as the father of his people were those of both transcendent American and representative American.

There is probably nothing quite like the monumental and mythical Washington in history. Surely no one else has been so thoroughly venerated, and so completely frozen into legend. His image is the one to which Americans have turned for sustenance during virtually every period of history. As American society has grown ever more pluralistic, the notion of a unified cultural identity has become increasingly elusive. Although it is difficult to envision even George Washington as an overarching heroic presence, his image is nonetheless anchored in both the small-scale and the monumental, carrying the time-honored messages of strength, benevolence, and veneration.

DANIEL CHESTER FRENCH
(1850–1931) and
EDWARD CLARK POTTER
(1857–1923)
Equestrian George Washington,
1900

Bronze, 32 ¼ x 20 ½ x 9 ¼ inches
Inscribed base, left: D C French/
E C Potter/Paris 1900

*At the end of the nineteenth century,
Daniel Chester French was commis-
sioned by a patriotic women's organiza-
tion in America to make a life-size
equestrian George Washington as a gift
to France. The sculpture in the Warner
collection is a small-scale version of the
final work, which was unveiled at the
Paris Exposition on July 4, 1900.
Washington is depicted in a heroic,
dramatic pose as he took command of
the army at Cambridge. The sculpture
was a collaboration with other artists,
including Edward Clark Potter, who
sculpted the horse. A replica of the
original was made for the entrance to
Washington Park, Chicago, Illinois.*

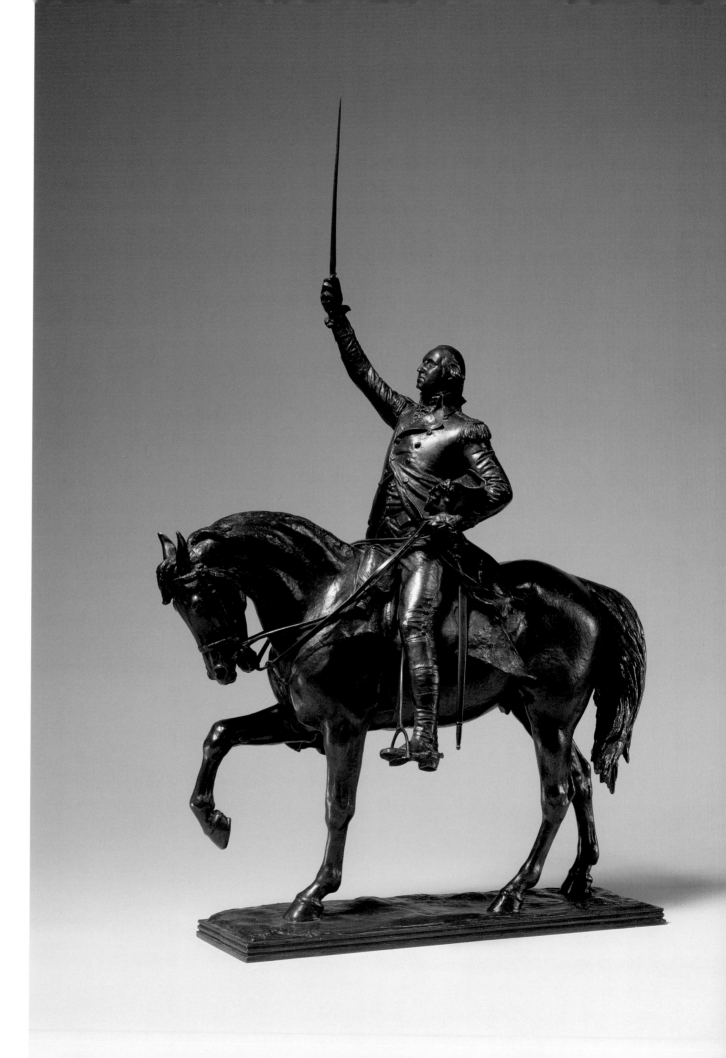

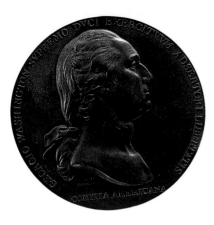

Pierre-Simon Duvivier,
French (1728–1819)
General George Washington, circa 1790

White medal, 3 ¼ inches in diameter
Inscribed below bust: Duvivier Paris F
Inscribed around rim in Latin (English
translation): The American Congress to
George Washington Supreme Commander
of the Army, the Champion of Freedom
On reverse is a scene of Washington and
his staff on horseback observing the British
departure from Boston and the advancement
of American troops.

*The original of this medal was authorized
by the Continental Congress in 1776 to
commemorate General George Washington's
victory in driving British forces from Boston.
However, a definitive image of Washington
was not available at that time. In 1786
Thomas Jefferson commissioned Duvivier,
a renowned French medal engraver, to
create the dies for the medal from Houdon's
1785 bust portrait. The original gold medal
is said to have been given to Washington by
Jefferson in 1790.*

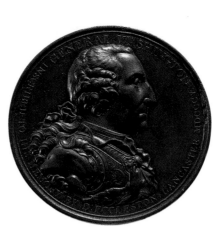

Daniel Eccleston,
English, publisher, and
Thomas Webb, engraver (active 1804–27)
**Commemorative medal of
George Washington,** 1805

Bronze, 5 inches in diameter
Inscribed around rim: GENERAL WASHINGTON
INSCRIBED TO HIS MEMORY D: ECCLESTON.
LANCASTER MDCCCV
On reverse: Native American warrior

*George Washington was a celebrated hero
throughout Europe and England as well as in
America. The detailed, elaborate coiffure and
the suit of armor he wears in the image on this
English commemorative medal were inspired
by various European prints of the period,
which depicted Washington as an idealized
and also an allegorical figure.*

Anonymous maker
**George Washington memorial
leaf dish,** circa 1800

Porcelain, 5 ⅜ inches long
Inscribed on funerary monument:
WASHINGTON
Inscribed below stem: JRL

*Many types of commemorative objects,
including memorial dinner services,
were made following Washington's death.
A Chinese-export-porcelain-covered
vegetable dish with the same design as
this leaf dish is in the collection of Mount
Vernon, gift of the great-great-granddaughter
of George Washington's only sister, Betty
Lewis. The monogrammed initials are
presumed to represent the names of Betty
Lewis's son, Robert, and his wife, Judith.*

Anonymous maker
**Washington memorial
Masonic pendant**

Gold and silvered metal, 2 ⅛ inches in diameter
Inscribed on funerary monument: Washington
born on Feb 22, 1732, Obt. Dec 14, 1799 AE
69 yrs.

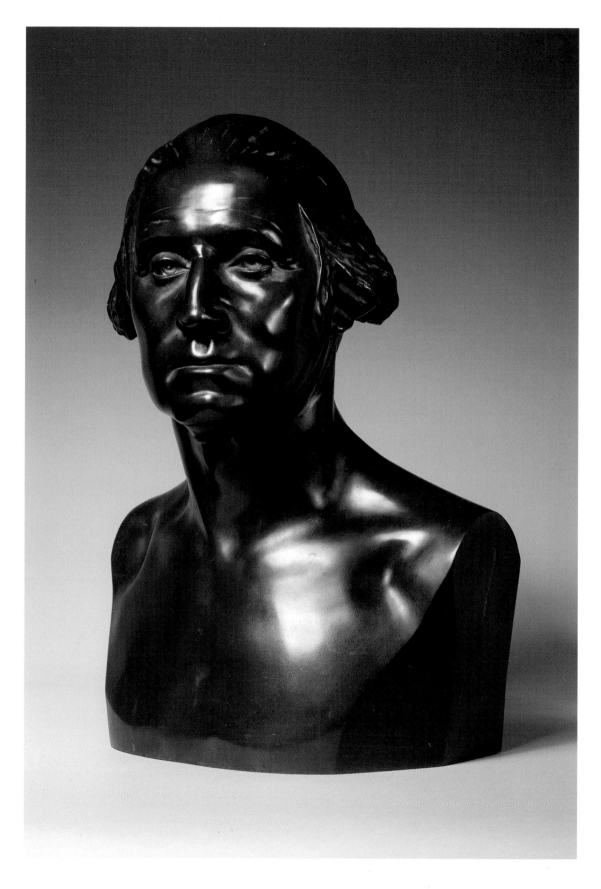

JAMES WILSON ALEXANDER MACDONALD
(1824–1908)
Bust of George Washington, 1898

Bronze, 18 x 12 ³/₄ x 11 inches
Inscribed base, rear in relief: notarized statement that this is
a copy of a bust portrait modeled from life by Jean Antoine
Houdon at Mount Vernon in 1785 and owned by Mrs. Belle
A. MacDonald, New York City

Artists depicting George Washington during his lifetime
and after his death relied on a few primary sources for his
likeness. The most popular was the terra-cotta bust portrait
from life by Jean Antoine Houdon, 1785, made as a gift
to Washington by the artist after a visit to Mount Vernon
to study his subject in preparation for the life-size marble
figure commissioned for the capital building in Richmond,
Virginia. Both the Honoré Pons clock and the bust by
James MacDonald refer to the Houdon portrait, which has
never left Mount Vernon.

BELOW

HONORÉ PONS, French (active 1806–47)
Mantel clock with bust of George Washington,
circa 1820

Gilt-brass and bronze,
21 ¹/₂ x 8 ³/₄ x 8 ³/₄ inches
Movement signed

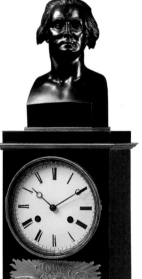

JOHN TRUMBULL (1756–1843)
General Washington at Trenton, 1792

Oil on canvas, 92 ½ x 63 inches
Yale University Art Gallery
Gift of the Society of the Cincinnati in Connecticut

*The city of Charleston, South Carolina, commissioned
John Trumbull to make a life-size, full-length portrait of
Washington; General Washington at Trenton, 1792,
was not accepted and was eventually acquired by Yale
University. The painting, said by Trumbull to be from life,
was taken to London by the artist when he was appointed
secretary to the Jay Treaty Commission. Thomas
Cheesman made an engraving of it, and the standing
figure with arm extended holding a field glass (which
became a scroll in adapted copies) was widely imitated by
other artists. It is the source for the figure on the Dubuc
clock and the sculpture by an anonymous artist in the
Warner collection.*

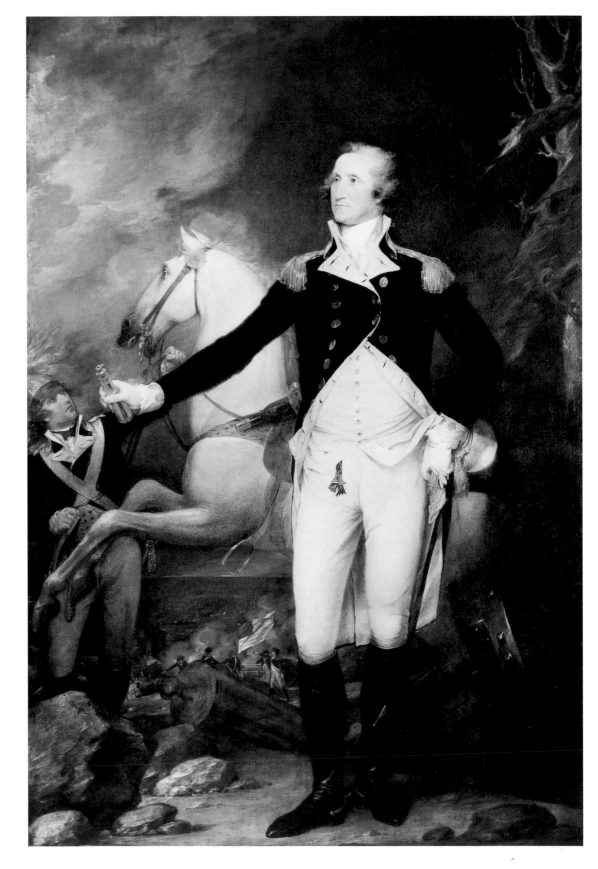

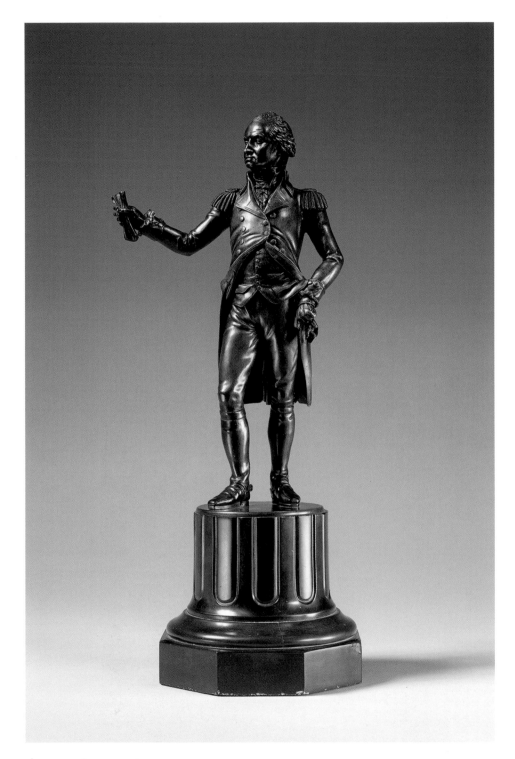

ANONYMOUS ARTIST
George Washington, circa 1820

Bronze with slate base, 19 1/2 x 6 3/4 x 6 3/4 inches

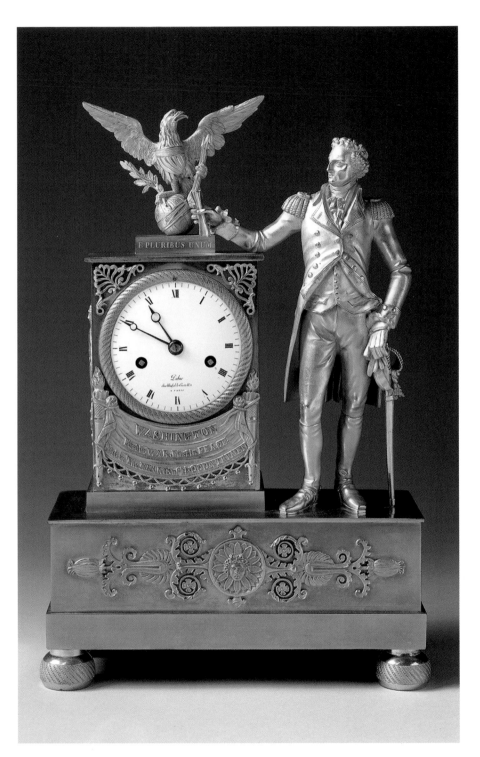

JEAN-BAPTISTE DUBUC, French
(active 1790–1819)
Mantel clock with figure of George Washington
Paris, 1815–17

Gilt-brass and enamel, 16 x 10 1/2 x 4 1/2 inches
Signed and inscribed on the dial

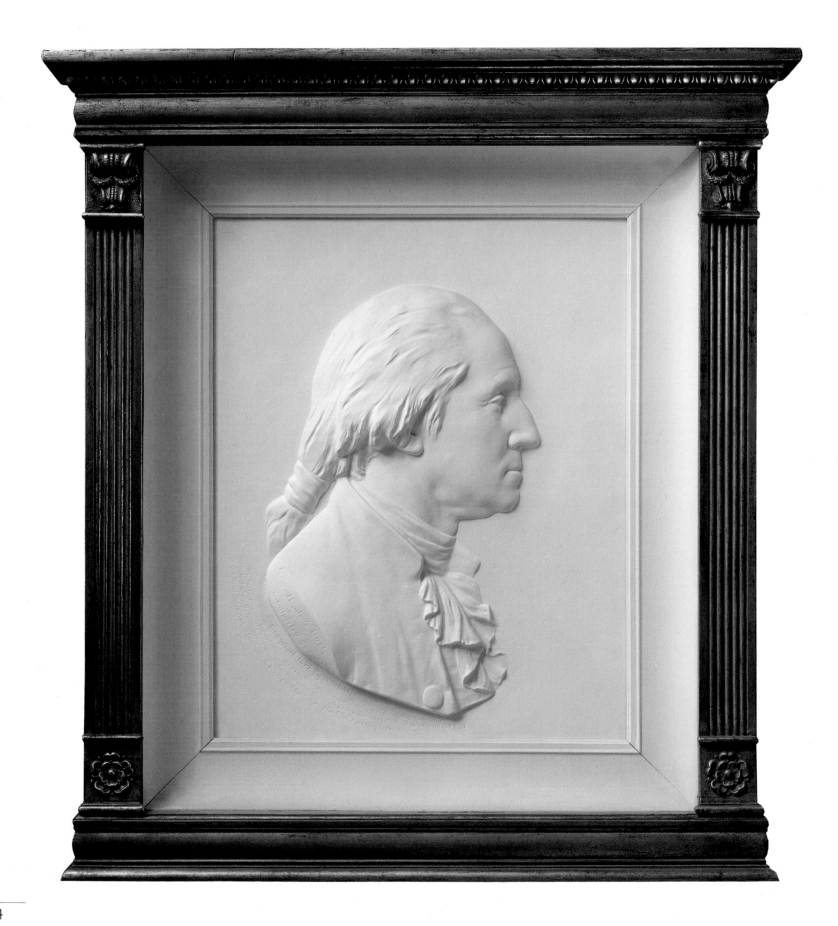

44

ANONYMOUS ARTIST, French
Marquis de Lafayette, circa 1834

Red marble, 13 inches in diameter

CHARLES CALVERY (1833–1914)
Portrait of George Washington,
circa 1877

Plaster, 21 x 17 inches
Inscribed left: From Houdon's bust by C Calvery SC. 1877 copyright 1877 by
WS Barlow N.Y. The bust from which I made this medallion has carved upon
it the following inscription. C. Calvery SC. This bust is from the living face of
Washington by Houdon Oct. 1785. Permission was granted to Clark Mills in
1849 by Col. Washington at Mount Vernon to take a copy of the original Bust
in Bronze. Clark Mills, SC

ANONYMOUS ARTIST, French
George Washington, circa 1834

Red marble, 13 inches in diameter

*In 1777 the Marquis de Lafayette, a young idealist and adventurer, traveled to
America from France to offer his services in the revolutionary cause against the British.
He was awarded a commission as a major general by the Continental Congress and
assigned to George Washington's staff. The older American general had a paternal
influence on Lafayette as the two men became closely associated. Lafayette served
as an intermediary with the French forces that joined Washington's campaigns and
participated in the tactical maneuver that resulted in the British surrender at Yorktown
in 1781 and the end of the Revolutionary War.*

 *In 1824, after several years in France, Lafayette returned to the United States,
accompanied by his son George Washington Lafayette, for a triumphant tour as
the "adopted son" and guest of Congress. A theme of his visit, his friendship and
connection with Washington, was celebrated in Europe and the United States in
many art forms showing paired images of the two heroes. His grave in Paris is
covered with earth from Bunker Hill.*

Jonathan Westervelt Warner

Tom Armstrong

Jack Warner

In the English room of Elizabeth and Jack Warner's house at NorthRiver in Tuscaloosa, Warner sits below one of his favorite paintings, Racing at Fort Laramie, 1868, *by Alfred Jacob Miller (1810–74).*

Jonathan Westervelt Warner (Jack) was destined to continue the legacy of leadership established by his grandfather, Herbert Westervelt, and mother, Mildred Westervelt Warner, and become chief executive of the private Gulf States Paper Corporation in Tuscaloosa, Alabama. His mother, as president of the company, taught him the ways of the business, as her father had taught her. But no one could have guessed that the boy born in the Midwest who came to Tuscaloosa when he was eleven years old would, seventy years later, have the major thoroughfare of the city named after him.

With above average height and a solid build honed by a lifetime of athletics, Jack commands attention. He swims daily, exercises his horses, and makes his wishes known in stentorian tones interspersed with frequent laughter. He is constantly looking for ways to find the fun in life and share it with others. From an endless repertory of stories and jokes he can elaborate on any subject with a reminiscence or witticism—in appropriate dialect.

For as long as anyone can remember, people have been speculating about Warner and his seemingly spontaneous actions—"what next?" He is considered eccentric by some—not the case. He simply knows what he wants, knows how to get it, and shows no sign of self-doubt. He is a "character" in the most laudatory, respectful sense of the word. He most often acts alone; he abhors committees. He has had more advantages than most, but his circumstances have allowed his talents to flourish and his singular abilities to benefit many. Jack's heritage and his life are symbolic of the triumph of American individualism. And perhaps because of this, he is attracted to art, which, for him, is the most meaningful expression of individuality.

Jack Warner was born on July 28, 1917, in Decatur, Illinois. At that time, both of his parents were employed in the business his grandfather had founded, the E-Z Opener Bag Company. In 1929 they moved to Tuscaloosa, Alabama, when the company relocated and became Gulf States Paper Corporation. Three years later Jack

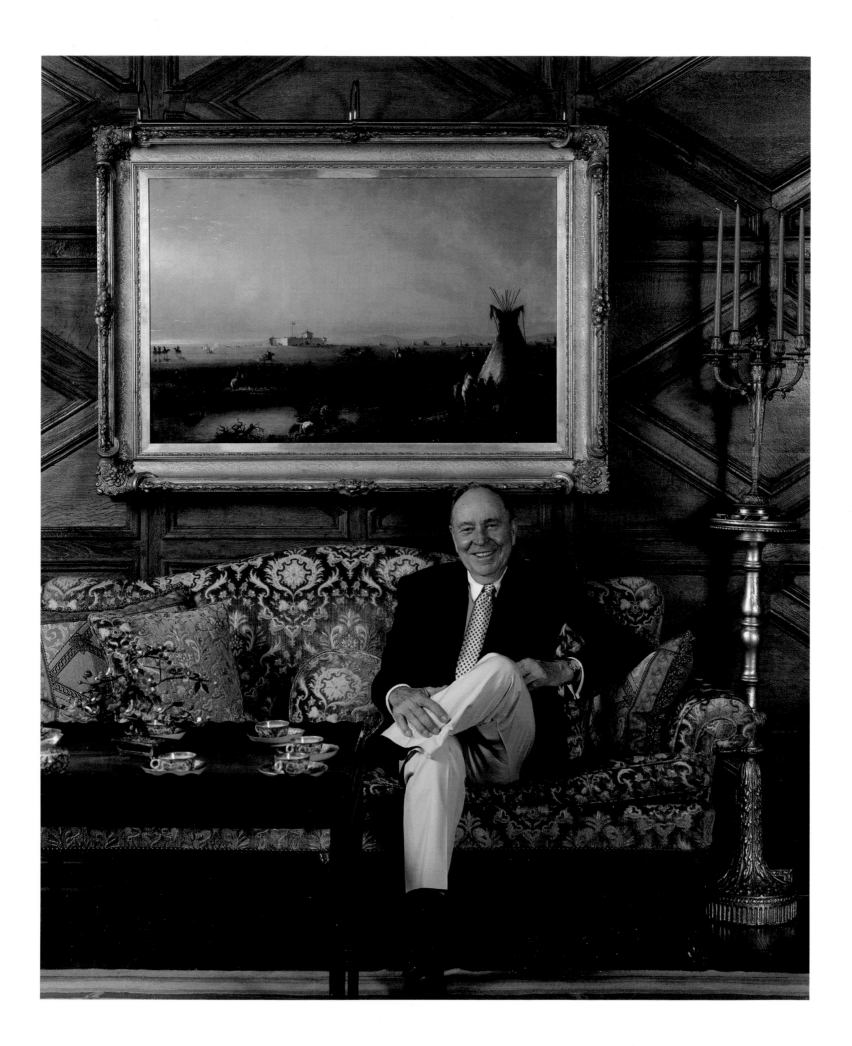

HERBERT HASELTINE (1877–1962)
Percheron Mare: Messaline and Foal,
modeled 1922–24, cast 1925

Bronze, 21 ³/₄ x 22 ³/₄ x 11 ¹/₄ inches (with base)
Inscribed base, front: PERCHERON
Inscribed base, rear: HASELTINE MCMXXV
Inscribed base, right: FIRST LA MORTAGNE SHOW MCMXVII
MCMXVIII MCMXIX • FIRST SHOW OF THE ROYAL COUNTIES
AGRICULTURAL SOCIETY MCMXX • FIRST AND GROUP PRIZE AT
THE SHOW OF THE NORFOLK AGRICULTURAL SOCIETY MCMXX
• FIRST AT THE SHOW OF THE ROYAL AGRICULTURAL SOCIETY
OF ENGLAND MCMXX • FIRST MORETON-IN-THE-MARSH MCMXX
• FIRST AND CHAMPION AT THE SHOW OF THE ROYAL
AGRICULTURAL SOCIETY OF ENGLAND MCMXXI MCMXXII
Inscribed base, left: MESSALINE • FOALED MCMXII SIRE
DOUVREUR-EX-COUVREUR • DAM PAQVERETTE BRED IN
FRANCE AND THE PROPERTY OF MRS. ROBERT EMMET THE
GREYLING STUD • MORETON MORRELL WARWICKSHIRE

Always within Jack Warner's view in his office are two
bronze sculptures by Herbert Haseltine—a Percheron
stallion and a Percheron mare and her foal. In the 1920s
in Great Britain, where animal husbandry was highly
developed, these animals were legendary, as the inscrip-
tions on the sculpture bases attest. They are part of a
series of twenty-six single animals or groups of animals
Haseltine originally modeled in 1922–24, known as
British Champion Animals. For Jack, the sculptures he
keeps close to him represent three categories of his life:
works of art, horses, champions.

Warner has always been involved with horses—
as a young rider, as a cavalry officer, as an owner and
trainer of champion jumpers, as a patron of the United
States Equestrian Team, and as a man who loves riding.
His jumpers Tuscaloosa and Do Right, which he lent to
the team, won many honors, including the Team Gold
Medal for the United States at the 1975 Pan American
Games in Mexico City.

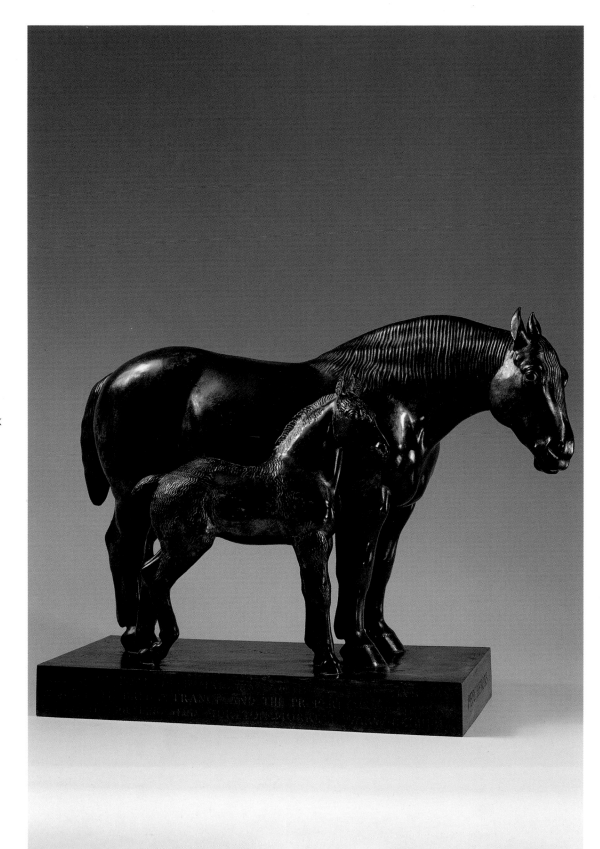

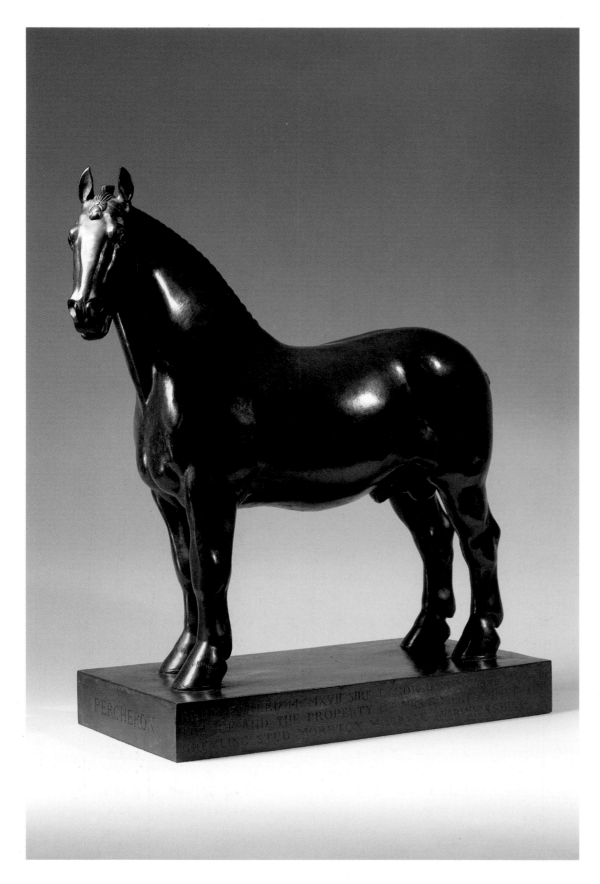

HERBERT HASELTINE (1877–1962)
Percheron Stallion: Rhum, modeled 1922–24, cast 1925

Bronze, 28 ¼ x 22 ½ x 11 ¼ inches (with base)
Inscribed base, front: PERCHERON
Inscribed base, rear: HASELTINE MCMXXV
Inscribed base, left: FIRST LA MORTAGNE SHOW MCMXIX •
FIRST AND CHAMPION AT THE SHOWS OF THE ROYAL
AGRICULTURAL SOCIETY OF ENGLAND MCMXXI MCMXXII
MCMXXIII • FIRST AND CHAMPION NORWICH STALLION
SHOW MCMXXII MCMXXIII
Inscribed base, right: RHUM • FOALED MCMXVII • SIRE LACOR
DAM MAZURKA • BRED IN FRANCE AND THE PROPERTY OF
MRS. ROBERT EMMET THE GREYLING STUD • MORETON
MORRELL WARWICKSHIRE

Thailand Temple Garden, late 1950s
Pinehurst, Tuscaloosa, Alabama

Designed and built by Jack Warner

began his secondary school education at Culver Military Academy in Culver, Indiana, and then spent his college years at Washington and Lee University in Lexington, Virginia. In the summer between his junior and senior years he married Elizabeth Butler, a student at Sweet Briar College who was the daughter of Judge and Mrs. James Turner Butler of Jacksonville, Florida. Elizabeth left her women's college to begin married life on an all-male campus; soon afterward she and Jack moved to Tuscaloosa, where they have lived for the last sixty years and raised two boys, David Turner and Jonathan Westervelt (Jon), who is now chairman of Gulf States Paper Corporation.

Jack volunteered for service in World War II and as a commissioned officer in the army was assigned to the last mounted cavalry unit that formed Lord Louis Mountbatten's Southeast Asia Command in Burma. His experience in Asia and subsequent trips to the Far East with Elizabeth have had remarkable effects, particularly in the architecture he has commissioned. When he returned to Tuscaloosa after the war and began his career in management at Gulf States Paper Corporation, Warner built the Thailand Temple Garden behind the house where he and his family lived at the time, in the Pinehurst section of Tuscaloosa. This structure is the forerunner of a style of architecture that in years to come would form a major component of the built environment of Tuscaloosa. Constructed by Jack himself, working with an itinerant mason, it is a personal translation of the iconography of ancient Asian architecture. It is evident that the garden—behind a traditional American house, which hides it

MATHEW KAHLE, a Lexington, Virginia, cabinetmaker
"Old George," circa 1840

Bronze, 8 feet tall, installed on Washington Hall
Collection of Washington and Lee University, Lexington, Virginia

For 146 years a wooden figure of George Washington, "Old George," has presided over the campus of Washington and Lee University from the top of the main building, Washington Hall. In 1990 it became obvious that the figure was disintegrating, held together only by numerous coats of white paint. The figure was removed, sent to Birmingham, Alabama, restored, and cast in bronze. The bronze version was installed as a permanent feature on Washington Hall; the original, restored wooden sculpture was placed on exhibition in the university's James G. Leyburn Library. This contribution to legend and history was made possible by Jack Warner and a fellow alumnus from the class of 1940, the late Sydney Lewis of Richmond, Virginia. These men, who maintained a friendship and great mutual respect throughout their lives, both headed family companies. Lewis founded and was chief executive of Best Products, a catalog-showroom chain. Each became a major collector of American art. The Frances and Sydney Lewis collection of twentieth-century American art is now a permanent part of a wing of the Virginia Museum of Fine Arts, Richmond, Virginia, established by the Lewises and Paul Mellon. Warner and Lewis served together as trustees of Washington and Lee University, and each is represented by a named building on campus.

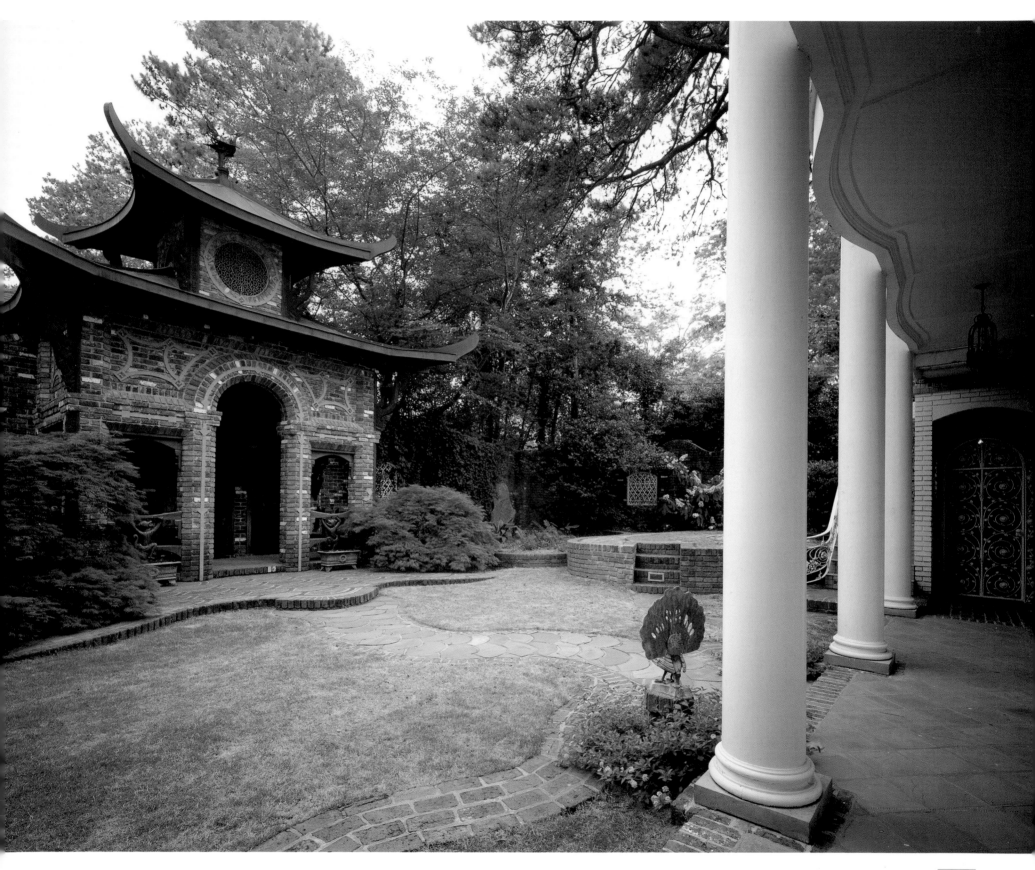

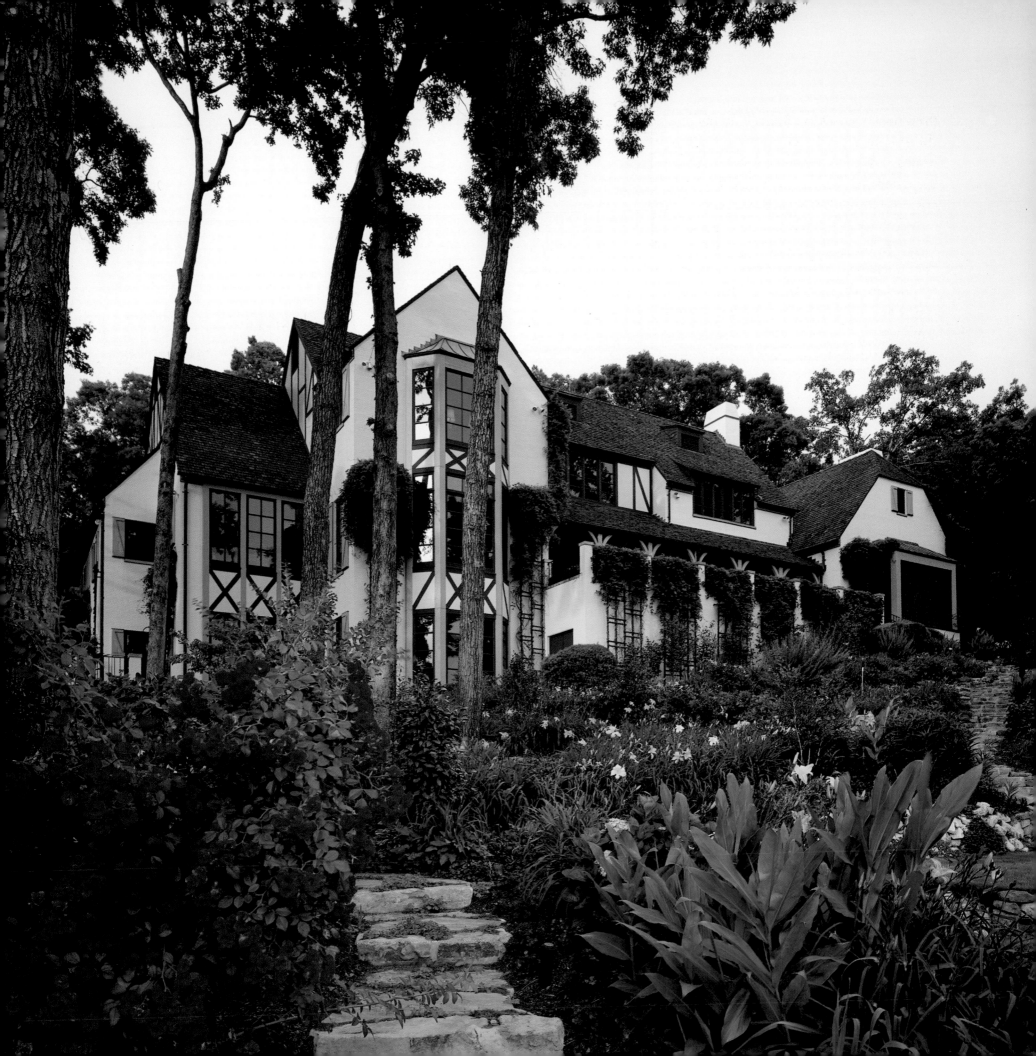

from the street—was created by someone with remarkable powers of observation and the intellectual capacity and imagination to surpass conventional ideas. In many respects, the Thailand Temple Garden, a creation of his own hand, is one of the keys to understanding the complex amalgam of experiences, talents, and passions that combine in the life of Jack Warner.

Jack always seems to be involved in an architectural project. The house he and Elizabeth have lived in for many years was built for them high on a bluff above Lake Tuscaloosa and is an interpretation of English Tudor, half-timbered style; Warner oversaw every detail of construction and interior design. Filled with handsome fur-nishings, mementos of travels, and remarkable American art, it is the place they cherish because of the affection and sense of accomplishment shared in its creation and continuous, mutual enjoyment. When on rare occasions Elizabeth does say no to Jack's enthusi-asms (and few have dared), hers is the definitive, restraining voice for him—and the most endearing. Their home celebrates complementary personalities, both attracted to objects expressive of many cultures and aesthetic interests.

In 1957 Jack became president of Gulf States Paper Corporation. After more than a decade of man-aging the company, he began a project that, in the con-text of everyday life in Tuscaloosa, was beyond fanta-sy—he commissioned a complex of buildings inspired by the Katsura Imperial Palace in Kyoto. Raised pavil-ions joined in a rectangular pattern by glass-enclosed walkways overlooking an interior Japanese garden replaced a Colonial Revival building and became the headquarters for Gulf States Paper Corporation. This

OPPOSITE

Elizabeth and Jack Warner House

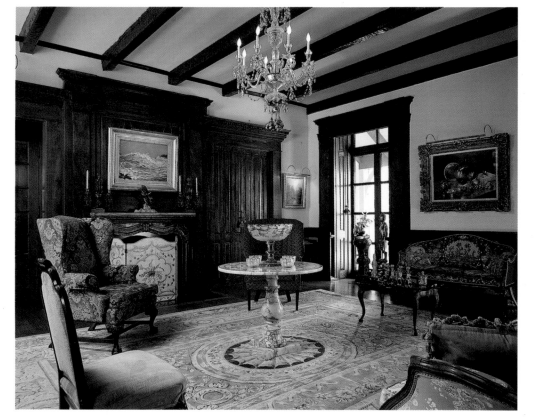

ABOVE

Elizabeth and Jack Warner House, sitting room

*The paintings in the sitting room include
The Backrush, circa 1895, by Winslow Homer
(1836–1910) above the mantel,* Autumn on the River,
*1877, by Jasper Cropsey (1823–1901) in the corner, and
Still Life, Brass and Glass, circa 1887, by William
Merritt Chase (1849–1916) above the settee.*

environment—the progeny of ideas first expressed in the Thailand Temple Garden in Pinehurst—is an inspirational, contemplative workplace, the result of visionary determination.

The way Warner went about the headquarters project is indicative of how he generally conducts his affairs. The architect was Cecil Alexander of Finch, Alexander, Barnes, Rothschild and Paschal, Architects, in Atlanta. Jack was inti-mately involved, making all of the decisions and many constructive suggestions. It was obvious to all that he knew exactly what he wanted to express in the architec-ture. He was not as knowledgeable about garden design, so he identified the most qualified landscape designer and left the job to him. David Harris Engel was the first

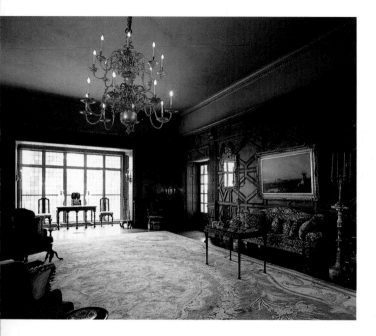

ABOVE

Elizabeth and Jack Warner House, English room

The paneling is from a historic residence in northern England. The painting is Racing at Fort Laramie, *1868, by Alfred Jacob Miller (1810–74).*

RIGHT

Elizabeth and Jack Warner House, dining room

Boards for the paneling in the dining room were obtained from the derelict nineteenth-century outbuildings of a state mental hospital across the road from the former head-quarters of Gulf States Paper Corporation. The painting is Still Life with Fruit, *circa 1865, by Severin Roesen (active 1848–71).*

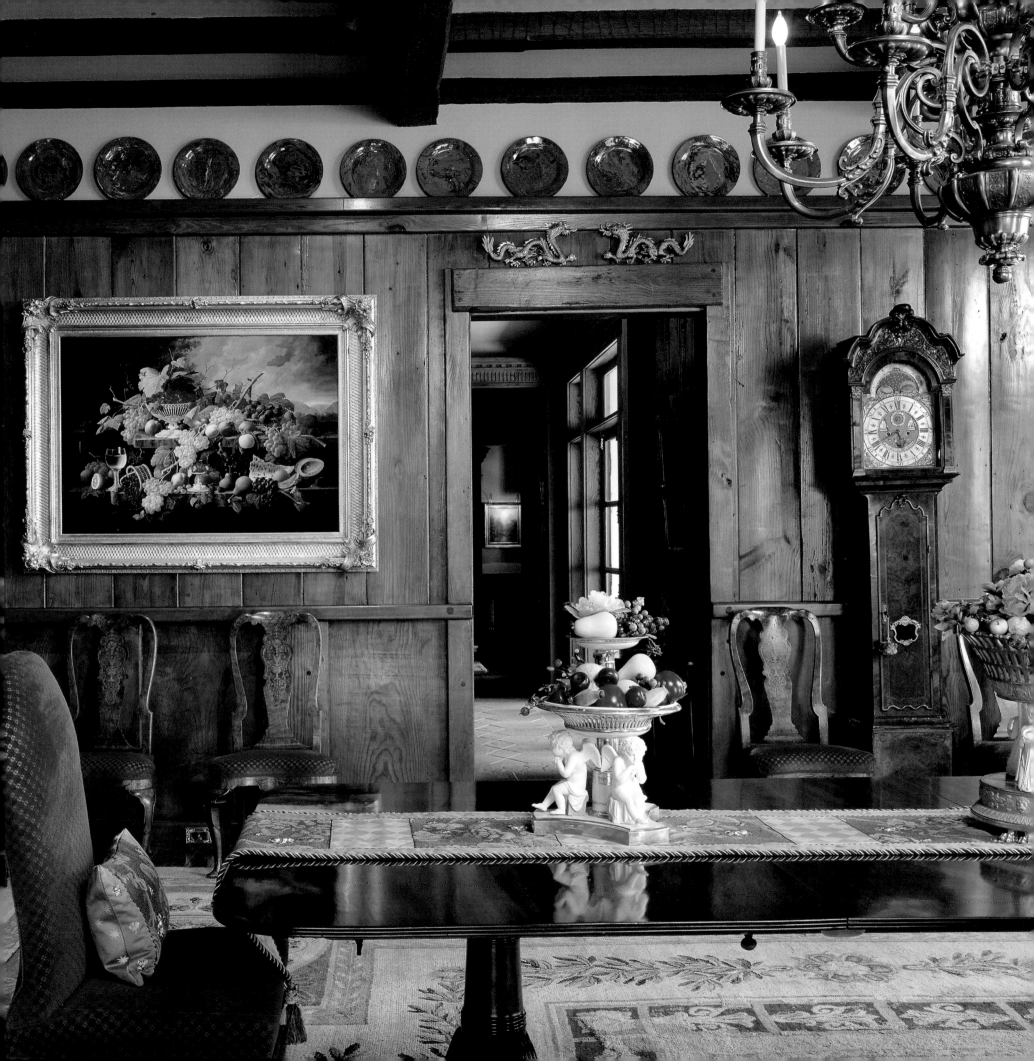

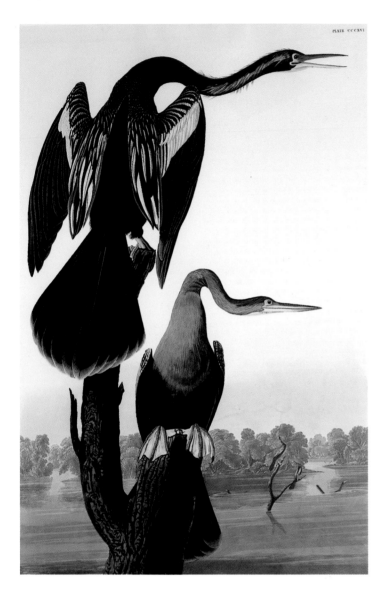

JOHN JAMES AUDUBON (1785–1851)
American Anhinga (Black-bellied Darter),
1827–38

Hand-colored etching and aquatint, 38 ¼ x 25 ⅝ inches
Robert Havell, engraver

*Jack Warner has had a lifelong interest in birds, which
encouraged his first experiences as an art collector. As a
young boy and through his college years he raised carrier
pigeons. In 1953 he started to assemble what was to
become a complete set of hand-colored engravings from*
Birds of America, *John James Audubon's elephant folio
of 1827–38.*

*Today, when visitors approach Gulf States headquarters
and enter the interior garden, they are surrounded by pea-
cocks and peahens, guinea fowl, Belgian pletinckx
pigeons, black-necked swans, African white-faced ducks,
shelducks, and Mandarin ducks. From cages in the halls
inside the building, whistles, calls, and occasional words
are produced by parrots, a white cockatoo, and a Camelot
macaw.*

JOHN JAMES AUDUBON (1785–1851)
White-Headed Eagle (Bald Eagle), 1827–38

Hand-colored etching and aquatint,
25 ⅝ x 38 ¼ inches
Robert Havell, engraver

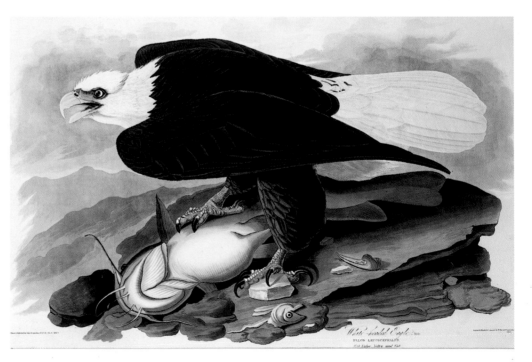

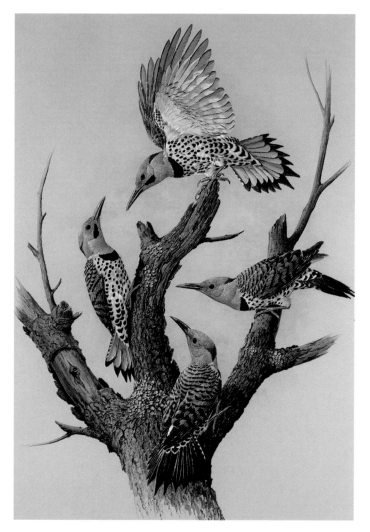

BASIL EDE, English (b. 1931)
Northern (Yellow-shafted) Flicker, 1972

Watercolor on paper, 38 x 25 inches

Warner first saw bird paintings by Basil Ede in the English artist's 1971 exhibition at Kennedy Galleries in New York City. In 1975 Jack commissioned Ede to paint a collection of life-size paintings of the wild birds of America. The first subject was the wild turkey, then on the U.S. Department of the Interior's endangered list. Ede finished one hundred works, many of which were published at full scale and distributed by Gulf States Paper Corporation, before his health prevented him from continuing the project.

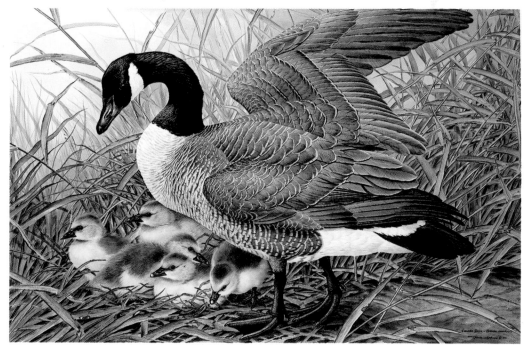

BASIL EDE, English (b. 1931)
Canada Goose, 1976

Watercolor on paper, 29 x 45 inches

CHARLES BIRD KING
(1785–1862)
**Black Hawk,
Makataimeshikiakiah,**
circa 1833

Oil on panel, 24 x 19 ³/₄ inches

Black Hawk *was purchased by Jack
Warner at the Sotheby's sale in May
1970 of the collection of twenty-one
American Indian portraits
bequeathed by Charles Bird King
to the Redwood Library and
Athenaeum, Newport, Rhode
Island. King, a native of Newport,
was commissioned in 1821 to paint
portraits of Native American chiefs
brought to Washington to meet the
president in an effort to establish
peaceful relations. Black Hawk,
a Sauk chief, was defeated as he
and his followers resisted relocation
to lands west of the Mississippi.
He was captured and taken to
Washington for an audience with
President Andrew Jackson, who
presented him with the peace medal
he wears in the portrait. One
hundred forty-seven portraits by
Charles Bird King were in the
collection of the Indian Gallery,
eventually a part of the Smithsonian
Institution. In 1865 most of the
Smithsonian Collection was
destroyed by fire, and the Redwood
Library and Athenaeum collection
became the largest representation
of King's Indian subjects.*

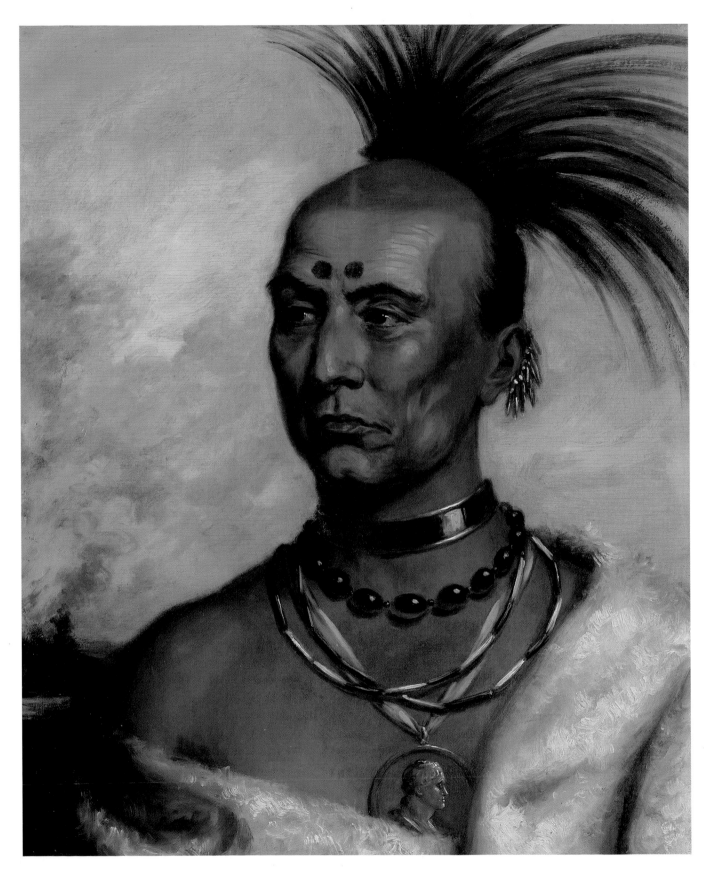

American recipient of a Japanese Ministry of Education grant to study landscape architecture in Japan, and Jack was aware that he had designed a Japanese garden for Nelson Rockefeller in Pocantico Hills, New York. Long before the current widespread interest in Japanese gardens, Tuscaloosa had one of the finest examples in the country, particularly in the placement of rocks, David Engel's special talent.

The new headquarters building and the need to fill its walls triggered a milestone moment in Jack's life that resonated from his past into his future. In the Warner family odyssey, the western frontier was at once background and inspiration for Jack. Both of his parents were children of families from the East who moved westward in the first half of the nineteenth century as opportunities there encouraged exploration and development of the country. In his first public activity as a collector of American art, Jack was the largest single buyer at Sotheby Parke Bernet's sale on May 21, 1970, of American Indian portraits bequeathed by the artist Charles Bird King to the Redwood Library and Athenaeum in Newport, Rhode Island. This event was also Jack's introduction to John Marion, auctioneer and later chairman of Sotheby's North America, who would frequently recognize two active bidders in the front of the sales room, Elizabeth and Jack Warner.

In 1975 Jack purchased *Progress*, 1853, by Asher B. Durand and *The Falls of Kaaterskill*, 1826, by Thomas Cole, each a masterpiece of American painting. In the 1980s he augmented the Warner collection with a continuous and rigorous program of acquisition, the standards of which he had firmly established with his earlier purchases. Paintings and sculpture began to appear in all the buildings associated with Gulf States Paper Corporation, particularly in the headquarters, the interior of which quickly took on the appearance of a museum. Today, guided tours are given after working hours and during weekends when the public sees a collection of American art in a building and garden setting unlike any other.

Since 1990 Jack has also placed major emphasis on enhancing the quality of the decorative arts collections in the Mildred Warner House. This house museum, a per-

ASHER B. DURAND (1796–1886)
Progress (The Advance of Civilization),
detail, 1853

Oil on canvas, 48 x 72 inches
Inscribed lower left: AB Durand 1853

manent expression of his admiration and respect for his mother, represents a combination of collections of American art and decorative arts that is unsurpassed in any American museum of its type. Through his unyielding attention to his domain, guided by the historical motto of Gulf States Paper Corporation, "Quality Counts," Jack has given the city of Tuscaloosa the educational and aesthetic pleasures of the Warner collection. The result of one man's energies and judgment, it is universally important as a statement of the creative spirit of America.

Warner's relationship to art is a personal, deeply felt, emotional attachment. He acquires what appeals to him based upon a complex variety of sensory and intellectual responses. If it tells a story, he is intrigued. If it is about George Washington, he is captivated. If it draws him in visually, he will enjoy it as an aesthetic experience. He looks at art for extended periods, cherishing time when he is alone with it and his thoughts can wander over the subject, the artist, the circumstances under which the work was made, while his eyes can enjoy the visual pleasures of color, form, surface. He delights in changing installations to see works in different juxtapositions. When he acquires furniture or decorative objects, he already has their ultimate location and arrangement in his mind. Details such as colors of rooms and positions of objects are always his decision. He is constantly involved in every aspect of the care and presentation of works.

HOWARD PYLE (1853–1911)
Washington Met by His Neighbors on the Way to His Inauguration, circa 1889

Oil on canvas, 14 ³/₄ x 23 ³/₄ inches
Inscribed lower right: H Pyle

His genuine feeling for his art inspires a coterie of dedicated and admiring associates who ceaselessly change, fix, adjust, replace, and maintain works to satisfy the constant demand for the highest level of stewardship.

Jack Warner is a particularly astute connoisseur of the finest of American art and decorative arts. It should be recognized, however, that the means to pursue his love of art is the reward of his hard work and widely recognized talents as a business leader who instills loyalty, seeks innovation, and withstands hardship. Jack is a keen observer who has consistently and successfully spotted emerging trends in an enormous variety of packaging needs. He has brought Gulf States Paper Corporation from a limited scope to a wide range of paper and associated products. Expanding the types and uses of packaging in creative and pacesetting ways has been Warner's brilliant contribution through the efforts of a staff who shares his determination to be preeminent in the industry.

The NorthRiver Golf Club was built and opened in 1977. The clubhouse was recently expanded under Jack's direction through an extension of the dining room with the dramatic addition of a glass-walled space overlooking the golf course. High on a hill at the entrance to the NorthRiver Golf Club property is a clock tower, a folly designed by Warner after he had seen a similar structure in some now forgotten European location. All the NorthRiver facilities, as well as the University Club, the Mildred Warner House, Elizabeth and Jack's house, and many as yet unidentified properties, could be considered works in progress. It is only a matter of time until "what next?" will be answered with a new project.

At a dinner party at the Mildred Warner House, a special place rarely used for such events, Jack was surrounded by childhood friends from Tuscaloosa, many of whom knew his parents. In his remarks, he expressed sadness at the loss of many people the assembled group had known in the past. He recognized his own mortality. But then his attention shifted to his continuing preoccupation with the art that fills the house named for his mother. He had rearranged things and brought in new works to make new associations. Warner's inspiring observations about his art replaced the poignancy of his initial comments.

A fifth generation of Herbert Westervelt's family is represented in his great-great-grandchildren, Cade, Westervelt, and Elizabeth, children of Elizabeth and Jack's son Jon and his wife, Sheila. Jack is very attached to them and enjoys their accomplishments, particularly in sports. As he observes his present life and two successive generations, he is undoubtedly aware that established patterns may change. His dinner comments underscore, however, that certainly one of Jack Warner's most enduring legacies will be the pride in America that he and Elizabeth offer through the art they cherish and share so generously.

OPPOSITE

NorthRiver Golf Club, dining room

Jack Warner recently designed an addition to the dining room of the golf club, with a glass wall overlooking the golf course. The painting at left is Ulysses and the Sirens, *1900, by Thomas Moran (1837–1926);* Ulysses Deriding Polyphemus *or* The Voyage of Ulysses, *circa 1862, by Moran is at right.*

ARCHITECTURE AND GARDENS

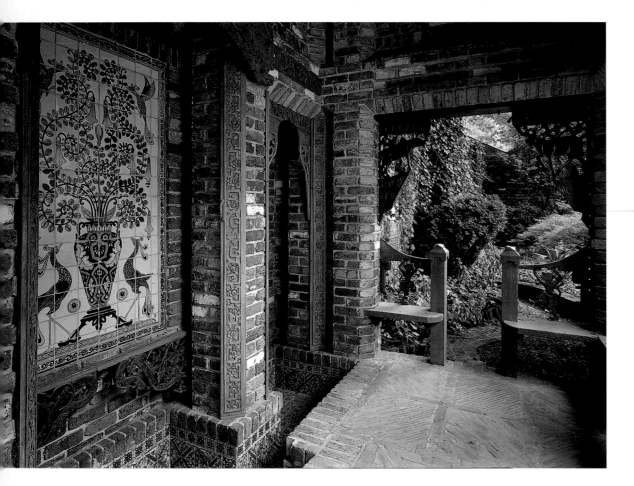

ABOVE

Thailand Temple Garden, interior,
late 1950s
Pinehurst, Tuscaloosa, Alabama

Designed and built by Jack Warner

OPPOSITE

Thailand Temple Garden, facade

The environment, in both the broadest sense of the term and its most particular detail, has been an enduring concern for Jack Warner. Through Gulf States Paper Corporation, he has built, preserved, and managed vast forests, wisely using the products of the land and replenishing its resources. Natural history was the focus of his earliest collecting, while equestrian and field sports have engaged his lifelong enthusiasm for the outdoors. But architecture and the creation of beautiful interior environments have interested him most in later years. Through the scope of his vision, he creates practical yet exotic work-places, gives form to inspired recreational and living spaces, and restores handsome interiors that bring the dignity and elegance of the past into contemporary experience.

Making imaginative architecture and gardens can be one of the most generous extensions of creativity. Jack Warner's regard for history and his discernment as to how life is enjoyed in public and private spaces add a unique dimension to the built environment and greatly enhance the natural one as well.

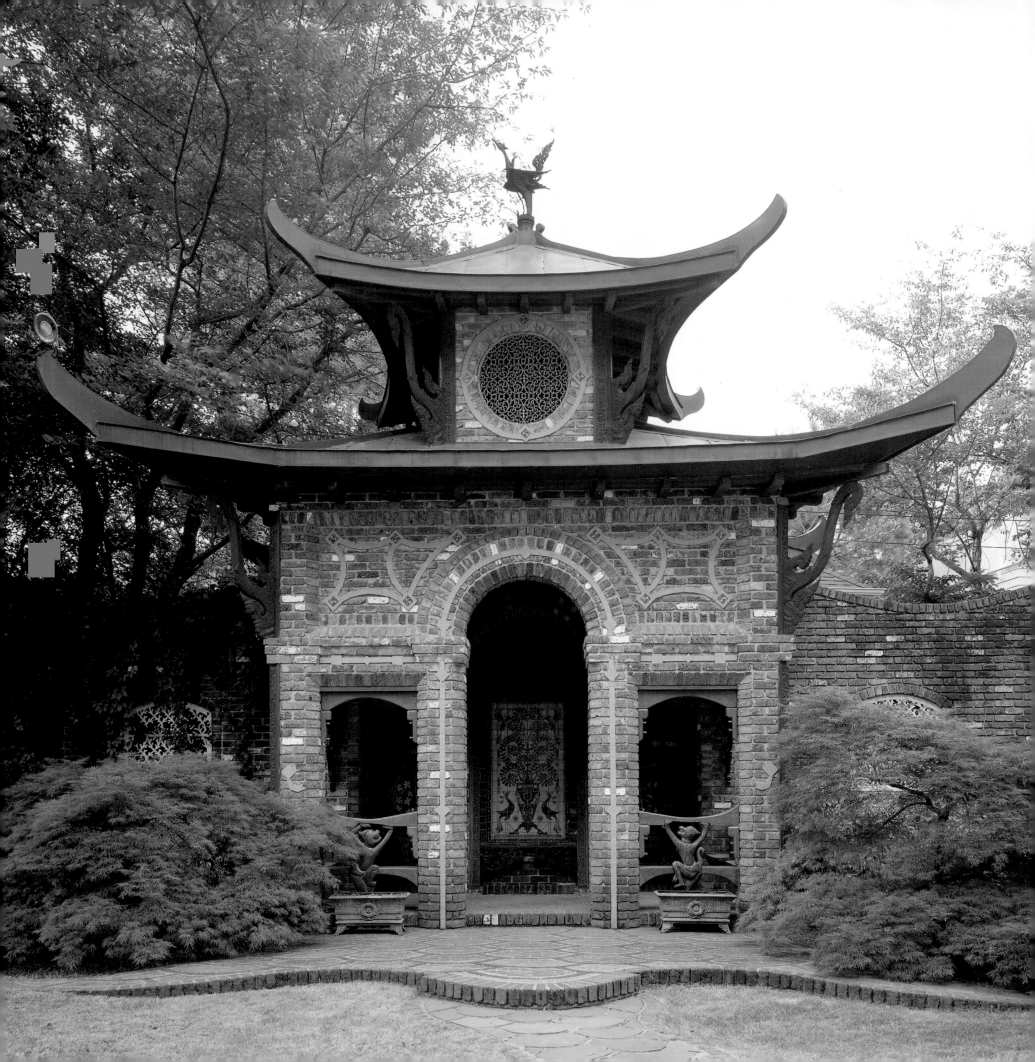

Gulf States Paper Corporation Headquarters, 1970
Tuscaloosa, Alabama

Designed by Cecil Alexander of Finch, Alexander, Barnes,
Rothschild and Paschal, Architects, Atlanta, Georgia

*In the late 1960s, Jack Warner decided that Gulf States
Paper Corporation needed a new headquarters building,
one that suited his temperament as well as his feeling that a
workplace should have a distinctive style conducive to
creative thought and personal expression. He alone made
the startling decision that Gulf States would have an
oriental-style complex with an interior Japanese garden.
He dismissed proposals from architects for what he referred
to as motel architecture, supplied reference material for
what he visualized, insisted on scale models he could criti-
cize, and with tireless devotion to the project, achieved
what he had in mind from the beginning. The resulting
architecture suggests eleventh-century Japan.*

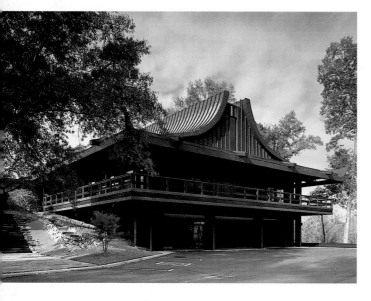

ABOVE

**Gulf States Paper Corporation Headquarters,
executive entrance**

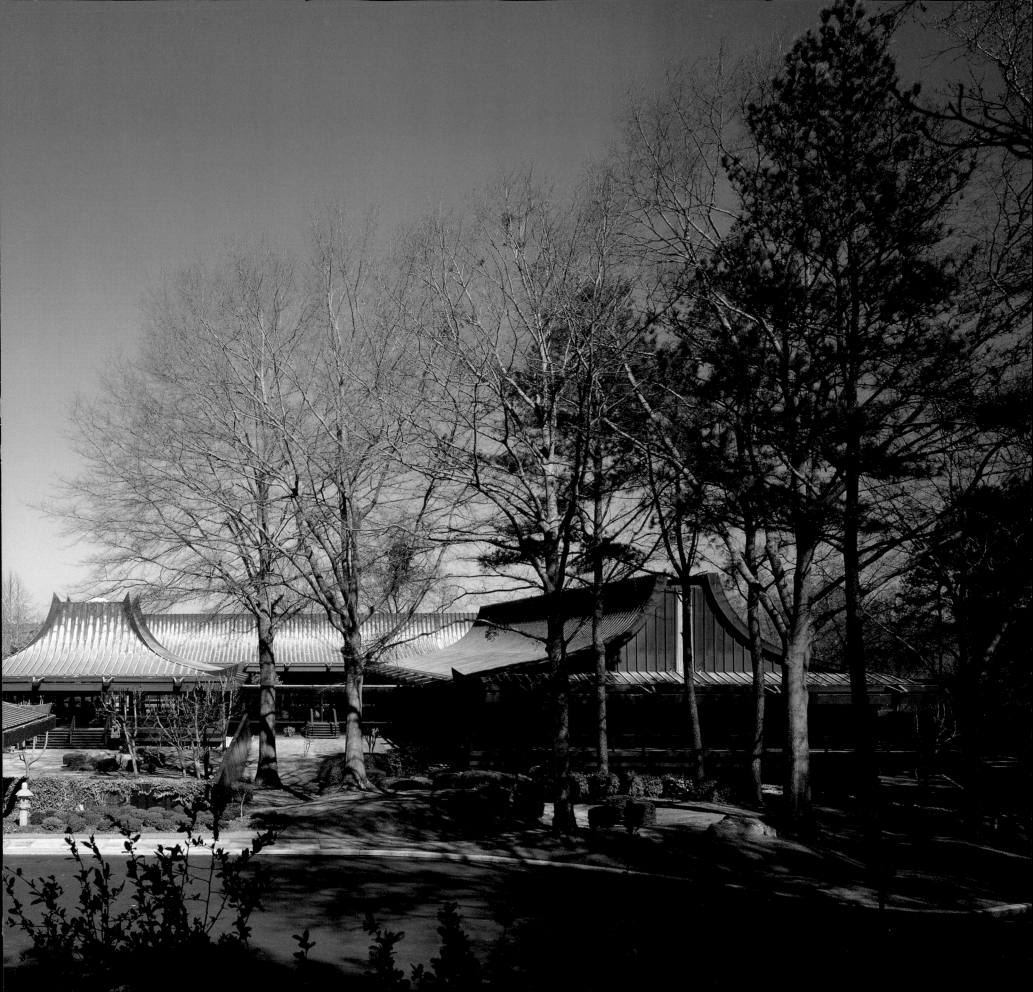

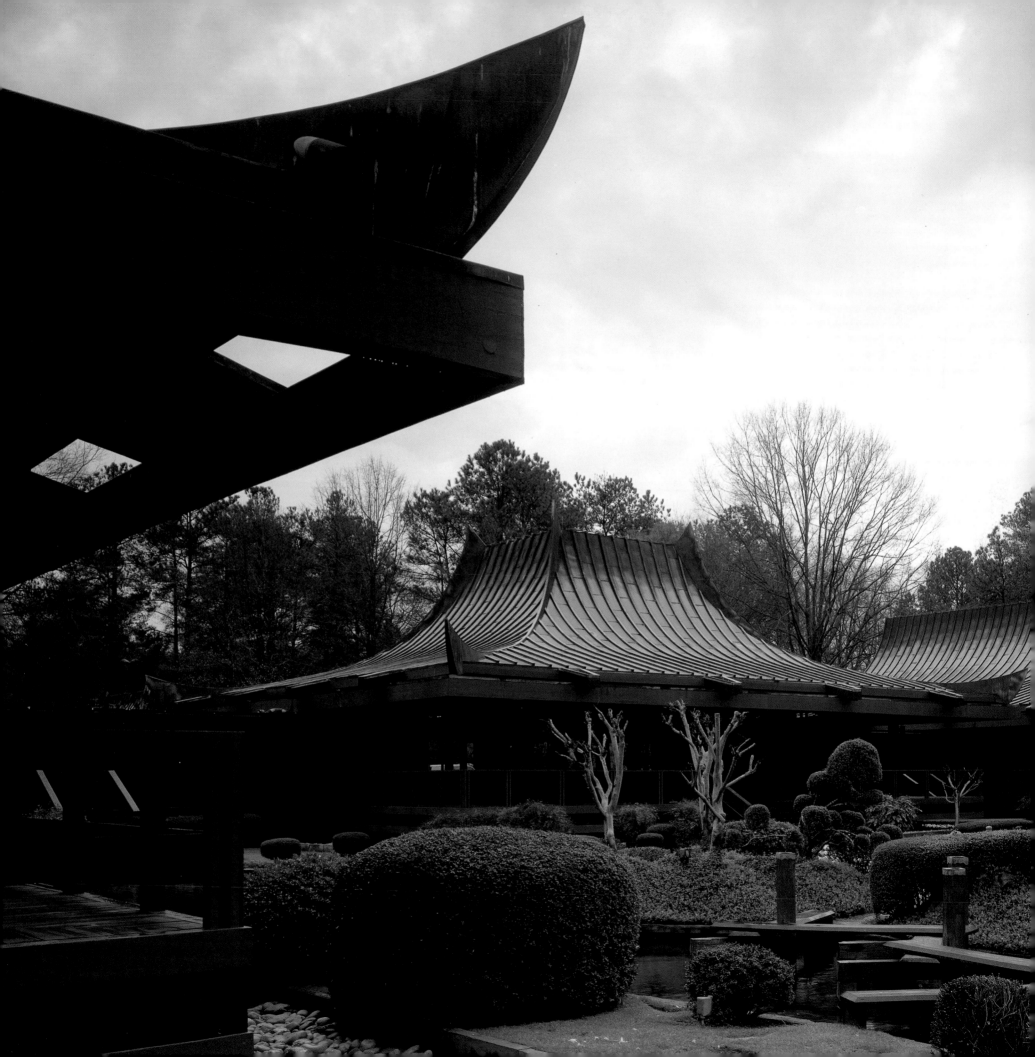

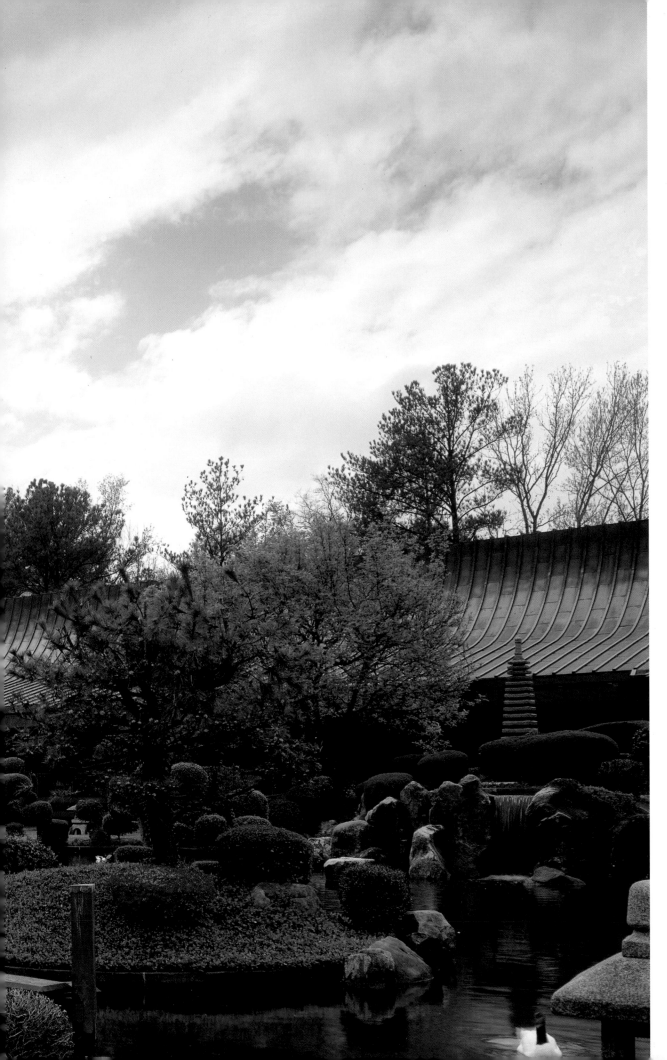

**Interior Japanese garden,
Gulf States Paper Corporation Headquarters,** 1970

Designed by David Harris Engel, Landscape Architect,
New York, New York

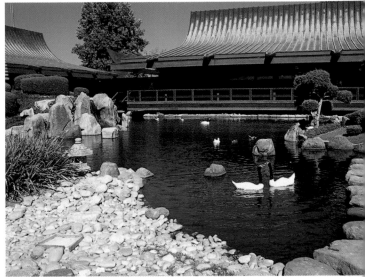

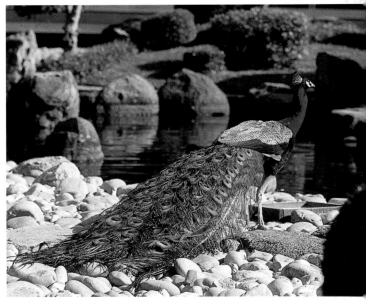

TOP

Black-necked swans in Japanese garden

ABOVE

Peacock in Japanese garden

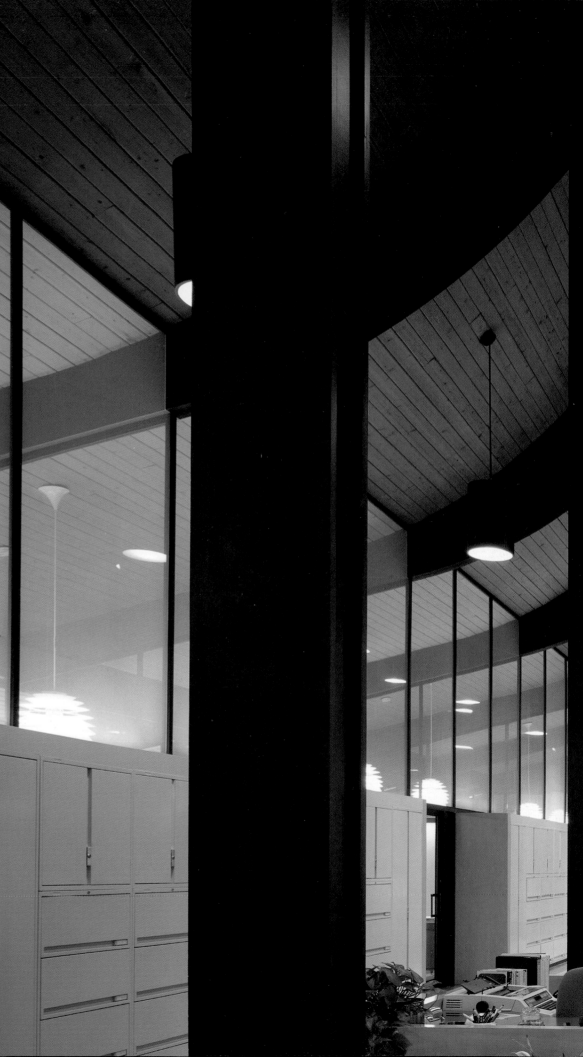

**Gulf States Paper Corporation Headquarters,
interior of executive office pavilion**

*In a dramatic, humanistic gesture reminiscent of
Frank Lloyd Wright's atrium in the core of the Larkin
Building, Buffalo, New York, 1906 (destroyed 1950),
the architects created a soaring, light-filled workspace
in the executive office pavilion.*

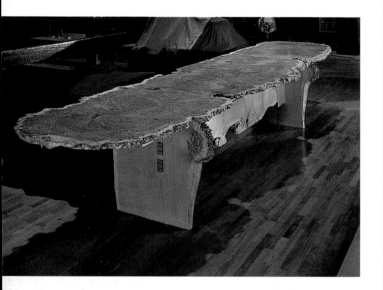

ABOVE

GEORGE NAKASHIMA (1905–90)
Reception desk, 1969–70

English burl oak from California,
15 feet 6 inches x 28 ¹/₂ inches x 37 inches

*In 1969 Warner commissioned George Nakashima to
design furniture for important locations throughout the
new Gulf States Paper Corporation Headquarters building
then under construction. At the time Nakashima was
considered by many to be the most important American
furniture maker. A Japanese-American born in Spokane,
Washington, he was trained as an architect at the
University of Washington and the Massachusetts Institute
of Technology. David Engel, landscape architect for the
headquarters building, recommended Nakashima to Jack,
who commissioned the furniture after visiting Nakashima
in his studio in New Hope, Pennsylvania.*

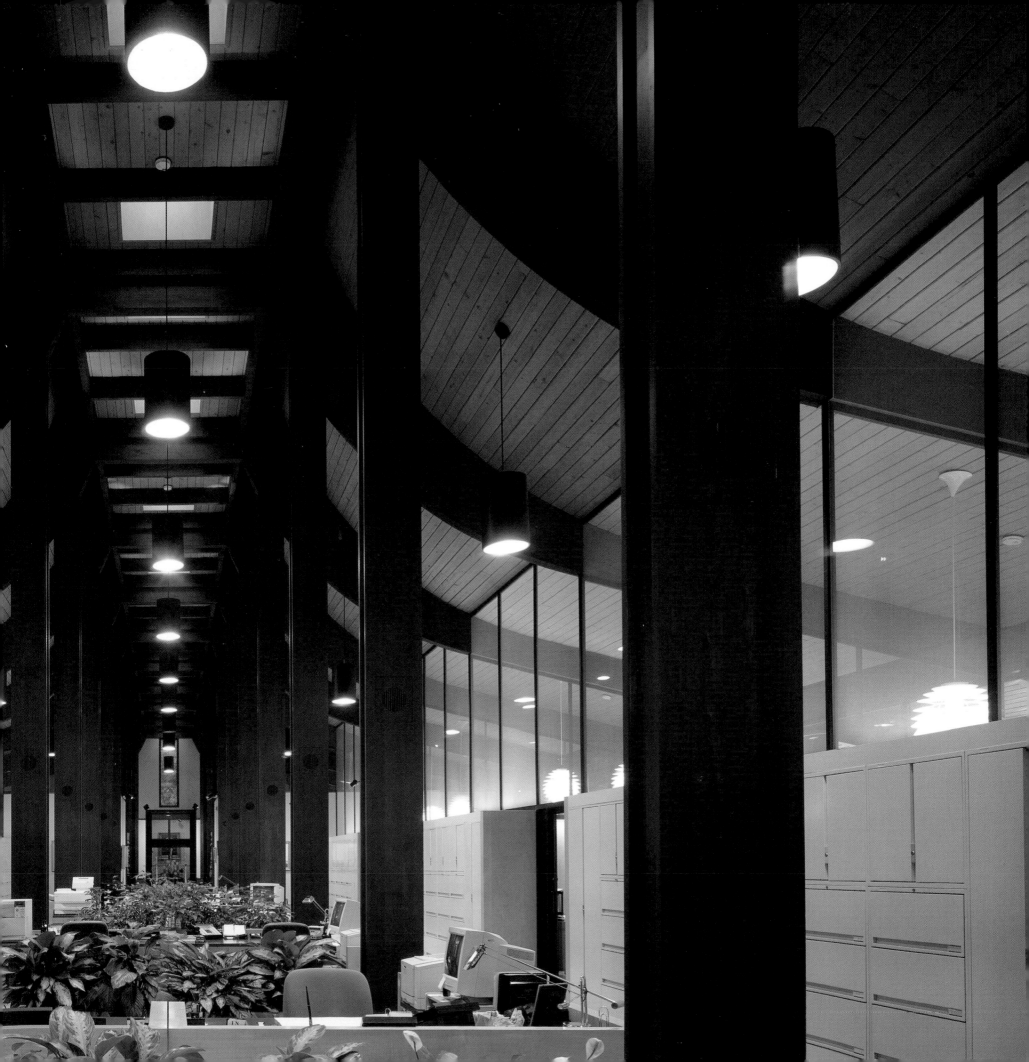

President's Mansion, University of Alabama, 2000

The University of Alabama, Tuscaloosa, was founded in 1831. Construction of the Greek Revival President's Mansion was completed in 1841. The building is one of four on the campus that survived after the Civil War, and it is now on the National Register of Historic Places.

For many years, whenever he visited or passed by the President's Mansion, which is just a short distance from the Mildred Warner House, Jack Warner sensed that something was not correct about the building—something was missing. And so he decided to correct the situation—a new project.

But what was wrong? Research proved that the original balustrade around the top of the porch was missing. Over the years attempts to replace it had been unsuccessful. In 1997 Jack supervised the design and installation of the new balustrade, and the building has been restored as near as possible to its original condition. When Warner sees a need for improvement, something always gets done.

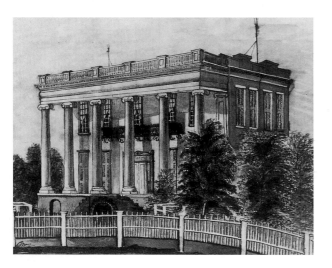

MARGARET CAMMER

President's Mansion, University of Alabama, 1841

Watercolor on paper

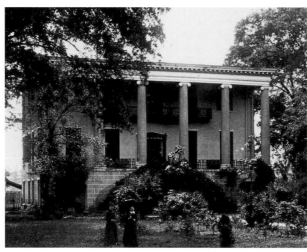

President's Mansion, University of Alabama, 1888

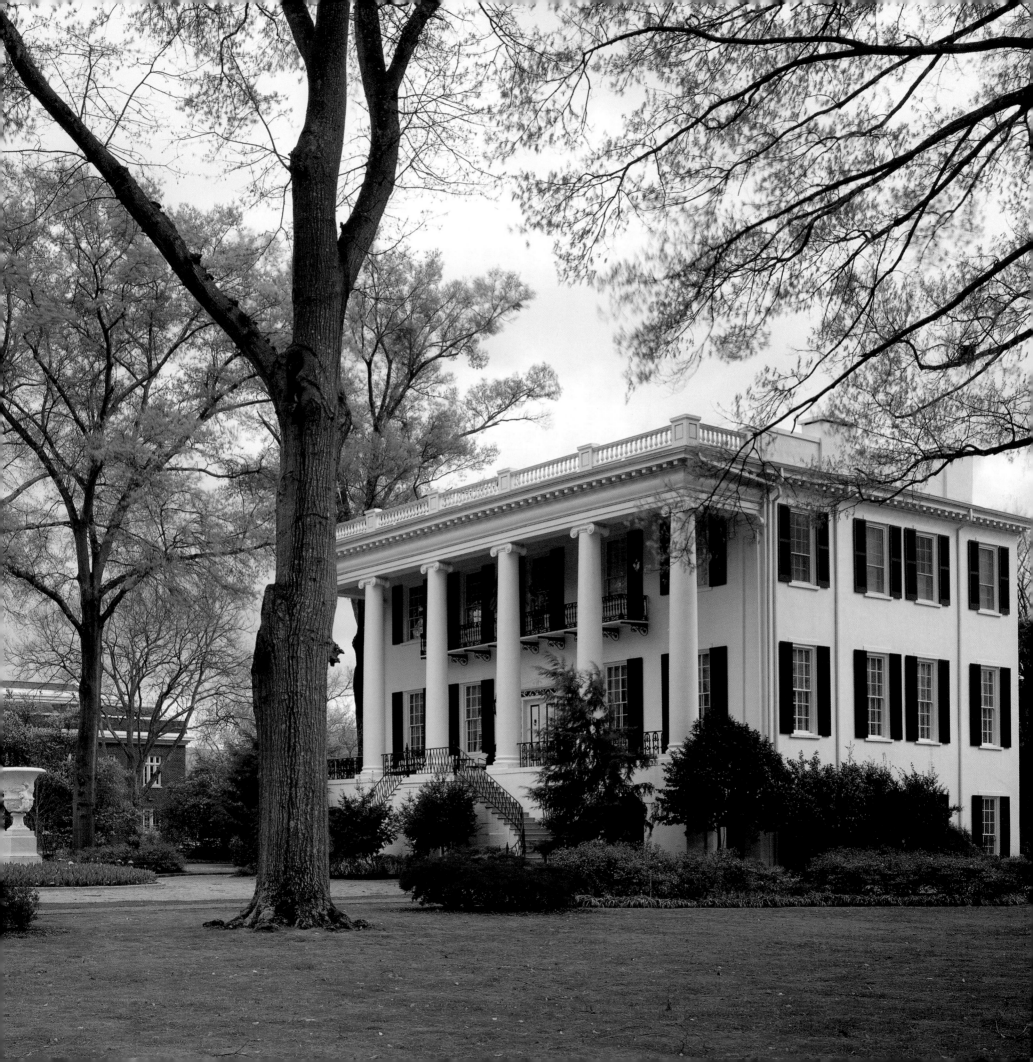

NorthRiver, clock tower, 1990

Designed by Jack Warner

*In 1964 Gulf States Paper sold the city of Tuscaloosa land
in a valley north of the center of the city; its water source
was dammed to create a lake for the city's water supply.
After several years, Jack Warner realized that the new
Lake Tuscaloosa provided the surrounding Gulf States
Paper land with a beautiful amenity that could be
incorporated into recreational and residential properties.*

*Throughout the NorthRiver area, at irregular
intervals and at prominent locations, decorative fencing
has been created with black anchor chain, some from
the U.S.S. Maine, looped between low red posts.
The sinking of the Maine in Havana harbor in 1898
initiated the Spanish American War.*

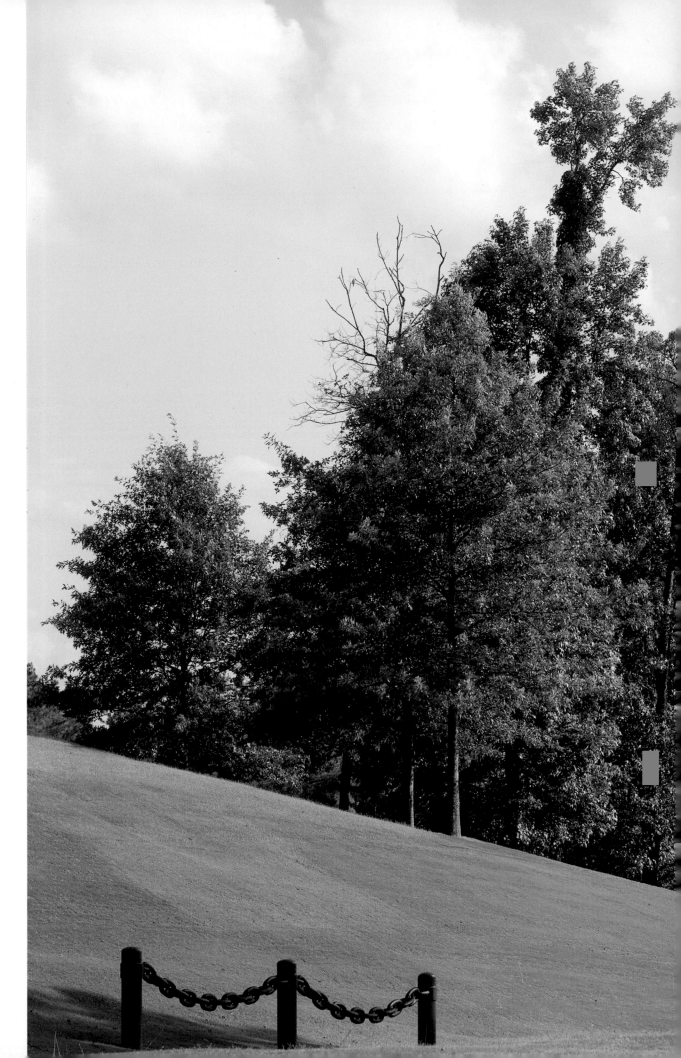

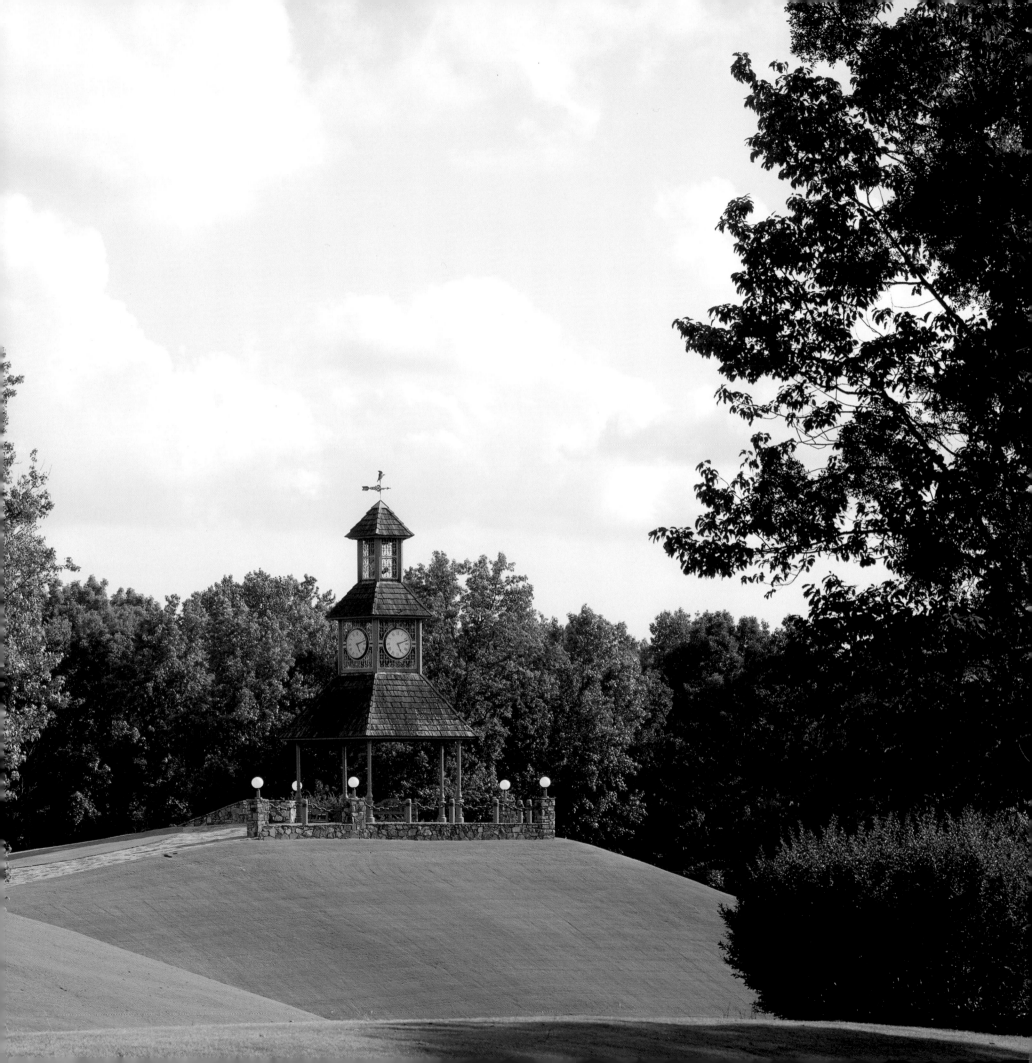

**NorthRiver Historic Area,
Plantation Schoolhouse,** circa 1818

*As part of the development of NorthRiver, Warner decided
to establish a historic area around Old Center Church,
which had been on the site as a center for religious and
community activities since 1875. He restored the church
and an existing dogtrot cabin and then brought to the site
a one-room schoolhouse from an old plantation and the
Gainesville Bank, each of which played a role in the
history of customs and public activities in Alabama.*

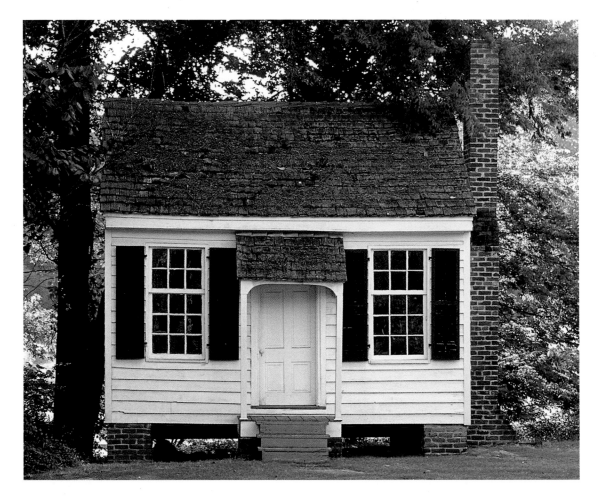

**NorthRiver Historic Area,
Gainesville Bank,**
circa 1835

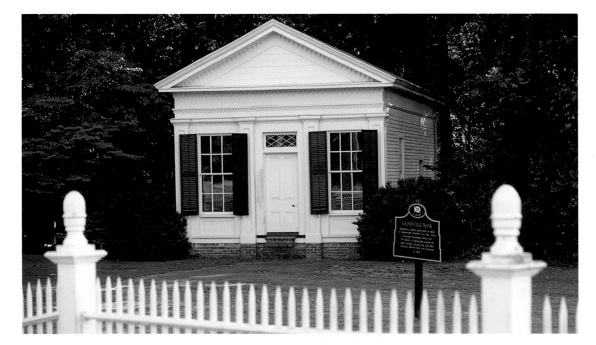

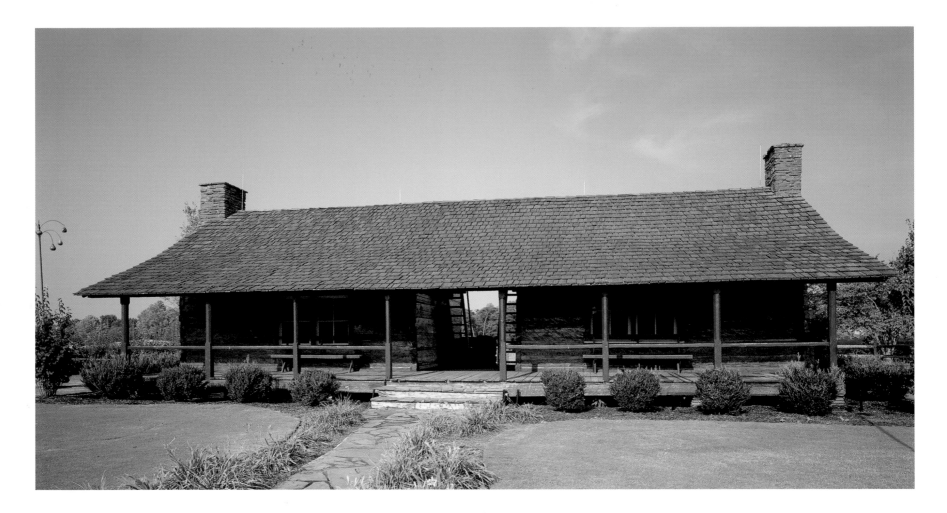

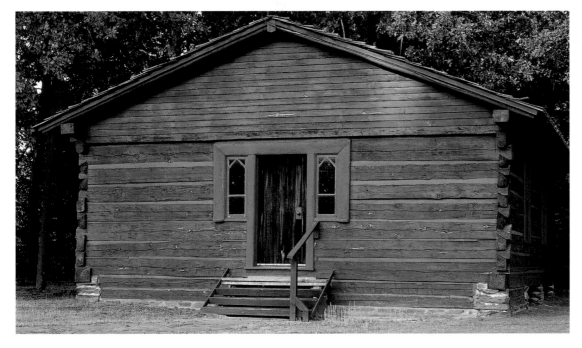

**NorthRiver Historic Area,
Dogtrot Cabin,** 1837

**NorthRiver Historic Area,
Old Center Church,** 1875

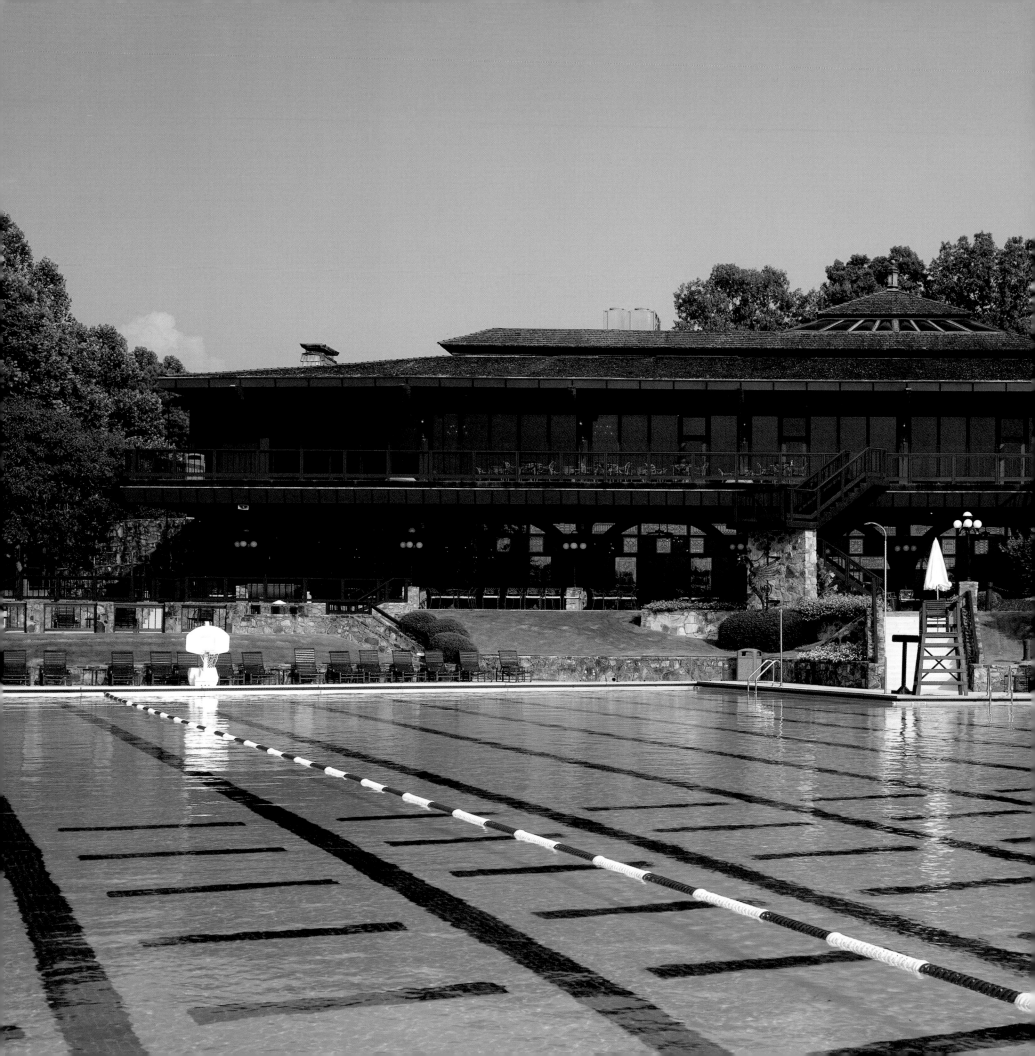

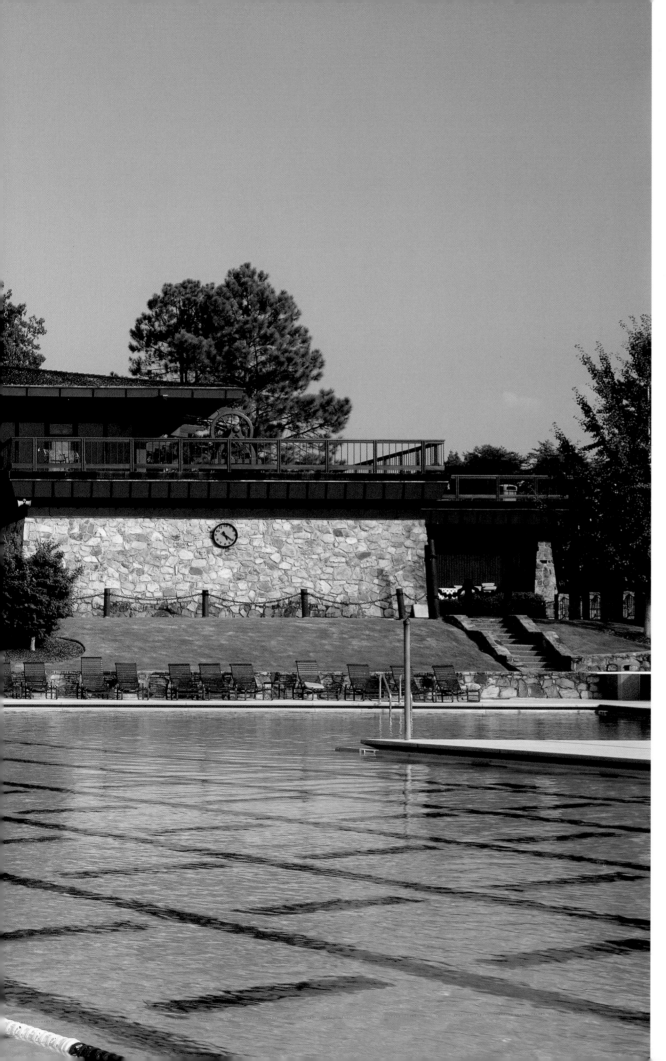

LEFT

**NorthRiver Yacht Club,
rear facade and swimming pool**

*The Yacht Club opened in 1974. Its Olympic-size
swimming pool greatly expanded recreational facilities
in the area.*

ABOVE

NorthRiver Yacht Club, interior

NorthRiver Golf Club, small dining room

Jack Warner's continuous attention, planning, and design talents fostered the NorthRiver Golf Club, completed in 1977. Its eighteen-hole golf course was originally designed by Gary Player. The painting between the tall cabinets in the small dining room is Tanis, 1915, a portrait of the artist's daughter by Daniel Garber (1880–1964). On the right is Le Pesage de Longchamps, 1910, by Réné Achille Rousseau-Decelle, French (1881–1964). The color and style of chairs in the painting inspired the furnishing of the room.

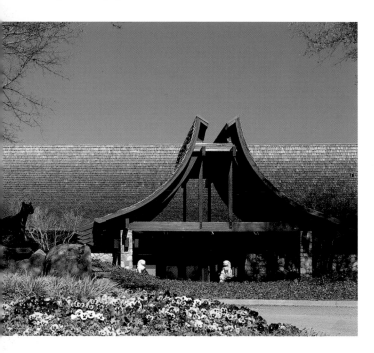

ABOVE

NorthRiver Golf Club, entrance

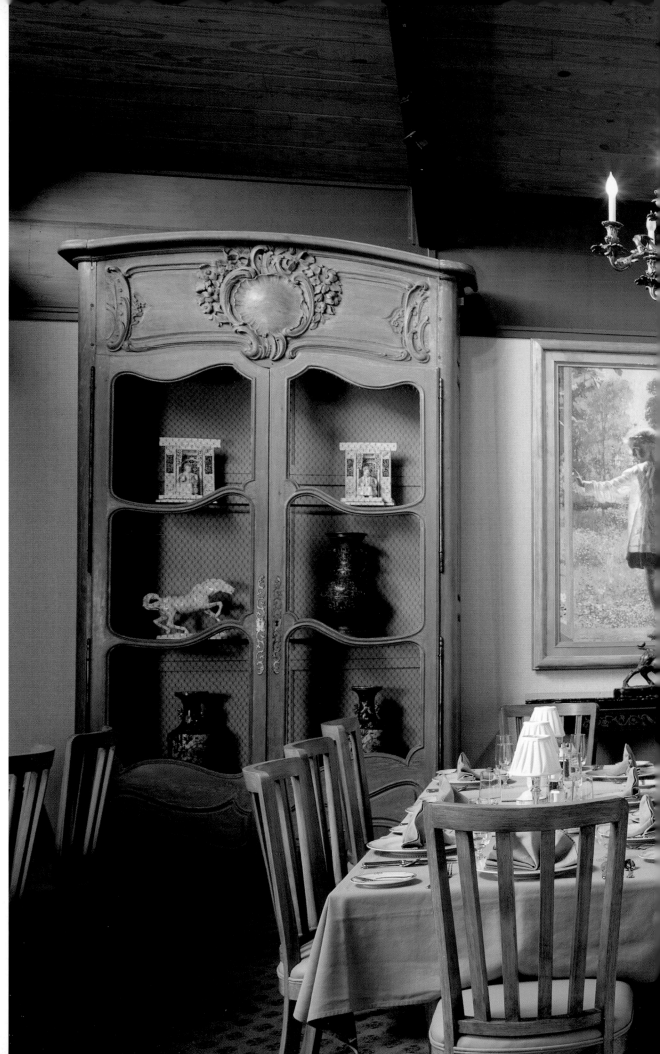

82

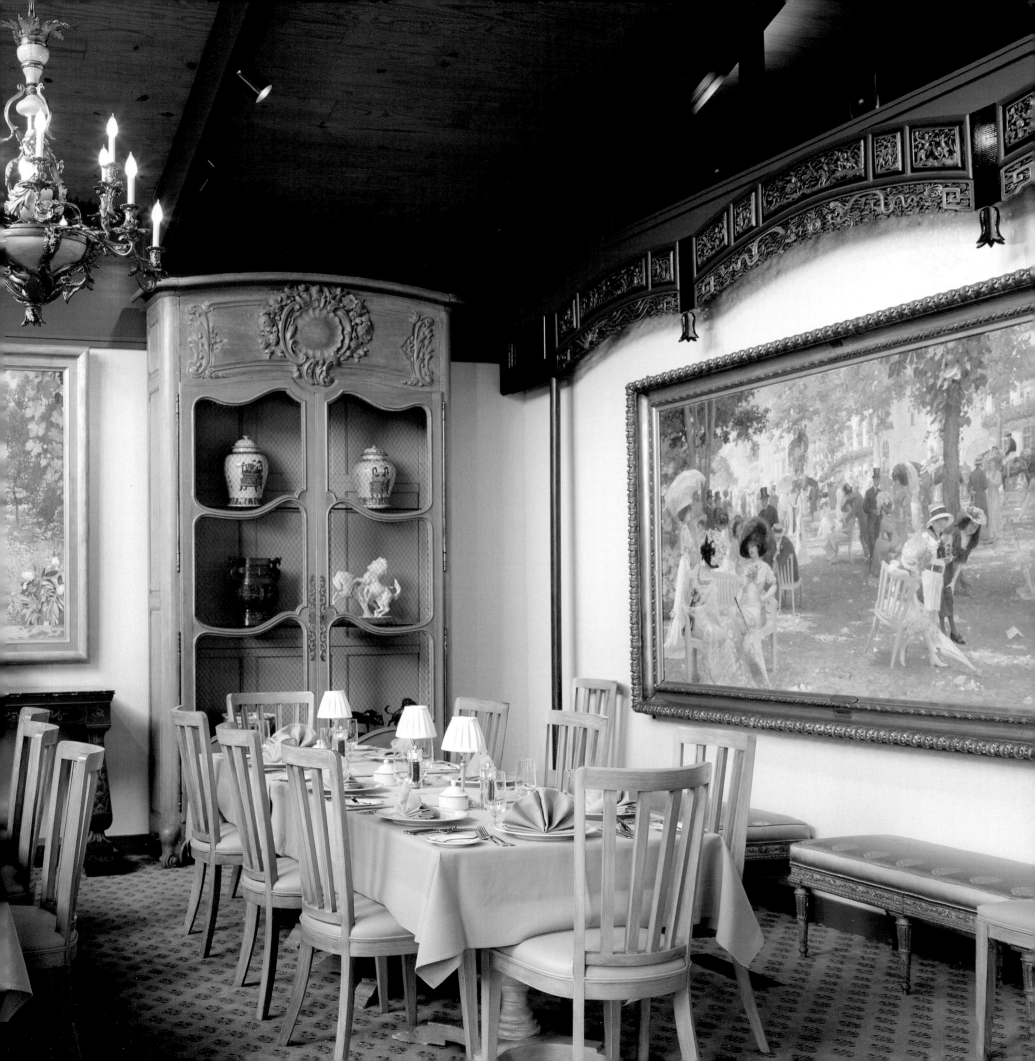

ART FOR THE DEMOCRACY

ELLA M. FOSHAY

Whether portrait, history, landscape, or genre subject, all the paintings and sculpture in the Warner collection of Gulf States Paper Corporation illustrate the story of America. The story is both fact and fiction, just as the images in the works are both real and ideal, and it is recounted in various voices, with richly different tonalities. Jack Warner, the impresario who gathered the artworks together, speaks robustly of his desire "to live history"—to be transported to the scene and see through the eyes of the artist. It is possible to see and almost hear and feel Kauterskill Falls as it looked to Sanford Gifford in 1862 in his painting of that dramatic landscape site. The artist offers a form of "you are there" television reporting in a nineteenth-century mode. The artists in the Warner collection, both painters and sculptors, express various views of American history in what they say about their work, in the subjects they select to represent, and in the manner of their making. The works themselves, although seemingly mute, speak volumes about America's vision of itself; but this is a language not spoken by everyone. To learn it requires both a profound interest in and a lively passion for art. Jack Warner has both. He says that he chose to collect works in which he is "emotionally involved."

The works he has chosen are, in a sense, self-portraits. "What you select shows what kind of a person you are," says Warner. And he considers himself a down-to-earth, grassroots American without Old World pretensions. "If you're cultured, you like maybe old European masters. Me? I'm a flag-waving, nostalgic American," remarks the collector. This unapologetic, deep commitment to his country, its history and its values, directs his emotional and aesthetic response to American painting and sculpture, principally of the nineteenth and early twentieth centuries. Jack has also responded to the relative neglect of American art by collectors. An independent spirit inspired him to follow his own path rather than tread in the well-worn tracks of American collectors of European art. He prefers the power of Bierstadt's *Niagara Falls*

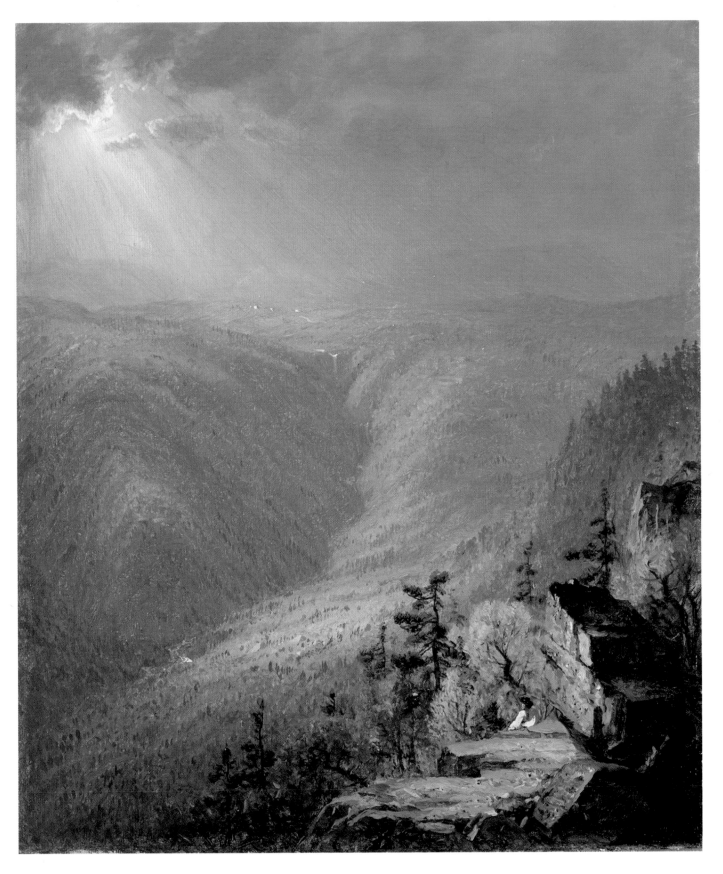

SANFORD GIFFORD (1823–80)
Kauterskill Falls, 1862

Oil on canvas, 11 x 9 inches
Inscribed lower right: S R Gifford

ALBERT BIERSTADT (1830–1902)
Niagara Falls, circa 1869

Oil on canvas, 30 ½ x 44 ¼ inches
Inscribed lower left: A Bierstadt

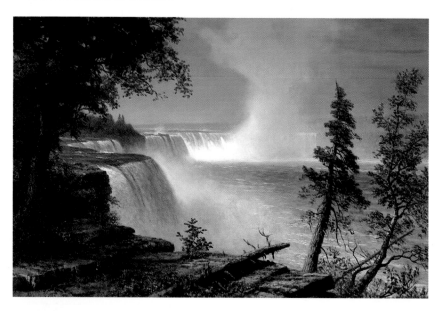

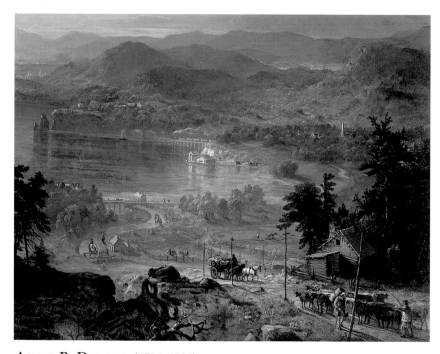

ASHER B. DURAND (1796–1886)
Progress (The Advance of Civilization), detail, 1853

Oil on canvas, 48 x 72 inches
Inscribed lower left: A B Durand 1853

to the elegance of Monet's *Terrace at the Seaside, Sainte-Adresse.* He revels in supporting the underdog; he recognized American art as "a neglected field." Out of a patriotic spirit, he has wanted to bring attention to native work and to encourage the taste and respect for American art that he has felt it deserves.

The love of country that inspires Jack Warner to collect American art matches the spirit of the age in which the works were produced. While the American Revolution achieved political freedom from England in the eighteenth century, economic and cultural independence were sought and won in the century that followed. It was a desire to cut the umbilical cord with England that fostered a burgeoning spirit of nationalism following the War of 1812. Economic nationalists sought protective trade tariffs and such internal improvements as the building of canals and roads; cultural nationalists advocated encouragement of the arts by government, communities, and individual patrons. Economic and cultural sentiments were inevitably linked. DeWitt Clinton, New York's canal commissioner, advocated government-sponsored canal building but also contributed to the founding of such arts organizations as the American Academy of Fine Arts. He argued that revenues gained from the operation of canals could be used in "encouraging the arts and sciences; in patronizing the operations of industry; in fostering the inventions of genius; and diffusing the blessings of knowledge." The Erie Canal, completed and opened in 1825, both promoted trade and produced a thriving economy. Fortunes were made by such merchants as Luman Reed of New York and Daniel Wadsworth of Connecticut, who began to support contemporary American artists and thereby fostered the development of America's first native school of painting.

The Warner collection of American art mirrors Jack Warner's self-image as a patriotic citizen. However, the relationship between the collector and the collection became more personal than ideological once the paintings entered the Warner domain. Jack got to know his paintings so well that he considered them friends. According to Warner, nothing gives him more pleasure than sitting in a comfortable chair, coffee in hand, "conversing with my most recent acquisition."

John James Audubon's engravings of birds were among the earliest images to engage Jack Warner in conversation. "Audubon's prints trained my eye to recognize quality in avian portraiture," he says. Like the artist, he is attracted both to the aes-

thetic beauty of birds and to the challenge of the hunt. Warner has been devoted to bird hunting since childhood. Setting off in 1820, Audubon, also an avid huntsman, traveled thousands of miles to accomplish his goal of finding and recording from life all the species of birds in America. Along with this ambitious project, Audubon wanted to make representations of birds unlike any made before him. He criticized the practice of painting birds as specimens in a flat profile view without a natural setting. "Nature must be seen first alive, and well studied," wrote the artist, "before attempts are made at representing it." Moreover, he determined that wherever possible the birds should be depicted in their natural environment and engaged in activities that Audubon had observed from life. *Wild Turkey,* which became plate one in Audubon's engraved volumes *Birds of America,* is a magnificent emblem of the artist's desire to explore and visually document the natural treasures of the New World. It is also an image that set Jack on a trek through western Alabama with the contemporary bird painter Basil Ede "to stalk the turkey with his sketchbook." For Audubon, "the great size and beauty of the wild turkey, its value as a delicate and highly prized article of food, and the circumstance of its being the origin of the domestic race now generally dispersed over both continents, render it one of the most interesting of the birds indigenous to the United States of America." Indeed, the native turkey cock had widespread appeal for the American public. Although it lost the competition for America's national symbol to the bald eagle, Audubon restored iconic status to the bird in his life-size portrait, with its richly patterned plumage, striding majestically through the reeds and cane typical of riverbanks of southern Louisiana where the artist sighted it in 1825. No wonder Audubon's work appealed to Warner, who regarded "plumage [as] a brilliant mirror of sunlight and shadow" and "stressed motion and movement" as essential to expressive bird painting.

Along with representations of the American flag and George Washington, the bald eagle, the new republic's national symbol, was a popular and ubiquitous subject in the plastic arts. The German immigrant sculptor Wilhelm Schimmel is best known for fashioning eagles out of soft pinewood with a jackknife. The rugged elegance of the eagle in the Warner collection, with its plumage rendered in finely incised geometric patterns, demonstrates the rugged elegance of the self-taught artist. The popularity of the eagle subject allowed this itinerant self-taught sculptor to eke out a meager subsistence during the late 1800s. He traded his carvings for food and

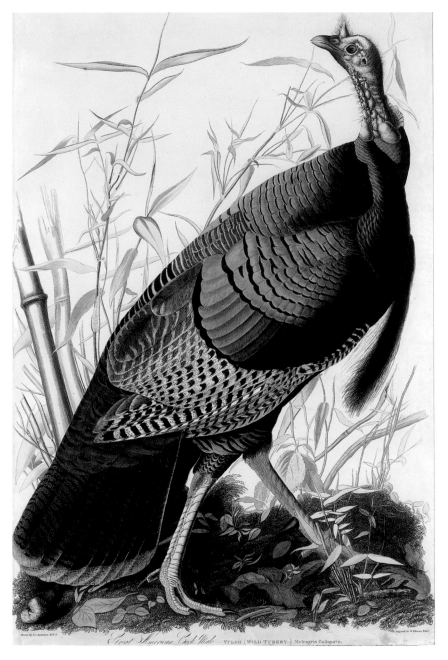

JOHN JAMES AUDUBON (1785–1851)
Wild Turkey, circa 1825

Hand-colored engraving by
W. H. Lizars, 38 ³/₄ x 26 inches

spirits in the area of Carlisle, Pennsylvania, where his obituary said he made "his headquarters in jails and almshouses."

A craftsman of the early republic, Samuel McIntire also earned his living as a woodcarver. A resident of Salem, Massachusetts, he specialized in ornamental architectural and furniture decoration; he also produced figureheads for ships. Like all early woodcraftsmen McIntire could not confine himself to special talents and survive. He had a wide range of woodworking skills and could tackle almost any subject; one sideline specialty was carving eagles to crown cupolas, archways, and gateposts. Warner's exquisite McIntire eagle is a fine example of this artist's specialty trade.

Animal symbolism of a more idealized form, but still with patriotic overtones, appears in Edward Hicks's *The Peaceable Kingdom*, a beautiful example of many versions of this subject by the artist. Two discreet images appear side by side in the painting: on the right is a scene from the Bible's Book of Isaiah representing a group of wild animals assembled peacefully with their prey; on the left is a re-creation of a historical scene showing William Penn's negotiation of a peaceful land treaty with the Indians of Pennsylvania. For Hicks, Penn's "Holy Experiment" represented Isaiah's biblical prophecy of God's heavenly kingdom on earth. In the promised land of the New World, there existed the ideal that the lion would lie down with the fattling (calf) and the settlers and the Native Americans would resolve conflicts peacefully and for their mutual benefit.

Portrait painting held pride of place in America from the foundation of the democracy through most of the nineteenth century. Tracing the profiles of individuals and families was the bread and butter of artists during the colonial period and in the new republic. So exclusive was the demand for portraits that even Gilbert Stuart, who made a fortune tracing the physiognomy of George Washington, would complain about the tyranny of the form and the proliferation of its practitioners. "By and by," said Stuart, "you will not by chance kick your foot against a dog kennel, but out will start a portrait painter."

Nevertheless, what better way to establish a national profile than to record the faces of heroic, prominent, and prosperous inhabitants? Images of George Washington as Revolutionary War hero, founder of the country, president, and mythic saint were more numerous than those of any other individual. But many of the faces and figures of men in supporting roles in the War of Independence and the founding of the United States were memorialized as well. Alexander Hamilton was honored in bronze by Erastus Dow Palmer, an Albany, New York, sculptor who earned a national reputation for emphasizing American subjects in a naturalistic style. His portrait of America's first secretary of the treasury demonstrates his goal of capturing an ideal through a naturalistic approach to form rather than a revival of classical style. Palmer maintained a reverence for the portrait form later in the nineteenth century when

SAMUEL McINTIRE (1757–1811)
Eagle
Salem, Massachusetts, 1804–5
Giltwood, 18 1/2 x 14 1/4 x 11 1/2 inches

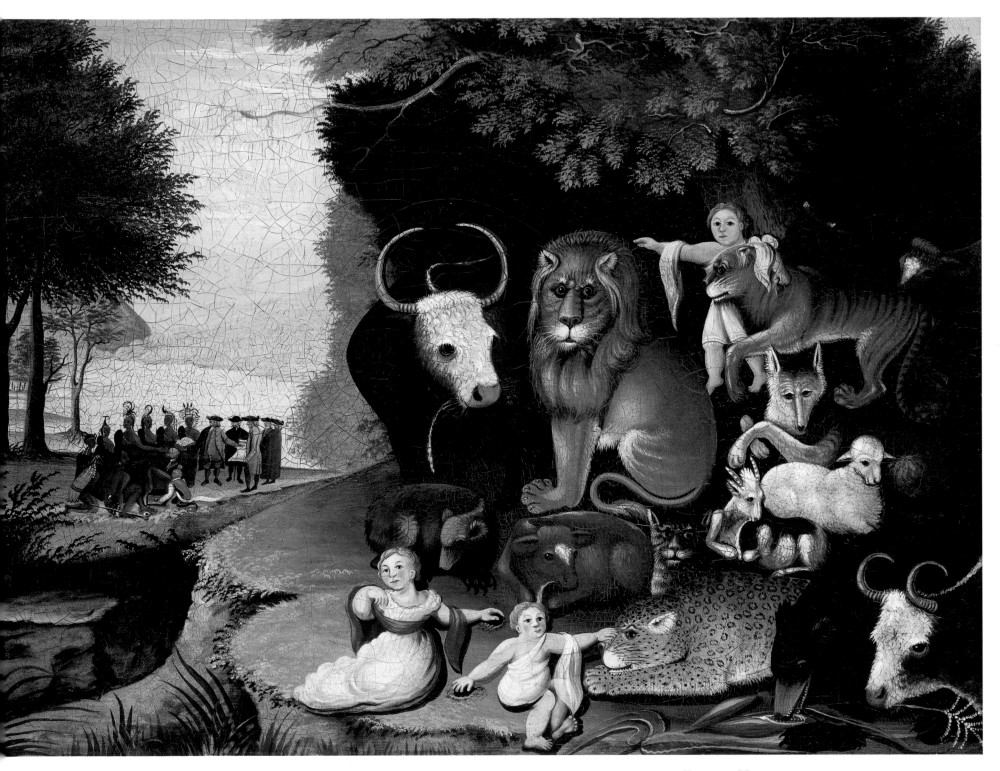

EDWARD HICKS (1780–1849)
The Peaceable Kingdom, circa 1833

Oil on canvas, 17 ¹/₂ x 23 ¹/₂ inches

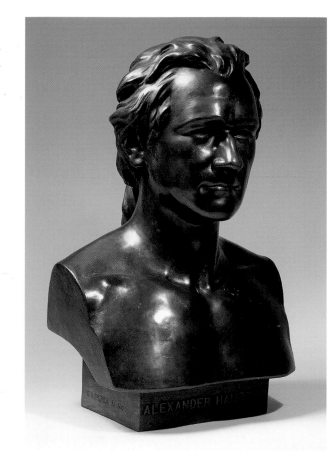

many sculptors had begun to look down on it. "The purest and best of our nature is evinced in portraiture," wrote Palmer, "not by copying the forms, but by reaching after something higher—a spiritual modification of them."

Thomas Sully, Benjamin West's pupil, was one of the handful of painters given the opportunity of painting from life the Revolutionary War hero the Marquis de Lafayette. This study was the basis for a full-length portrait commissioned of Sully for the city of Philadelphia. The likeness of Lafayette was taken by the artist when the French-born soldier returned to the United States in 1824–25 for a triumphal tour. So popular was Lafayette in the public imagination that his appearances reportedly "provoked demonstrations of frenzied enthusiasm without precedent or parallel in American history." When he toured the United States, Lafayette was the last surviving ranking officer to have participated in the battlefields of the American Revolution. Not yet twenty-one years of age, Lafayette came to America to offer his services to the revolutionary cause. He was commissioned a major general by the Continental Congress and placed in command of the troops in Virginia. He demonstrated extraordinary military leadership and became a much admired and lifelong friend of George Washington. Sully captures the

ERASTUS DOW PALMER (1817–1904)
Bust of Alexander Hamilton, 1860

Bronze, 28 ¹/₂ x 18 x 12 inches
Inscribed base, front: Alexander Hamilton
Inscribed base, left: E D Palmer Sc. 1860
Inscribed base, rear: Roman Bronze Works NY

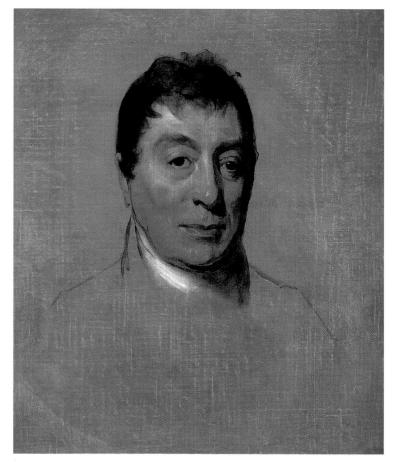

THOMAS SULLY (1783–1872)
Marquis de Lafayette, circa 1824

Oil on canvas, 22 ³/₁₆ x 19 ¹/₄ inches

This was a study from life made in Washington, D.C., in December 1824 for the life-size, full-length portrait of Lafayette now in the collection of Independence National Historic Park, Philadelphia.

vitality of Lafayette in the luminous and mobile expression of his face. His flesh is rosy and lifelike. Sully may have achieved this verisimilitude by following the painterly advice of Gilbert Stuart. Stuart warned against the blending of tones in the representation of flesh in portrait painting. "No blending," wrote Stuart, "t'is destruction to clear and beautiful effect. It takes the transparency and liquidity of colouring and renders the flesh of the consistency of buckskin."

Although less obvious than in the portraits of national heroes, patriotism is also deeply embedded in early American family portraiture. A spirit of domestic harmony was keenly valued in America from the earliest years of the republic. The personal harmony of a family reunited pervades John Lewis Krimmel's *Self-Portrait with Susannah Krimmel and Children*. John Lewis Krimmel left his native Germany to join his brother George, who had settled with his family in Philadelphia. The artist portrays himself entering a room in his brother's Philadelphia house, perhaps a paradigm for his new country. Susannah, his brother's wife, and her children are assembled to greet and welcome him into his new home. The family unit is completed by the inclusion of a portrait of the father, probably a representation of an actual painting by John—a portrait within a portrait. The image stands as a reenactment of the immigrant arrival in the land of freedom and opportunity. The happy demeanor of the mother and her children suggests a warm family spirit, which the artist reinforces by centering the figures and connecting them with each other through posture and gesture, thereby creating a family circle. Strong family ties were regarded as the mortar for the building blocks of the nation's strength. Art plays a part in the domestic connection. John, trained in Germany, brought his artistic skills with him. He probably served as the teacher of his nephew Henry, seated in the chair and engaged in painting in watercolor. Below, Henry's sister holds a watercolor drawing in her hand. It appears as though she has just been interrupted in her contemplation of the work. An immigrant artist who settled and made his living as a professional artist in the United States, John Lewis Krimmel, through his work and through his teaching, fostered the development of culture in the land that allowed him to flourish in his profession.

Krimmel's informal family portrait derives from the European tradition of the "conversation piece." Figures are posed in a relatively natural way in a familiar setting, unlike formal portraiture, in which figures take on standardized postures and hold traditional accessories. The settings are theatrical, and sometimes the figures are dressed as mythical figures from classical literature. In contrast, the Krimmels are most likely dressed in their own clothing and sitting in their own home with their own fur-

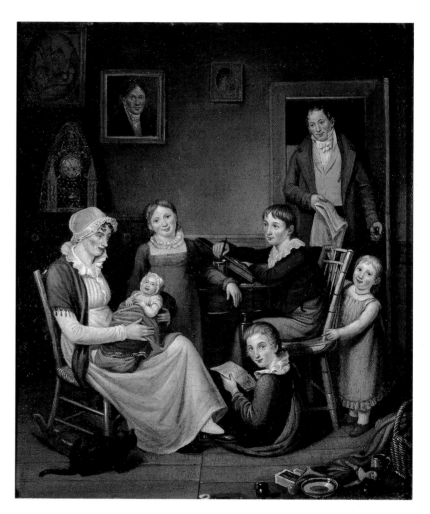

JOHN LEWIS KRIMMEL (1789–1821)
Self-Portrait with Susannah Krimmel and Children, circa 1816

Oil on canvas, 14 x 12 inches

niture. Some of the details of the portrait, however, do derive from the tradition of seventeenth-century Dutch genre painting, probably through such British interpreters of that genre as Sir David Wilke, whose work became popular in America. The foreground details of the basket, pottery ware, blanket and doll, and even the cat derive from that genre. The original religious and moral symbolism of these objects had diminished by this time; they now served as allusions to the virtues of domesticity and the untainted innocence of childhood.

History painting recorded significant events or subjects from ancient literature or the Bible, but genre painting told of everyday life. The subjects were intended to describe contemporary history as it was lived by individuals both in the city and in the country. It shows what people wore, what they did for work, and how they spent their leisure time; it suggested moral ideals as well. The Krimmel family portrait records each family member and uses the particular family to applaud the importance of strong family ties to the health of the nation. This dual objective of conveying the real and the ideal simultaneously informs genre painting in America throughout the nineteenth century. At midcentury it reached its heyday.

William Sidney Mount carried out a successful career painting the everyday pastimes of rural life, particularly in his native Long Island. In *Any Fish Today?*, his charming painting of a young boy poised on a doorstep to peddle his daily catch, Mount paints a frequent and popular subject in American genre painting. The itinerant peddler appears in paintings by John Lewis Krimmel, Francis William Edmonds, and Asher B. Durand. Artists identified with peddlers who traveled from town to town in search of customers, since most painters were unable to support themselves in one location. Although Mount was not obliged to travel, he recognized the importance of painting salable subjects. "Paint pictures that will take with the public," he wrote, "never paint for the few, but for the many—some artists remain in the corner by not observing the above."

Mount endowed his popular themes with dignity and meaning through his gift for monumental design. There is no better example of his classic mode of composition than *Any Fish Today?* The young fisherman is firmly framed by the wooden door; its horizontal crosspieces lock him in place. Vertical accents such as the door jambs, sectioned views of the landscape, shotgun, jug, and ax visually reiterate the upright posture of the boy. The muted palette of ochres, browns, and greens with highlights of red further balances and unifies the composition. Within Mount's strong structural setting, which at least one cultural historian has compared to those of the Renaissance master Piero della Francesca, the narrative takes place. There can be multiple interpretations of the story. Clearly, one theme is the contrast of nature and civilization. With one foot firmly planted on the earth and one on the door saddle, the young fisherman straddles the exterior and interior worlds. Inside, a leatherbound book, representing learning

and the life of the mind, lies on a finely carved chair finished with caning. The craft and artistry of the chair are echoed in the floral design, probably hand-painted or stenciled, on the floor. Art goes hand in hand with civilization. The shotgun is the emblem of the hunter who shoots his prey to survive, and the ax represents the chopping down of trees to provide shelter. Perhaps the jug refers to the nutrients necessary to support life. The boy offers his catch for sale, symbolizing commerce, and his orderly and complete outfit demonstrate that he is not a beggar but a young merchant. Glimpses of the landscape reveal a pleasant setting. The trees are in full foliage and two ducks swim undisturbed on the pond. But the question of symbolic intent remains. Is Mount praising the simple but profitable pleasures of rural life, or is he issuing a warning about man's potential, as hunter and builder, to destroy a God-given natural paradise?

The indoor/outdoor theme reverberates in Winslow Homer's painting *Noon Recess*, painted two decades after Mount's work. It is one of many images of country schoolhouses that Homer painted in the 1870s. In this schoolroom scene, the reflective teacher and the student, buried in his book as penance, engage in mental activity while the boys outside romp and play with abundant physical energy. Critics praised Homer's schoolhouse pictures as "purely American," representing what they saw as "the unadulterated product of our peculiar civilization." It was not just the appearance that gave national character to *Noon Recess*, but the values it projected. The importance of education and gentle discipline in the rearing of children, as well as outdoor activity, reflected the Enlightenment philosophy of learning as a pleasurable natural development rather than as a matter of strict discipline and conformity. This is a positive image of educational progress and its reflection in the spirit of American life.

Representations of the Native American in art proposed another chapter in the story of progress with its positive and negative implications. The Warner collection contains many examples of Native Americans in formal portraits and narrative scenes of daily life. Edward Hicks expressed best the ideal interaction of European settlers

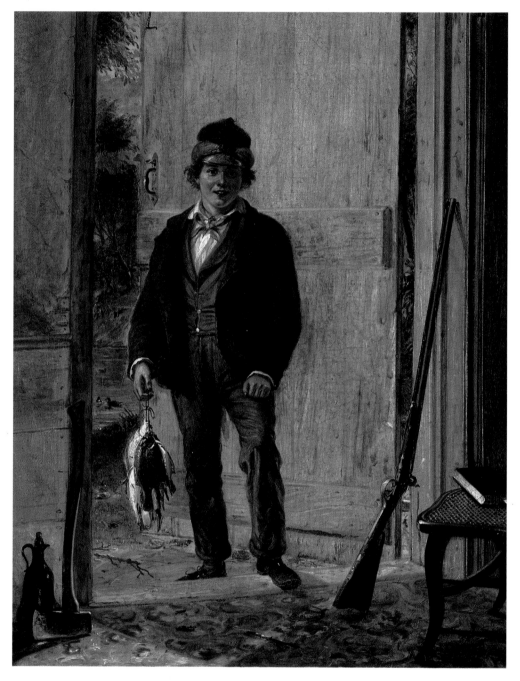

WILLIAM SIDNEY MOUNT (1807–68)
Any Fish Today?, 1857

Oil on panel, 21 ¼ x 16 ¼ inches
Inscribed lower right: Wm S Mount 1857

Winslow Homer (1836–1910)
Noon Recess, 1873

Oil on canvas, 9 ¹/₄ x 14 ¹/₈ inches
Inscribed lower right: HOMER 1873

with native inhabitants in his depiction of William Penn and the Indians in *The Peaceable Kingdom*. Early portraits of Indians, such as Charles Bird King's *Black Hawk*, convey the dignity of the subject along with the details of dress and face paint that serve as documents of an exotic culture. Some of the inspiration for this documentation emanated from the fear that these cultures would disappear as settlers moved west and acquired lands through treaty, trick, "peaceful" relocation, and war.

George Catlin preserved the image and cultural life of Plains Indians in much the same way that John James Audubon captured the appearances of native birds. When he was still a student in Philadelphia in 1829, Catlin came across a group of Indians and was so impressed by their "silent and stoic dignity" that he set out to record the appearances and customs of Native Americans. By 1838, his travels west, living with a number of different Indian tribes, had resulted in more than five hundred pictures. Whether recording scenes of war, such as *Battle Between Sioux, Sauk, and Fox*, or scenes of everyday life, as in *Interior of Mandan Lodge*, Catlin aimed at careful reproduction of every detail. He complemented his visual projections with written records published in *Letters and Notes on the Manners, Customs and Conditions of North American Indians*. In letter eleven, Catlin described the dwellings of non-nomadic Mandan tribes, who maintained permanent villages with sturdy earth lodges. Catlin recorded the interior of one such lodge in his *Interior of Mandan Lodge*. It is "constructed of poles, and civered [sic] with dirt. The Chief is seen smoking his pipe, and his family grouped around him," noted Catlin. "At the head of each warrior's bed, is seen a post, with his ornaments hanging on it, and also his buffalo mask, which every man keeps to dance the buffalo dance. Some of these lodges contain thirty or forty persons, and the beds are seen extending around the side of the Lodge."

Despite his goal of exact record keeping, Catlin inherited the romantic notion of the Indian as a "noble savage," an eighteenth-century conception of humankind in a state of nature, uncorrupted by civilization. In a letter of 1832, Catlin compared Native Americans, whom he dubbed "knights of the forest," to the victors of the Greek Olympic games, who served as models for ancient Greek sculptors:

> These graceful youths, without a care to wrinkle, or a fear to disturb
> the full expression of pleasure and enjoyment that beams upon their faces—their
> long black hair mingling with their horses' tails, floating in the wind, while they are
> flying over the carpeted prairie, and dealing death with their spears and arrows, to a

GEORGE CATLIN (1796–1872)
Interior of Mandan Lodge, circa 1832

Oil on canvas, 23 ¹/₄ x 28 inches

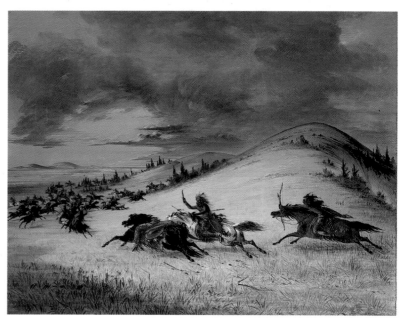

GEORGE CATLIN (1796–1872)
Battle Between Sioux, Sauk, and Fox, circa 1846

Oil on canvas, 25 ³/₄ x 32 inches

band of infuriated buffaloes; or their splendid procession in a war-parade, arrayed in all their gorgeous colors and trappings, moving with the most exquisite grace and manly beauty, added to that bold defiance which man carries on his front, who acknowledges no superior on earth, and who is amenable to no laws except the laws of God and honor.

It is difficult to believe that these words were written two years after the passage of Andrew Jackson's Removal Bill, which forced all the eastern tribes of Native Americans to relocate west of the Mississippi River, a route aptly termed the "Trail of Tears."

However, Catlin was not completely blinded by romantic idealism and the desire to find masculine aesthetic beauty on American soil comparable to ancient Greek athletes. He correctly feared that the Native American tribes and their cultures would soon be destroyed. Part of his mission in making visual records and written notes was to preserve for posterity this vanishing society: "I have, for many years past, contemplated the noble races of red men who are now spread over these trackless forests and boundless prairies, melting away at the approach of civilization." He warned that their extinction was imminent: "their rights invaded, their morals corrupted, their lands wrested from them, their customs changed, and therefore lost to the world; and they at last sunk into the earth, and the ploughshare turning the sod over their grave, . . . for they are *doomed*." Indeed, when Catlin lived among the Mandan, there were two villages of about two thousand people. The smallpox epidemic of 1837 and subsequent raids rendered the tribe extinct before 1850.

More than any other subject for painting in nineteenth-century America, nature became the repository for America's cultural identity. Jack Warner recognizes the importance of landscape painting in conveying "the nation's fierce independence." His collection includes masterful examples of the work of Thomas Cole, Frederic Church, and Asher B. Durand, the artists who deserve the primary credit for founding America's first school of landscape painting—the Hudson River School. It was the quality of light in their "expressive settings" that captivated Warner. The artists, too, noted the special light in the New World. It had a clarity and transparency unequaled in Europe. That it was more than just physical illumination did not escape the notice of American artists and poets. "The external appearance of this our dwelling place," wrote Durand in 1855, "is fraught with lessons of high and holy meaning, only surpassed by the light of Revelation."

What differentiated the landscape of the United States from that of Europe was that it had not been sculpted and tamed by centuries of civilization. For Thomas Cole, "the most impressive characteristic of American scenery [was] its wildness," and he made a vivid representation of that unspoiled wildness in *The Falls of Kaaterskill*. This gorge, with its massive rock walls and waterfall, was just a short walk from the Catskill

OPPOSITE

THOMAS COLE (1801–48)
The Falls of Kaaterskill, 1826

Oil on canvas, 43 x 36 inches
Inscribed lower right: T Cole 1826
Verso: Falls of Kaaterskill Thos. Cole 1826

*The painting once belonged to Cole's friend
William Cullen Bryant (1794–1878).*

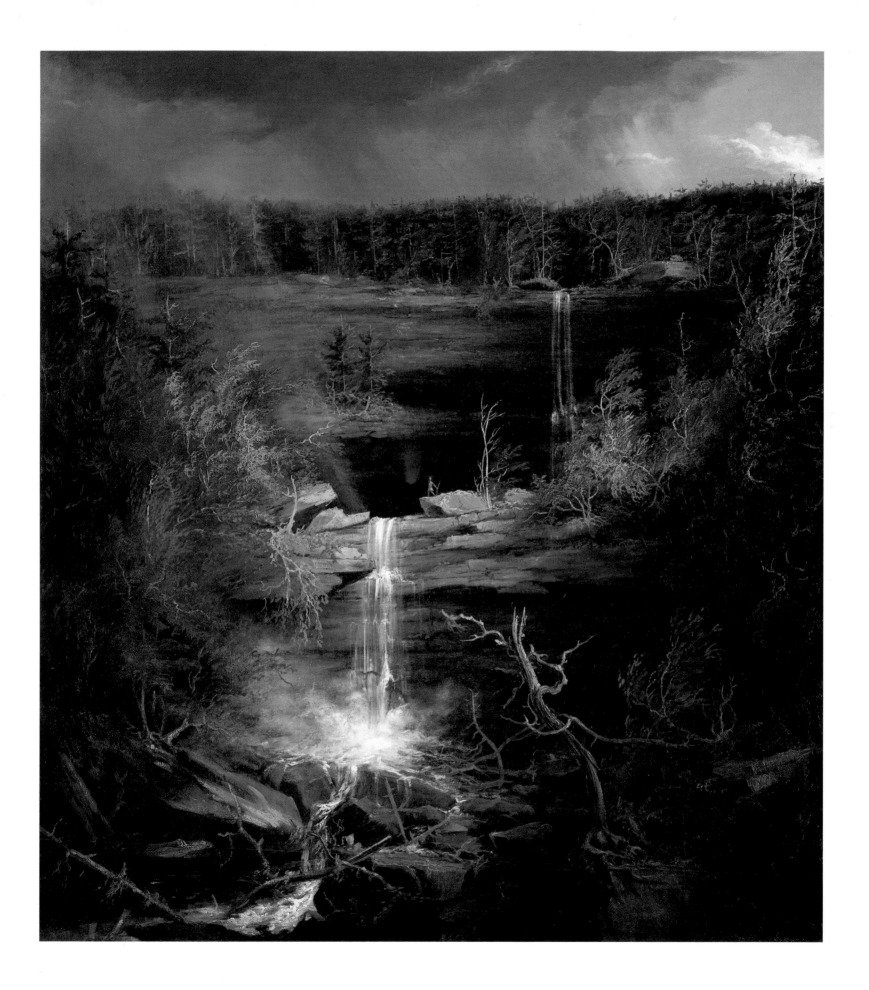

Mountain House where artists and tourists stayed to explore the natural wonders of the region. This was a site that particularly inspired Cole in its majesty of form and its spiritual associations. "Like a gush of living light from heaven," wrote the artist, "the cataract leaps, and foaming into leathery spray" descends over not one, but two enormous ledges of rocks. "Then struggling and foaming through the shattered fragments of the mountains, and shadowed by fantastic trees, it plunges into the gloomy depths of the valley below." Cole placed a diminutive figure of an Indian atop a sheer rock on the central cliff as the human equivalent to this scene "of savage and silent grandeur."

FREDERIC E. CHURCH (1826–1900)
Above the Clouds at Sunrise, 1849

Oil on canvas, 27 1/4 x 40 inches
Inscribed lower right center: F E Church/1849

A similar grandeur of vision pervades Frederic Church's 1849 painting *Above the Clouds at Sunrise*. The only formal pupil of Thomas Cole, Church learned from his teacher about the high purpose of the artistic calling: "Work ought not to be a dead imitations of things" but rather should have "the power to impress a sentiment or enforce a truth." In this painting, Church invites the viewer to hover, like the soaring bird, over a magnificent mountaintop with a limitless view of sky at dawn. The rising sun illuminates the panorama of clouds in a rich array of pastel tints. The beauty of the painting celebrates the glory of heaven. The wind-blown trees and rough, craggy rocks seem to emerge freshly made. More than the dawn of a new day, Church describes the creation of a world, still in a wild state, bearing the imprint of the Creator. Like his teacher Cole, Church revered nature in America for its pristine beauty and its intimations of the divine. America offered the possibility of a new beginning, a fresh start, a chance to do it right: "Nature has spread for us a rich and delightful banquet. Shall we turn from it? We are still in Eden; the wall that shuts us out of the garden is our own ignorance and folly." Church celebrates nature in America as the new Eden; it is a virgin landscape that appears just born, at sunrise, and filled with the potential for national and spiritual illumination. There is no evidence of humankind, not even a single Native American as in Cole's *The Falls of Kaaterskill*, to disturb the wild elegance of the New World at its birth.

For Durand, too, nature in America was distinguished by its wildness, but his masterpiece of historical landscape painting, *Progress (The Advance of Civilization)*,

ASHER B. DURAND (1796–1886)
Progress (The Advance of Civilization), 1853

Oil on canvas, 48 x 72 inches
Inscribed lower left: A B Durand 1853

*The canvas was painted for Charles Gould
and exhibited at the National Academy of Design,
New York City, in 1853.*

HIRAM POWERS (1805–73)
The Greek Slave, 1841–43

Marble, 45 ¹/₂ x 15 x 12 inches
Inscribed base, rear: H Powers Sculp

*Beginning with Thomas Crawford,
who visited Rome in 1835, academic
American sculptors in the nineteenth cen-
tury were captivated by the idea that the
highest level of their achievement could be
attained by gaining inspiration from the
antique, classical sculpture to be found in
Italy. Hiram Powers was by far the most
successful in this pursuit. Powers estab-
lished a studio in Florence in 1837 and in
1841–43 produced what was to become
the most famous sculpture of the century,
The Greek Slave. The first version was
purchased by an Englishman and shown
in London in 1845. The second and third
of the six full-size versions traveled as
tourist attractions in the United States
in the late 1840s and early 1850s. The
various sizes, such as the two-thirds life-
size example in the Warner collection,
were made possible by the following
procedure: the original was modeled
in clay, then cast in plaster, and finally
produced in marble through the mechani-
cal pointing process. The pointing process
allowed for reduction in size and for
production in marble of different parts
of the work. Even the foot of* The Greek
Slave *became a separate sculpture.*

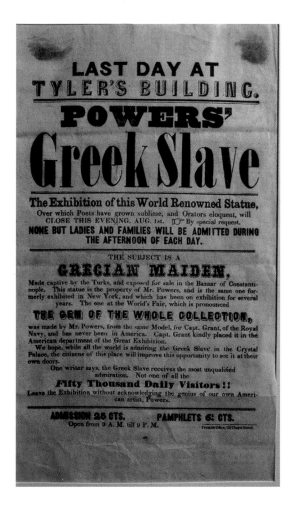

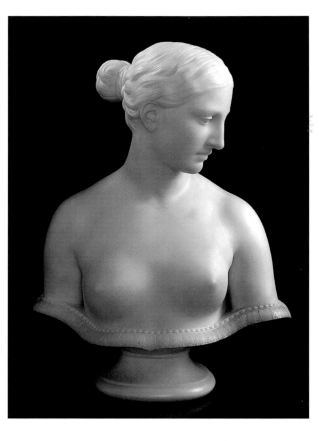

LEFT

Broadside announcing the appearance of Hiram Powers's *Greek Slave*

Printed on paper, 9 ⅝ x 5 ½ inches
Collection of Mr. and Mrs. John McCoubrey

RIGHT

HIRAM POWERS (1805–73)
Bust of *The Greek Slave,* after 1843

Marble, 24 ½ x 18 x 8 ¾ inches
University of Alabama,
gift of Mr. and Mrs. Jack Warner

BELOW RIGHT

HIRAM POWERS (1805–73)
Bust of *The Greek Slave,* after 1843

Marble, 15 x 9 ½ x 6 inches

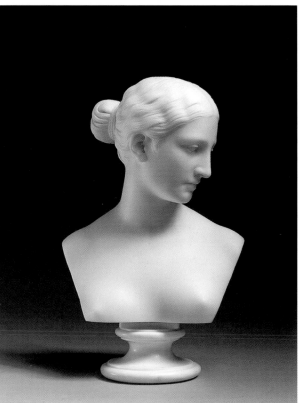

celebrates the development of the wilderness into a pastoral landscape of peace and plenty. By 1853, when Durand painted this picture for railroad magnate Charles Gould, America had much to be proud of in advances in technology, travel, and communication. Critics of the period applauded Durand's success in portraying "the contrast of the raggedness of primeval nature with the culture and forces of our present civilization." Indeed, the right-hand portion of the picture is an encyclopedic projection of nature embracing the arrival and settlement of man in a vast valley. Farmers with hay wagons or herds of cattle make their way along a road gently winding through the landscape. A log cabin, a bridge, and a farmer using his plow provide further examples of the settlement of the land. A canal, with its barge traffic, symbolizes the progress of trade from the coast into the interior of America, while telegraph wires provide the connective tissue of communication so important to commerce and settlement in the frontier lands. A white church steeple in the middle distance gives its blessing to the notion of a cultivated land, and the nearby train running along its trestle in no way disturbs the pastoral beauty of the landscape. At the left of the painting

is a wilderness scene with tree trunks broken by storms; it recalls the landscape as a repository of history and creation. A group of Native Americans stands in this shadowed earlier world, gazing over the valley below with its incursions of settlement. Their reactions to the drama are undefined; it is difficult to imagine how they felt.

When *Progress* was exhibited at the National Academy of Design in 1853, it was applauded for its beauty and its nationalism. "It is purely American," wrote one critic. "It tells an American story out of American facts, portrayed with true American feeling, by a devoted and earnest student of nature." Durand's painting told the story of the settlement of the American West and embodied the ideal of Manifest Destiny, blessing the expansion of the United States across the North American continent.

In 1847, just six years before Durand painted his realistic narrative of American history, the nude sculpture *The Greek Slave*, by the expatriate American sculptor Hiram Powers, toured the country. That this idealized rendering of a foreign subject met with great success by an American public that favored "purely American" facts and feelings seems puzzling. The classical nude, however, did not represent a subject from antiquity, but rather from recent history. She is a victim of the 1841 struggle of the Greeks to free themselves from the domination of the Turks. Powers told the story of her fate in a pamphlet that accompanied her exhibition tour. "The Slave has been taken from one of the Greek Islands by the Turks . . . She stands exposed to the people she abhors, and awaits her fate with intense anxiety, tempered indeed by the support of her reliance upon the goodness of God. Gather all the afflictions together and add to them the fortitude and resignation of a Christian, and no room will be left for shame."

The Greek Slave tells a story, a moral tale that resonates with the American experience. She belongs to a people involved in a revolution to secure freedom, just like the American colonists in the struggle against the British. Moreover, this marble nude is not a figure of heathen idolatry and sensuality but an innocent Christian victim. According to one Unitarian minister, "the chasteness of this statue is strongly contrasted with the usual voluptuousness of the antique . . . It was clothed all over with sentiment, sheltered, protected by it, from every profane eye. Brocade, cloth of gold, could not be a more complete protection than the vesture of holiness in which she stands."

The American story can be told in voices as different as Durand's bucolic landscape painting of American progress depicting settlers moving west across the continent or Hiram Powers's idealized marble statue of an innocent victim of a war in the Balkans. The range of subject, form, and style could not be more removed from one another. However, they share a spirit of national optimism, a belief in freedom, and a dedication to Christian virtue, and they stand as emblems of America's aspiration to create a native culture to compete with, perhaps surpass, that of the Old World. Indeed, they provided the foundation for an American cultural identity that secured the way for artists after the Civil War and into the new century.

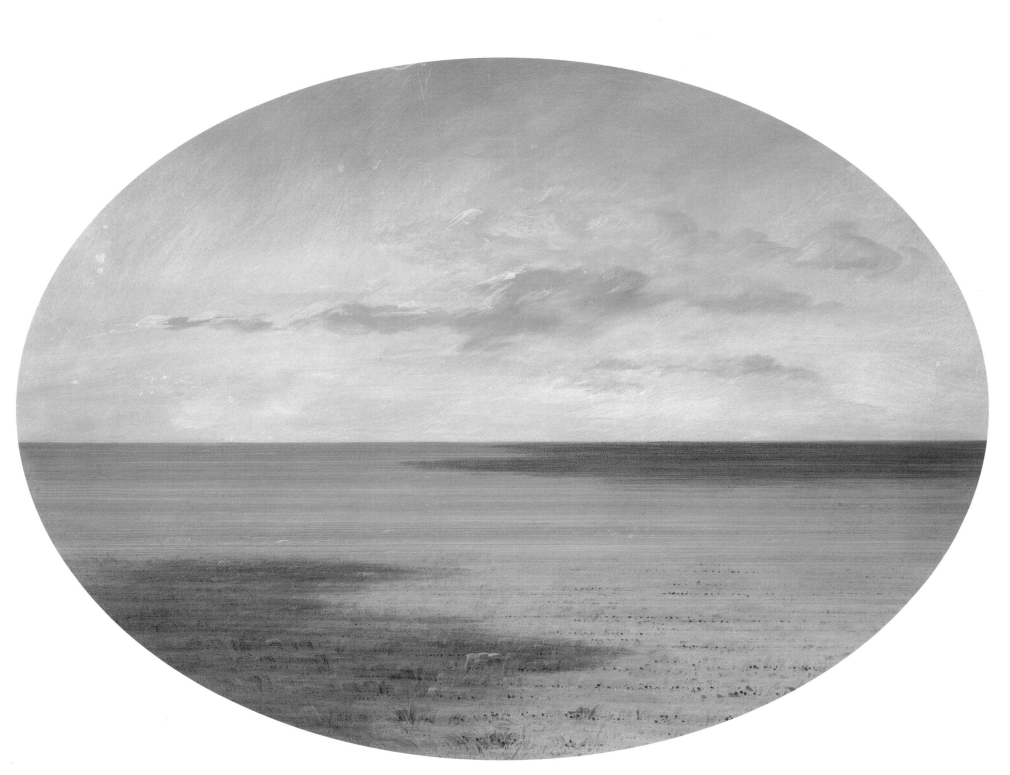

GEORGE CATLIN (1796–1872)
Out of Sight of Land—Great Buffalo Plains
North of the Platte, 1834

Oil on board, 25 ³/₄ x 32 inches

103

FINE ARTS I

It is the preoccupation with, if not profound devotion to, the natural wonder of the American landscape that shapes the profile of the Warner collection of Gulf States Paper Corporation. One of the earliest works in the collection, the 1829 *Arrangement of Grapes* shows the artist James Peale, at eighty years of age, marveling at nature's beauty and bounty in a loving close-up of its fruit. Likewise, Jonathan Fisher found every detail of the northeastern town of Blue Hill, Maine, and its surroundings worthy of precise depiction.

Artists of the first half of the nineteenth century find poetry in North America's east and west coasts, its central plains, and its mountains, whether the Adirondacks or the Rockies. The special effects of the season, the weather, and the time of day are revealed in such titles as *Sunset in the Shawangunk Mountains* and *Morning in the Adirondacks* by Sanford Gifford and *Autumn on the River* by Jasper Cropsey. Alfred Jacob Miller and John Mix Stanley chose to depict the customs and appearances of Native Americans in a respectful effort to document and preserve them. In their pictures, the broad sweep of the central Great Plains is shown as integral to the survival of these civilizations.

The optimism and nationalism of pre–Civil War America are palpable in the earlier works in the Warner collection. They are embedded in the landscape, which served as a source of pride and hope for the new nation. It is not background scenery, but a central character in the story of America's cultural development.

FITZ HUGH LANE
(1804–65)
A Smart Blow,
circa 1856

Oil on canvas,
24 x 42 inches
Inscribed on bow
of boat: Fitz Hugh Lane
Gloucester

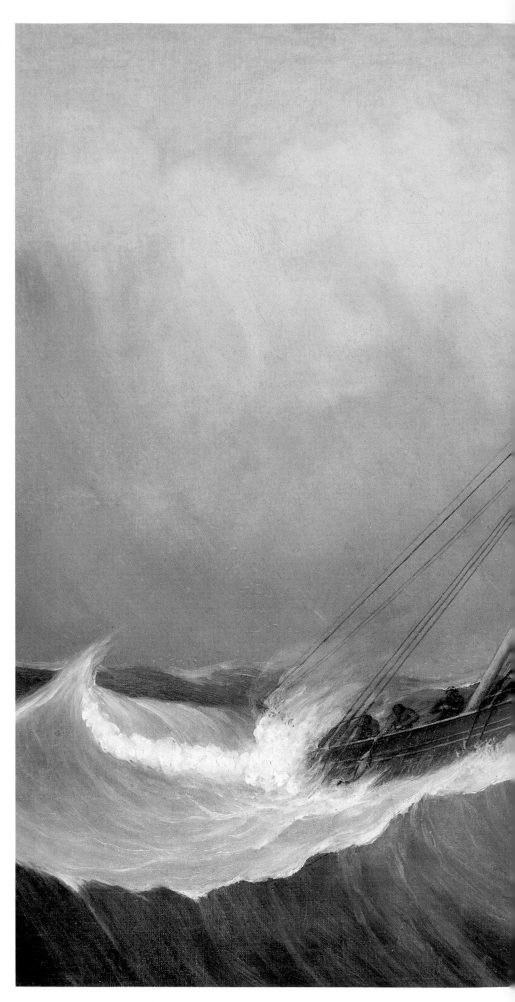

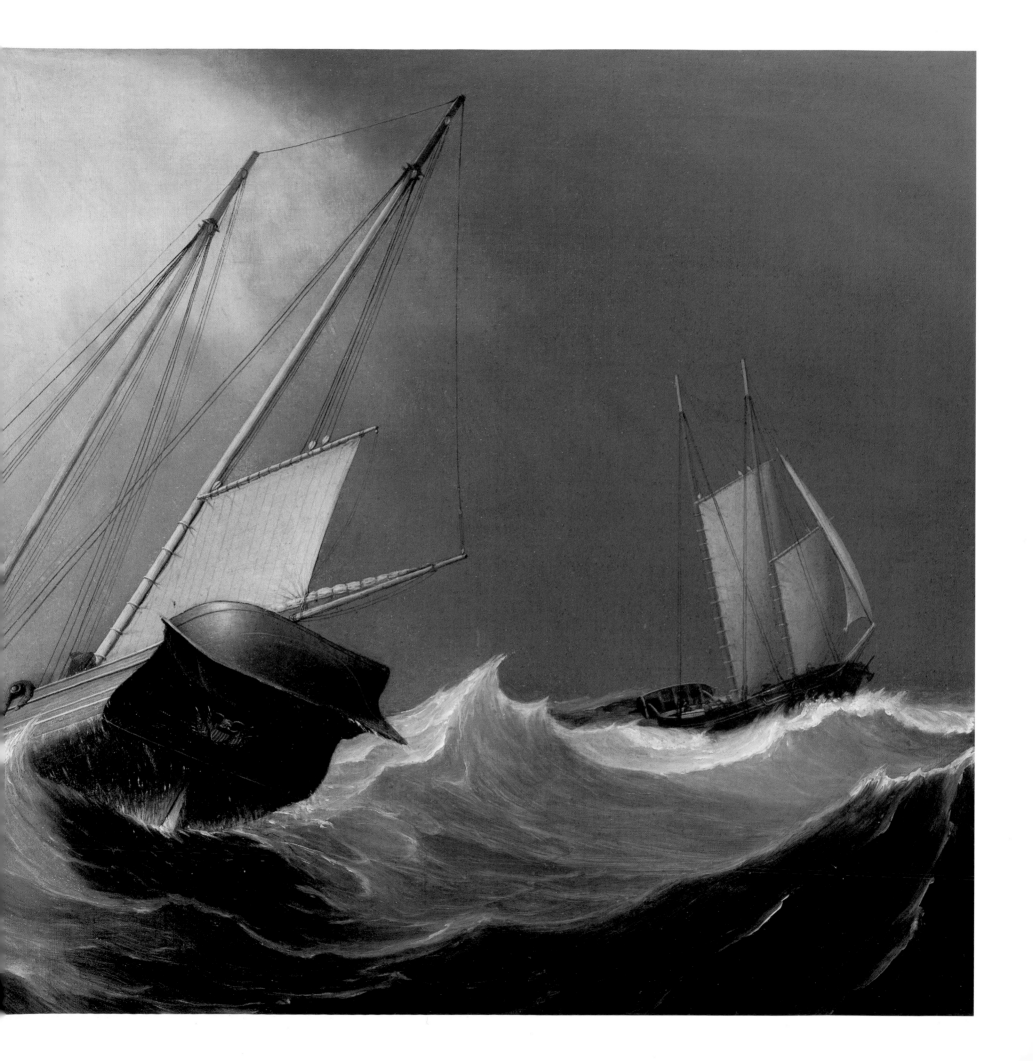

TOP

THOMAS COLE (1801–48)
Home in the Woods, circa 1847

Oil on board, 6 ½ x 10 inches

ABOVE

THOMAS COLE (1801–48)
Study for Hunter's Return, 1845

Oil on paper, mounted on canvas, 7 ½ x 10 inches

JONATHAN FISHER (1768–1847)
View of Blue Hill, Maine, circa 1824

Oil on canvas, 26 ¹/₂ x 46 ¹/₂ inches

THOMAS BALL (1819–1911)
Henry Clay, 1858

Bronze, 30 ³/₄ x 12 x 10 ³/₄ inches
Inscribed base, rear right: T Ball sculp. Boston 1858
Inscribed base, right: Ames Mfg. Co. Saunders Chicopee Mass
Inscribed base, rear left: PATENT assigned to C W Nichols

Leader of the Whig party and five-time unsuccessful presidential candidate, Henry Clay (1777–1852) played a central role on the stage of national politics for over forty years. He was secretary of state under John Quincy Adams, Speaker of the House of Representatives longer than anyone else in the nineteenth century, and the most influential member of the Senate during its golden age. In a parliamentary system, he would have undoubtedly become prime minister. Clay's personal magnetism made him one of America's best-loved politicians; his elaborate scheming made him one of the most cordially hated. Through it all he displayed remarkable consistency of purpose: he was a nationalist, devoted to the economic development and political integration of the United States.

The centerpiece of Clay's statecraft was an integrated economic program called "the American System." This envisioned a protective tariff, a national bank jointly owned by private stockholders and the federal government, and federal subsidies for transportation projects, termed "internal improvements." Clay was called "the Great Compromiser" because he played a major role in formulating the three landmark sectional compromises of his day: the Missouri Compromise of 1820, the Tariff Compromise of 1833, and the Compromise of 1850. Coming from the border state of Kentucky, he was predisposed toward moderation when sectional conflicts were involved, and his main objective was to avoid a civil war. But in this, as in so many of his more immediate goals, he was defeated.

Clay never became president, and his Whig party disappeared shortly after his death. But its successor, the Republican Party, put many features of the American System into operation. In the long run, his economic and political vision of America was largely fulfilled.

THOMAS BALL (1819–1911)
Daniel Webster, 1853

Bronze, 30 ¼ x 13 x 11 inches
Inscribed draped pedestal: T Ball sculp. Boston Mass 1853
Inscribed base, rear center: Ames Founder Chicopee Mass 23

Senator Daniel Webster (1782–1852) of Massachusetts and Robert Y. Hayne of South Carolina participated in the famous debate of January 19–27, 1830. The highly protective "Tariff of Abominations" of 1828 was the paramount sectional issue in the late 1820s. Southerners, who exported cotton and imported manufactured goods from Europe, paid higher prices on these manufactured items because of the tariff. Increasingly aware that the tariff failed to promote local manufacturing but still translated into profits for northeastern producers, southern politicians hoped to forge a sectional alliance to repeal the tariff. If westerners and southerners could agree to vote for low tariffs and cheap federal land, both regions would benefit economically.

Hayne proposed such an alliance between the South and West after Senator Thomas Hart Benton of Missouri denounced a pending proposal to restrict the sale of federal lands. Webster, a powerful voice for the northeastern manufacturing interests, responded to Hayne first by goading him into making a passionate claim for states' rights. Hayne blamed the Tariff of 1828 for economic difficulties in South Carolina. He argued that the federal Constitution was a compact among the states and raised the specter of nullification as an option for states harmed by federal action.

Hayne's remarks set the stage for Webster's famous reply. For two days, Webster held the floor and the attention of his colleagues and packed galleries. The Constitution was not a mere agreement of states, he said, but a compact of the American people guaranteeing freedom: "Liberty and Union, now and forever, on and inseparable!" With his impassioned rhetoric, Webster made the states' rights position look like treason, temporarily diffusing its potency.

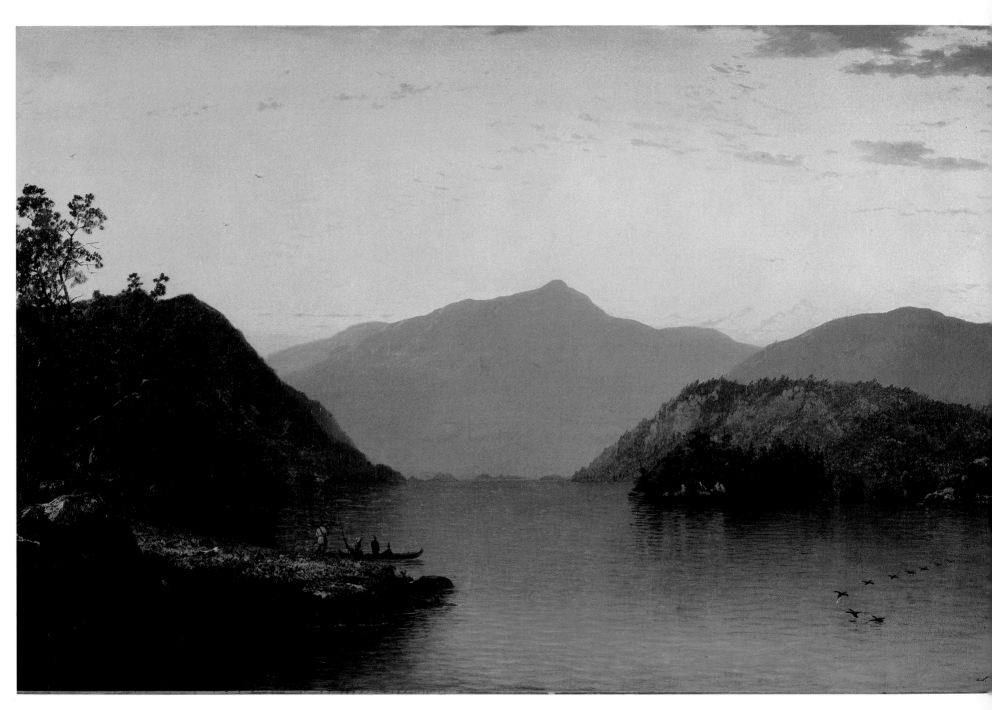

JOHN FREDERICK KENSETT (1816–72)
Lake George, 1858

Oil on canvas, 24 ¹/₈ x 36 ¹/₄ inches
Inscribed lower right: J F K 58

ALBERT BIERSTADT (1830–1902)
Afterglow "The Glory of the Heavens
Donner Lake," circa 1871

Oil on canvas, 26 x 36 inches
Inscribed lower right: A Bierstadt

JASPER CROPSEY (1823–1901)
Autumn on the River, 1877

Oil on canvas, 21 x 17 inches
Inscribed lower right: J F Cropsey 1877
Collection of Mr. and Mrs. Jack Warner,
Tuscaloosa, Alabama

ALBERT BIERSTADT (1830–1902)
Seal Rock, Farralon Islands, circa 1870

Oil on canvas, 37 x 58 inches
Inscribed lower left: A Bierstadt

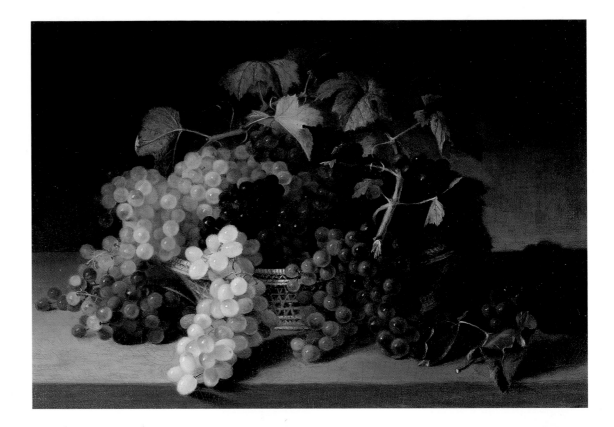

JAMES PEALE (1749–1831)
Arrangement of Grapes, 1829

Oil on canvas, 20 x 26 ³/₄ inches
Inscribed on reverse: Painted by James Peale
in the 80th year of his age

SEVERIN ROESEN (active 1848–71)
Still Life with Fruit, circa 1865

Oil on canvas, 36 x 50 ¹/₂ inches
Inscribed: S Roesen
Collection of Mr. and Mrs. Jack Warner,
Tuscaloosa, Alabama

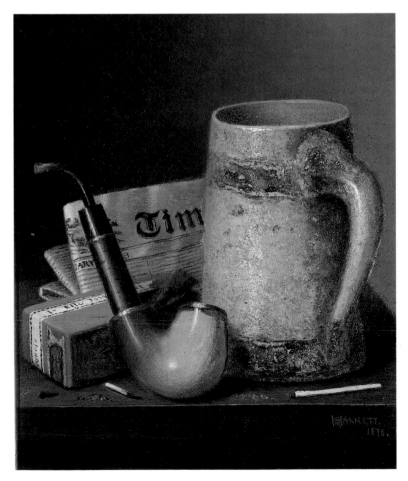

ABOVE

JOHN FREDERICK PETO (1854–1907)
Still Life with Oranges and Banana, circa 1880

Oil on panel, 5 x 10 inches

LEFT

WILLIAM M. HARNETT (1848–92)
Still Life, 1878

Oil on canvas, 12 x 10 inches
Inscribed: W M Harnett
Collection of Mr. and Mrs. Jack Warner, Tuscaloosa, Alabama

OPPOSITE

HIRAM POWERS (1805–73)
Fisher Boy, circa 1841

Marble, 19 x 12 x 10 inches

The year before he began work on The Greek Slave, Hiram Powers modeled the full-length figure Fisher Boy in his studio in Florence. He derived his forms from a living model, not an antique, classical sculpture as was the usual practice. Fisher Boy (Metropolitan Museum of Art) was the second completely nude male in American sculpture—the first is the figure of Orpheus in the sculpture Orpheus and Cerberus, 1843, by Thomas Crawford (1813–57) (Museum of Fine Arts, Boston). As with The Greek Slave and other full-length figures, bust portraits such as the example in the Warner collection were produced from the original plaster through the pointing process.

ABOVE

HIRAM POWERS (1805–73)
Proserpine, 1844

Marble, 25 x 19 ¹/₂ x 10 ¹/₂ inches
University of Alabama, gift of Mr. and Mrs. Jack Warner

LEFT

HIRAM POWERS (1805–73)
Eve Disconsolate, circa 1859

Marble, 22 ¹/₄ x 15 ¹/₂ x 9 ¹/₂ inches

ABOVE

GEORGE CATLIN (1796–1872)
Shooting Buffalo in the Snow, 1854

Oil on canvas, 19 ¼ x 26 ¾ inches
Inscribed lower left: Catlin 54

RIGHT

ALFRED JACOB MILLER (1810–74)
The Lost Greenhorn, 1851

Oil on canvas, 16 x 20 inches
Inscribed lower right: A Miller 1851

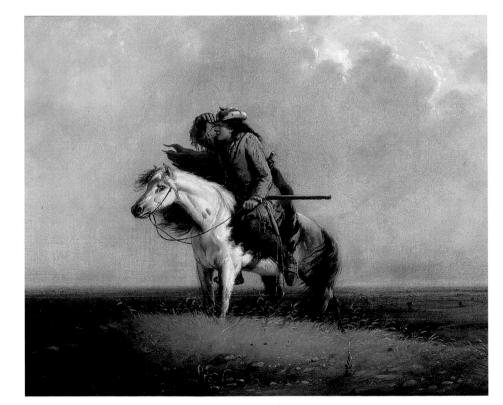

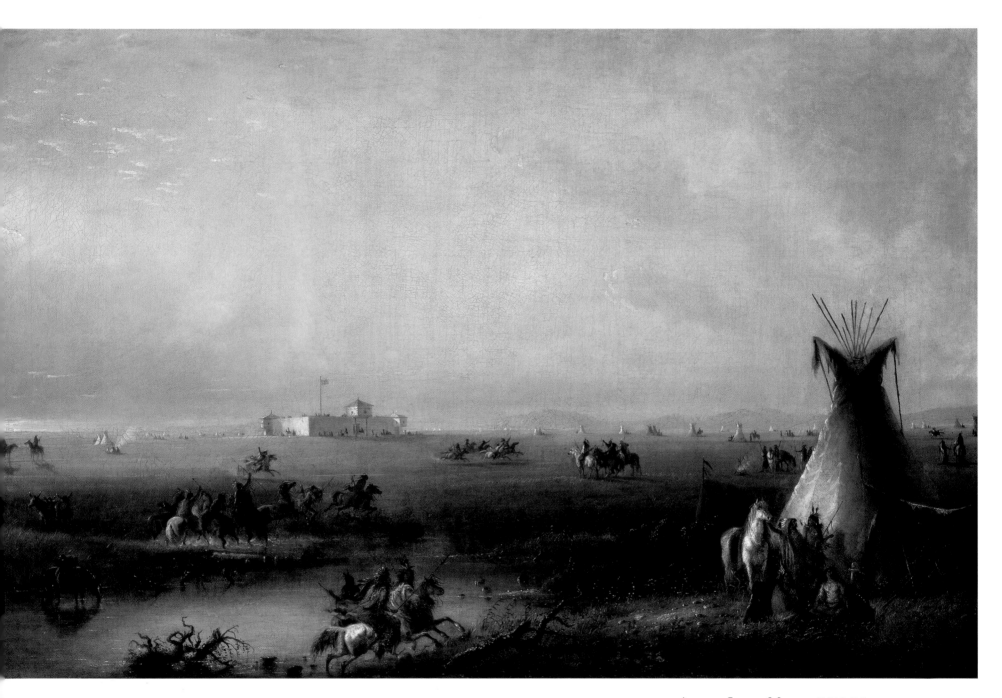

ALFRED JACOB MILLER (1810–74)
Racing at Fort Laramie, 1868

Oil on canvas, 31 x 48 inches
Inscribed: A J Miller
Collection of Mr. and Mrs. Jack Warner,
Tuscaloosa, Alabama

119

ABOVE

JOHN MIX STANLEY (1814–72)
The Abduction, 1847

12 ¹/₂ x 17 ¹/₂ inches
Inscribed lower left: Stanley 1847 California

RIGHT

JOHN MIX STANLEY (1814–72)
Indian Telegraph, 1847

Oil on canvas, 21 x 31 inches
Inscribed lower right: John Mix Stanley 1847

120

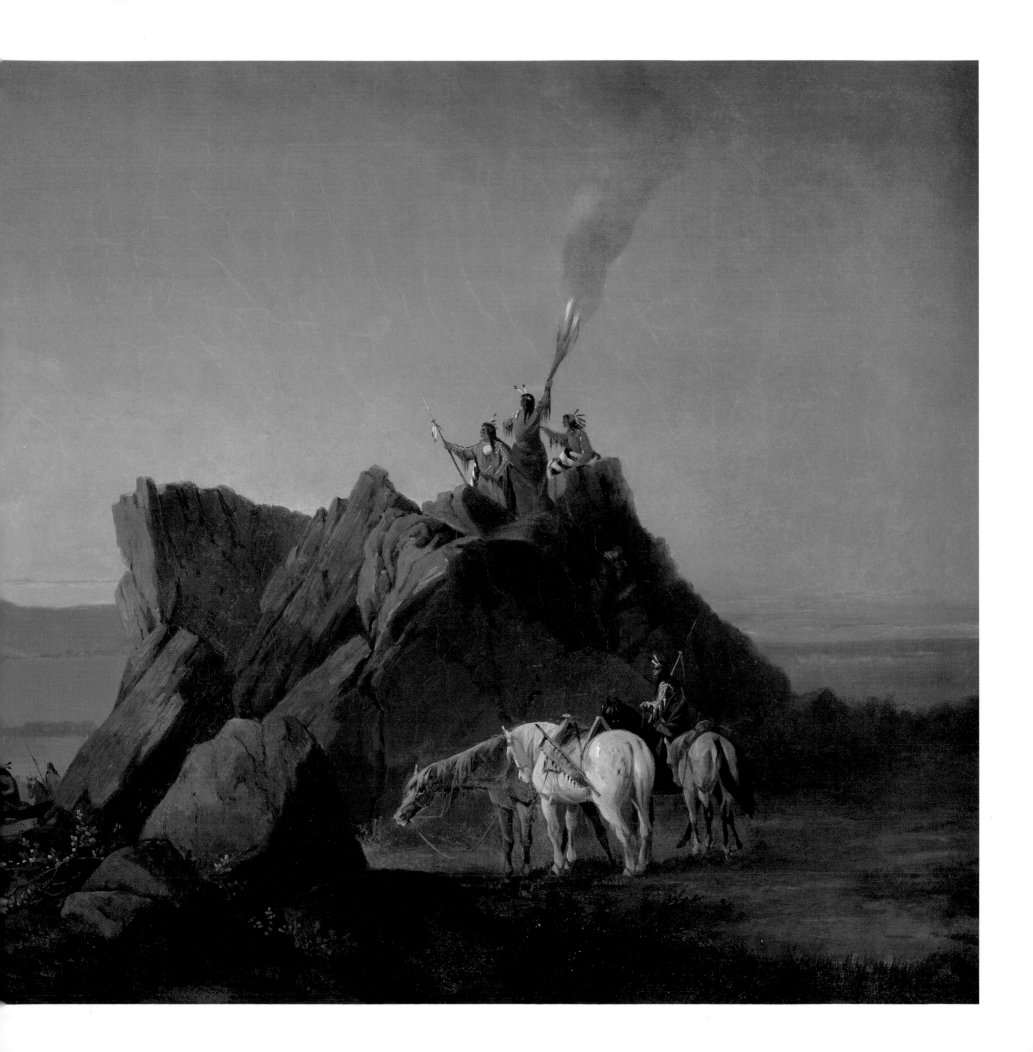

CHARLES WIMAR (1828–63)
Funeral Raft of a Dead Chieftain, 1856

Oil on canvas, 11 ¼ x 16 inches
Inscribed lower right: Charles Wimar 1856

WORTHINGTON WHITTREDGE (1820–1910)
Indian Encampment on the Platte River, 1868

Oil on canvas, 22 ¾ x 33 ½ inches
Inscribed lower left: W Whittredge, 1868
Collection of Mr. and Mrs. Jack Warner,
Tuscaloosa, Alabama

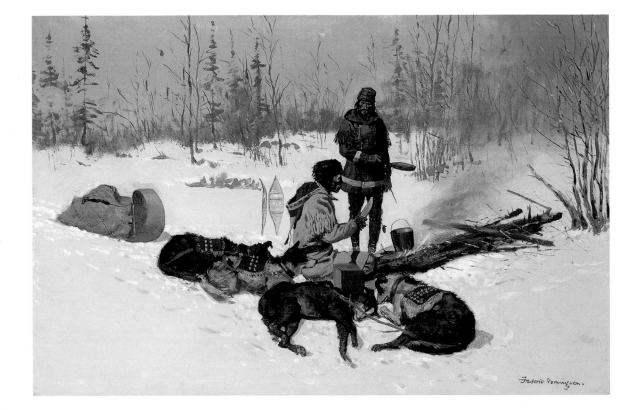

ABOVE

FREDERIC REMINGTON (1861–1909)
Noonday Tea, 1895

Oil on canvas, 27 x 40 inches
Inscribed lower right: Frederic Remington

RIGHT

VALENTINE W. BROMLEY (1848–77)
The Scalping, 1876

Oil on canvas, 48 x 60 inches
Inscribed lower left: V W Bromley 1876

GEORGE DE FOREST BRUSH (1855–1941)
The Shield Maker, 1890

Oil on canvas, 11 x 16 inches
Inscribed lower left: Geo de F Brush 1890

ABOVE

THOMAS MORAN (1837–1926)
Green River in Wyoming, 1899

Oil on canvas, 10 x 14 inches
Inscribed lower right: T Moran 1899

RIGHT

WILLIAM TROST RICHARDS (1833–1905)
Mackerel Cove, Jamestown, Rhode Island, 1894

Oil on canvas, 26 ¹/₄ x 47 inches
Inscribed lower left: W T Richards '94

THE COSMOPOLITAN PERSPECTIVE

ELLA M. FOSHAY

Jack Warner's first encounter with Edward Hopper's 1934 painting *Dawn Before Gettysburg* was personal, emotional, intense. He reported:

> From the first time I saw it I was completely mesmerized! Tears literally welled up in my eyes. The ten soldiers have marched all night and have just received their orders of battle. Their bellies are churning. They are all scared. It could be North, South, East, or West. It portrays the universal foot soldier and the tragedy of war. It is truly a masterpiece.

In *Dawn Before Gettysburg*, a history painting, Hopper calls up the memory of the Civil War's bloodiest battle, which took place in July 1863 near the small Pennsylvania crossroads town of Gettysburg. Almost a third of those engaged—fifty-one thousand men—were lost. Fifty years after the battle, the shattering sounds of men and horses engaged in violent combat rang clear in the memory of a private from Massachusetts. "The hoarse and indistinguishable orders of commanding officers, the screaming and bursting of shells, canister and shrapnel as they tore through the struggling masses of humanity, the death screams of wounded animals, the groans of their human companions, wounded and dying and trampled underfoot by hurrying batteries, riderless horses and moving lines of battle," he recalled. It was "a perfect hell on earth."

This is not the Gettysburg that Hopper re-creates. His painting is not of violent action but of quiet anticipation. It is precisely the emotional containment of the scene that provoked the visceral anguish Warner experienced. Nine soldiers are seated on a grassy bank along a dirt road in front of a simple white pitched-roof house. The yard is enclosed by a classic American white picket fence. A tenth soldier stands guard, his glance averted down the road. There is a stillness in the air as the blue light of dawn bathes the entire scene in a cool wash of pathos. The soldiers are individualized only by the ordinary activities in which they are engaged. Most are

129

slouched over, resting, dozing, or thinking. One figure has fallen asleep, his head supported on the shoulder of his companion. Another bends to tie his shoe. Perhaps Hopper knew that this great battle began as a clash over shoes. There was rumored to be a large supply of shoes in Gettysburg, and Confederate general Richard S. Ewell approached the town to commandeer them for his footsore men. Hopper captures the horror of war in the tying of a shoe; or as Warner noted, the artist conveys the universal in the particular. The tragedy of war, the inevitable suffering and death it entails, is expressed indirectly. It emerges from what the artist does not show.

The unified spirit of optimism that characterized America before the Civil War was shattered by this divisive and destructive confrontation. At the conclusion of four years of conflict, the national identity, so freshly wrought, was shaken. The United States emerged almost as a different nation. Mark Twain and Charles Dudley Walker described the transformation in *The Gilded Age: A Tale of Today* (1873):

The eight years in America from 1860 to 1868 uprooted institutions that were centuries old, changed the politics of a people, transformed the social life of half the country, and wrought so profoundly upon the entire national character that the influence cannot be measured short of two or three generations.

The spirit of disillusionment gradually diminished as growth in many areas brought America increased prosperity. Population, territory, and economic wealth expanded. Technological progress reverberated at home and abroad. The Central Pacific and Union Pacific Railways were united at Promontory Point in Utah in 1869, the same year that the Suez Canal was completed. The Brooklyn Bridge opened for traffic in 1883, and the Eiffel Tower, the first structure built entirely of iron, rose above Paris in time for the 1889 World Exposition. International trade and travel lured American artists abroad in search of sophistication and inspiration. Although American by birth, James McNeill Whistler was a thoroughly continental artist. The focus on developing a native art on American soil gave way to a more cosmopolitan view. American artists traveled and studied abroad and sometimes stayed there. The elusive abstraction of Whistler's *Harmony in Blue and Pearl: The Sands, Dieppe* derives from exposure to a wide variety of European art movements from Impressionism to Aestheticism. American art was to become a player on the world stage.

JAMES MCNEILL WHISTLER (1834–1903)
Harmony in Blue and Pearl: The Sands, Dieppe,
circa 1885

Oil on panel, 9 x 5 ¹/₂ inches
Inscribed lower right: artist's butterfly monogram

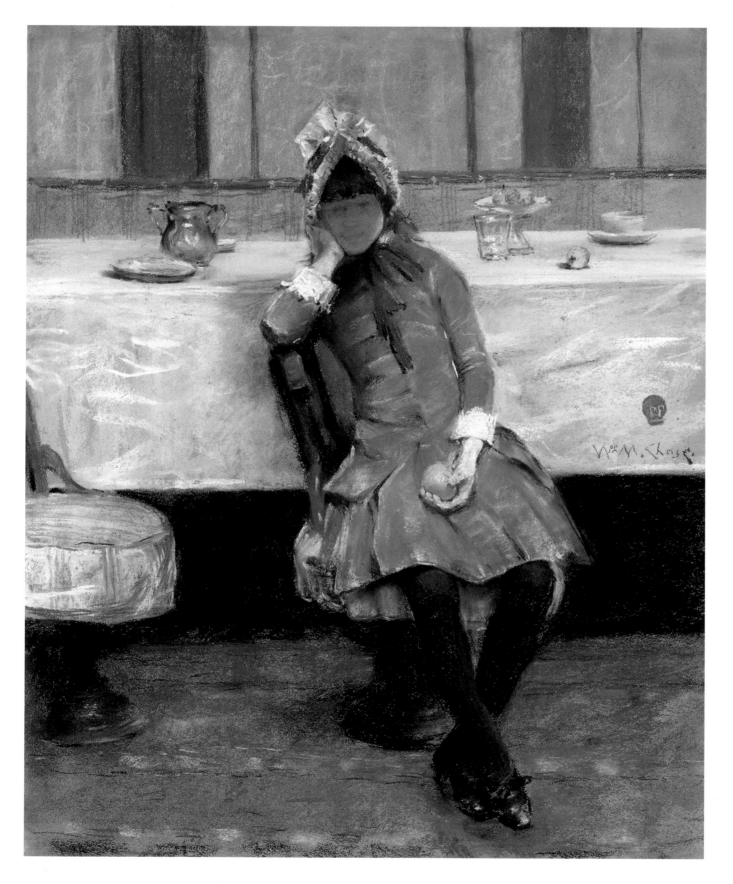

WILLIAM MERRITT CHASE
(1849–1916)
Young Girl on an Ocean Steamer,
circa 1884

Pastel on paper, 29 x 24 inches
Inscribed right edge center:
Wm M Chase

William Merritt Chase was an artist from Franklin, Indiana, who, after his first trip to Europe in 1872, traveled back and forth between continents regularly until 1900. He studied art in Munich, Amsterdam, Venice, Paris, and Madrid and became one of the most influential and important American artistic personalities of the late nineteenth century. His styles were both virtuosic and eclectic. It was on his return from Holland in 1884 to visit his friend the painter Robert Blum that Chase painted *Young Girl on an Ocean Steamer*. The artist represents a pretty young girl seated before a sparsely set dining table and holding in her hand an orange, a fruit brought by Portuguese travelers from India to Europe in the 1400s and subsequently by Christopher Columbus to America. The expression on her face is obscured; there is little evidence of story or moral lesson. It is the sumptuous interior, the vivid red dress with its delicate white-lace cuffs, and the bravura brushwork of the artist that engage the viewer. The subject of the painting is transatlantic travel, especially in the first-class salon. Chase, who achieved widespread fame and success from his art, epitomized the new cosmopolitan focus of the period in his flamboyant and sophisticated personal life-style. He owned the biggest of the studios in the celebrated Tenth Street Studio building in Manhattan. Along with his wolfhound and birds, he surrounded himself there with exotic bric-a-brac from around the world. His collections of European art, brass pots, musical instruments, Renaissance chests, oriental screens and rugs, artware pottery, and lavish textiles often appear as props in his paintings. So proud was Chase of his possessions that he recorded them in lavish detail in an 1880 painting he made of his studio.

Chase was only one of many artists of the period who traveled widely and absorbed an affinity for foreign cultures. Taste for the art of the Far East arrived in the United States in the wake of Commodore Matthew Perry's 1850s visit to Japan and the published reports of his journeys. Hokusai prints began circulating in exhibitions in the 1860s, the decade in which the Japanese embassy opened in New York. Chase's friend Robert Blum visited the Japanese Pavilion at the Philadelphia Centennial Exhibition in 1876, and the interest in Japanese art kindled there eventually resulted in a two-and-a-half-year stay in Japan starting in 1889. *Scribner's* commissioned Blum to create pastels and drawings for *Japonica* by Sir Edwin Arnold, which appeared in serialized form in the magazine. His small oil painting *The Picture Book*, circa 1890, created during his Japanese sojourn, shows a kimono-clad Japanese girl lying down on the floor with head in hands, absorbed in contemplation of an illustrated book. In much the same way, Japanese prints held the rapt attention of such American artists as Blum, John La Farge, and Whistler.

Born in Florence of American parents, John Singer Sargent was one of many later nineteenth-century American painters who responded to the call of Italy. Italy had also been a mecca to Thomas Cole and other Hudson River School painters. For

Cole, Italy was the land of poetry, history, and culture. He was drawn to those "glorious scenes of the old world—that ground which has been the great theatre of human events—those mountains, woods and streams, made sacred in our minds by heroic deeds and immortal song—over which time and genius have suspended an imperishable halo." Broken aqueducts and ruined temples evoked, for him, the grandeur of earlier civilizations. They were repositories of the past. "To speak of Italy," said Cole, is "to call up the desire to return."

Sargent was attracted to the artistic possibilities of life in Italy. When he was eighteen, his parents moved the family to France, where Sargent trained for five years with Emile Carolus-Duran, the leading portrait painter at the time. In 1878 a twenty-two-year-old Sargent visited Naples and the island of Capri and discovered there "all that one can dream for beauty and charm." His painting *Capri* celebrates not the heroic past but the exotic present. It represents two gypsy women on the white stucco roof of a classic southern Mediterranean villa; one woman plays the tambourine and the other dances the tarantella. However, Sargent did not happen upon this picturesque scene and imprint it on canvas. The women were models, employed by Sargent to pose for the painting. The artist wanted to re-create the seductive pleasures available in Italy to leisure-class American travelers like himself. One of those travelers was Sargent's close friend the writer Henry James. James visited Capri in 1900 and summed up the evocative quality of the island: "beautiful, horrible, haunted; that is the essence of what, about itself, Capri says to you."

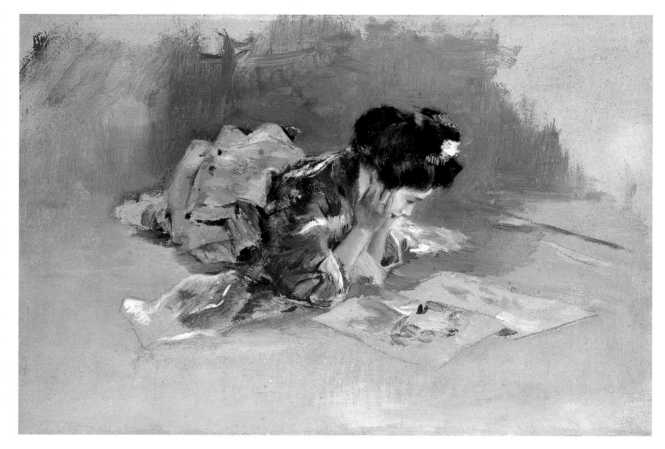

ROBERT BLUM (1857–1903)
The Picture Book, circa 1890
Oil on wood panel, 6 ¹/₂ x 9 ¹/₄ inches

It was the exotic tropical zones that lured the artist Martin Johnson Heade on extensive travels. Starting in the 1860s, he made three trips to South America. Brazil in particular was the ideal place to pursue the study of natural history. "There is probably no country where a person interested in ornithology, entomology, botany, mineralogy or beautiful scenery," wrote the artist, "could find so much to keep him enter-

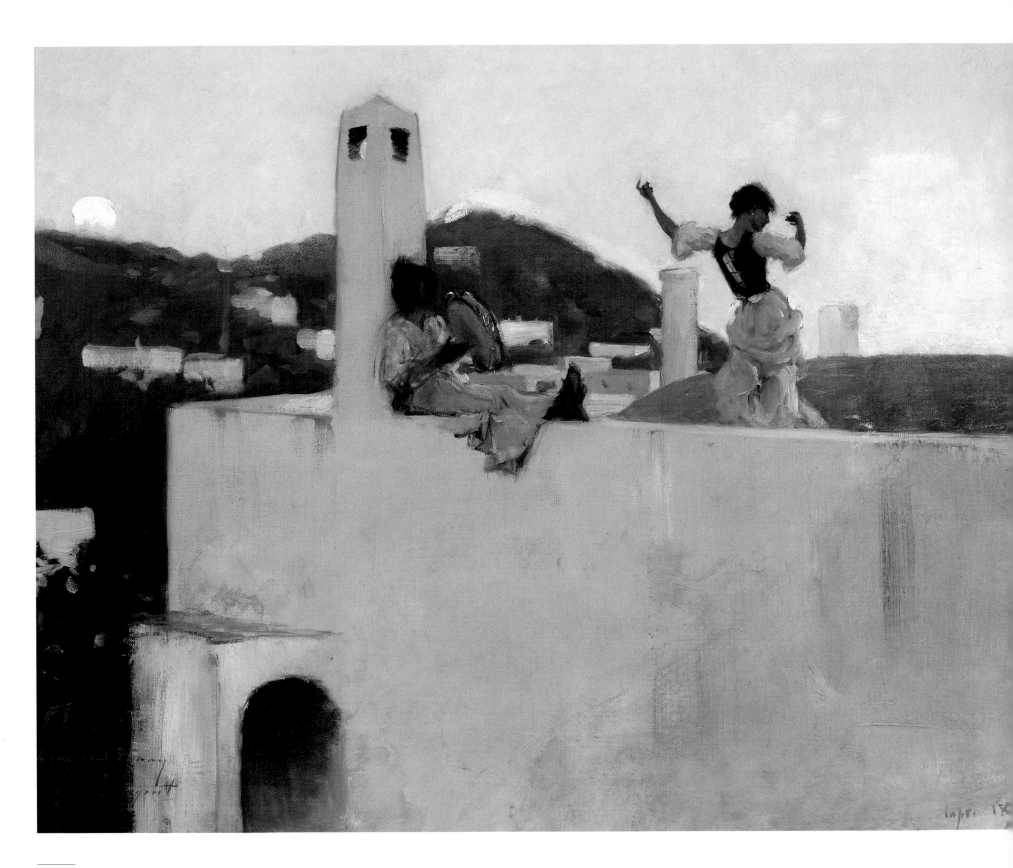

tained." Heade was a self-described "monomaniac" about hummingbirds. He was familiar with Audubon's publications on the birds of America, based on paintings from life. He had also studied John Gould's five-volume monograph on hummingbirds. Gould produced chromolithographs of the birds based on drawings made in England entirely from specimens and reproductions. Heade may have wanted to improve on Gould's chromolithographs by adopting Audubon's approach to nature painting—painting directly from life. Damning Gould's work with faint praise, Heade said Gould's "great work on the hummingbirds of South America was not made up from personal knowledge of their character and habits, but gathered from travelers and explorers. He never set his foot on South American soil, the habitat of this large family of birds." Whatever the motivation, it was the pursuit of these birds that drew Heade's attention to the magnificent tropical orchids of Brazil. By combining these subjects, he created a unique body of work featuring hummingbirds and orchid plants. The example of Heade's work in the Warner collection, *Two Hummingbirds by an Orchid*, 1875 (a magnificent combination of a male and female ruby-throated hummingbird and a cattelya orchid), shows nature in action. The birds interact with each other, and the flower bursts forth from the winding tendrils of a growing plant. The orchid plant itself is firmly attached to a tree trunk in its native habitat—a tropical forest. This dynamic interactive image of nature corresponds to the evolutionary view of the natural world that had been proposed in Charles Darwin's 1859 publication *On the Origin of Species by Means of Natural Selection; or, The Preservation of Favoured Races in the Struggle for Life*. Subsequent publications by Darwin were specifically devoted to the study of the reproductive contrivances of Orchidaceae. Darwin seems almost to have been describing Heade's *Two Hummingbirds by an Orchid* when he wrote in the *Origin of Species*:

> It is interesting to contemplate an entangled bank, clothed with many plants of many kinds, with birds singing in the bushes, with various insects flitting about, and with worms crawling through the damp earth, and to reflect that these elaborately constructed forms, so different from each other, and dependent on each other in so complex a manner, have all been produced by laws acting around us . . . and that,

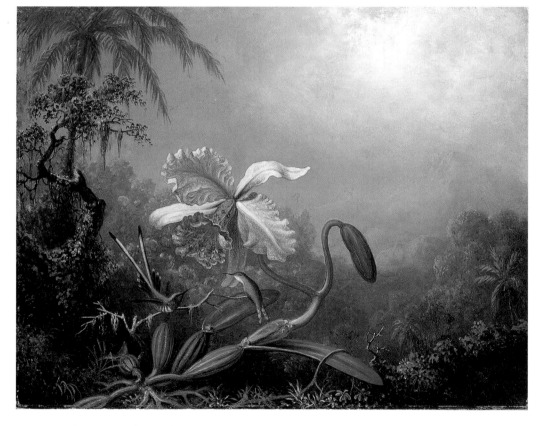

MARY CASSATT (1844–1926)
Denise and Child, circa 1905

Oil on canvas, 39 ½ x 29 inches
Inscribed lower right: Mary Cassatt

136

whilst this planet has gone cycling on according to the fixed law of gravity, from so simple a beginning endless forms most beautiful and most wonderful have been, and are being, evolved.

Domestic themes, especially images of women and children, remained popular throughout the nineteenth century, both in America and abroad, and they form a continuous theme in Jack Warner's collection. Henry T. Tuckerman, the critic of and for his age, considered the child the solace of art and life. In an 1867 article, he wrote:

> Always and everywhere the image of childhood to poet and painter, to the landscape, the household, the shrine, the temple and the grave . . . is a redeeming presence, a harmonizing and hopeful element, the token of what we were, and the prophecy of what we may be.

Although she never married or had children of her own, Mary Cassatt is best known for her images of women engaged in domestic activities, particularly mothers tending their children. Although her domestic themes were traditional, as would befit the daughter of a wealthy and socially prominent Philadelphia family, as an artist Cassatt gravitated to the avant-garde. During the late 1870s in Paris, she became involved with the Impressionist circle of revolutionary painters. The saturated color of Cassatt's oil painting *Denise and Child*, circa 1905, with its intense yellow and green hues spilling over into the flesh tones of the nude figure of the child, reflects Cassatt's engagement with the color and light experiments of the French plein air painters. However, the full-bodied, three-dimensional solidity of the figures represents the continuation of her classical academic training at the Pennsylvania Academy of the Fine Arts. There is also an emotional directness that differentiates her work from that of Edgar Degas, her French mentor. The palpable maternal affection between Denise and her daughter takes on a spiritual dimension. The work can be seen as a modern-day Virgin and Child. The artist demonstrates her more

MARY CASSATT (1844–1926)
Bare Footed Child, circa 1898

Dry point and aquatint, 9 x 5 inches
Inscribed lower right in pencil: Mary Cassatt

137

experimental approach to form in printmaking, particularly in the aquatint technique, which she learned from James McNeill Whistler. In the engraving *Bare Footed Child*, circa 1898, she plays more on the tension between drawing and color, flatness and depth, abstraction and illusion, than on the expression of emotion.

Albert Herter, a painter of the Aesthetic Movement, takes a neutral position in his depiction of a family of women in his *Family Group*, painted about the same time as Cassatt's *Bare Footed Child*. Charmed by the exoticism of fifteenth-century primitive paintings and tapestries, Herter produced furniture and tapestries in addition to paintings, and the flat, abstract style of his painting may reflect his affinity for two-dimensional decoration. In *The Family Group*, the landscape setting, with its tree trunks and blanket of red blossoms, suggests the pattern of a woven textile. The five female figures are decoratively aligned and emotionally detached. The effect is of a tableau, a scene frozen in a timeless space.

It was a group of painters called "the Eight" who returned the focus of American painting to "an American story out of American facts, portrayed with true American feeling," so much admired in Durand's 1853 painting *Progress*. But it was a new set of facts, and the feelings they evoked were different. These artists painted topics from urban life that reflected the shift in population from country to city as a result of the industrial revolution. In their view, authentic American life was the grit and grime of the city and the people who lived there. Working-class activities gained heroic authenticity.

George Luks, a member of the revolutionary group that exhibited together at the New York Macbeth Gallery in 1908, grew up in a Pennsylvania mining district. He identified closely with the day-to-day life of American workers and treated them in his painting with the same directness he brought to his work as an artist-reporter for the *Philadelphia Evening Bulletin* and later newspapers in New York City. Luks's painting in the Warner collection, *In the Corner*, 1920–21, captures the whisper of a childhood secret. Two children stand close to each other in the corner of a picture gallery. The proximity allows the more finely clad child, in red dress and hat, to whisper into

ALBERT HERTER (1871–1950)
The Family Group, circa 1898

Watercolor and gouache on paper, 15 x 11 ¹/₂ inches
Inscribed lower right: Albert Herter

the ear of her less fortunate companion and provoke merriment. The expression of real human connection between these two children, so far removed from Herter's emotionally neutral female family members, reflects George Luks's desire to capture the vitality of personal contact in urban life. He eschewed sentiment and emphasized a reportorial approach. He followed the directive of the critic Charles W. Larned, who encouraged artists to "go out into the highways of life, and paint us the tragedies, the comedies, beauties, hopes, aspirations and fears that live; bring in the poor, and the maimed, and the halt, and the blind, with the rest, and let us see the panorama of life more before us." But European traditions played a role even in these local American subjects. An admirer of the Dutch artist Frans Hals, whose works he had studied while traveling abroad, Luks adopted the robust brushstrokes and earth tones of the European master of everyday life for his contemporary vision of life in the streets of early-twentieth-century New York City. Luks also heeded the advice of Ralph Waldo Emerson: "Though we travel the world over to find the beautiful, we must carry it with us or we find it not." (Coincidentally, Emerson's words are engraved on a plaque in the Golf Club at NorthRiver; no doubt they resonate with Jack Warner's life-long travels, beginning with his military service in the Far East.)

By the twentieth century, American artists embraced the world of art and incorporated it into their native vision. Warner responds to the works produced by American artists of three centuries, to their constantly unfolding panorama of American history and life. Collectively these works give him the sensation of being "swept across the spacious land in one broad emotional wave." The love of art has had a profound effect on Jack's experience of life. It intensifies his senses. Through his relationship to the works of art he collects, Jack Warner learns to see and feel his surroundings more acutely: "You become more observant of beauty . . . the way the soft evening light hits the trunks of trees in the forest."

GEORGE LUKS (1866–1933)
In the Corner, 1920–21

Oil on panel, 48 x 37 inches
Inscribed lower right: George Luks

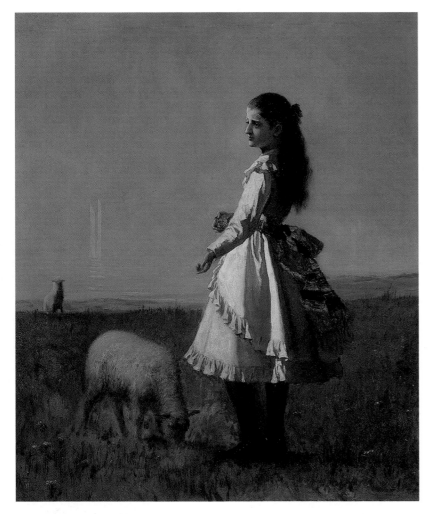

ABOVE

EASTMAN JOHNSON (1824–1906)
Girl in Landscape with Two Lambs, 1875

Oil on board, 26¹/₄ x 21¹/₄ inches
Inscribed lower right: E Johnson

OPPOSITE

FREDERICK C. FRIESEKE (1874–1939)
Sunspots, circa 1915

Oil on canvas, 28 ³/₄ x 36 ¹/₂ inches
Inscribed lower right: F C Frieseke

FINE ARTS II

Human activities, both private and public, take center stage in many of the works in the Warner collection, notably those dating from the mid-nineteenth century until well into the twentieth. The diversity of genres—portrait, landscape, and still life, as well as narrative scenes and historical subjects—reflects the growing sophistication of culture in America, as travel exposed artists to a wide range of influences.

Within the profusion of human figures, images of girls and young women, pictured indoors and out, dominate. They are engaged in such pastoral occupations as tending lambs in Eastman Johnson's *Girl in Landscape with Two Lambs,* gathering bouquets in Winslow Homer's *Picking Flowers,* playing in the surf in Edward Henry Potthast's *Children Playing at the Beach,* or just complementing the setting with their physical beauty in Frederick Frieseke's *Sunspots.* Male subjects play fewer roles. In *A Friendly Game* Julian Scott portrays Union soldiers engaged in an intellectual competition. They are matching wits in a game of cards during time off from the front lines of the Civil War. Constant Mayer portrays the grief of combat in *Recognition.* Such images demonstrate the significance of the human dimension and the variety of roles individuals play as participants in the maturity of the nation they inhabit.

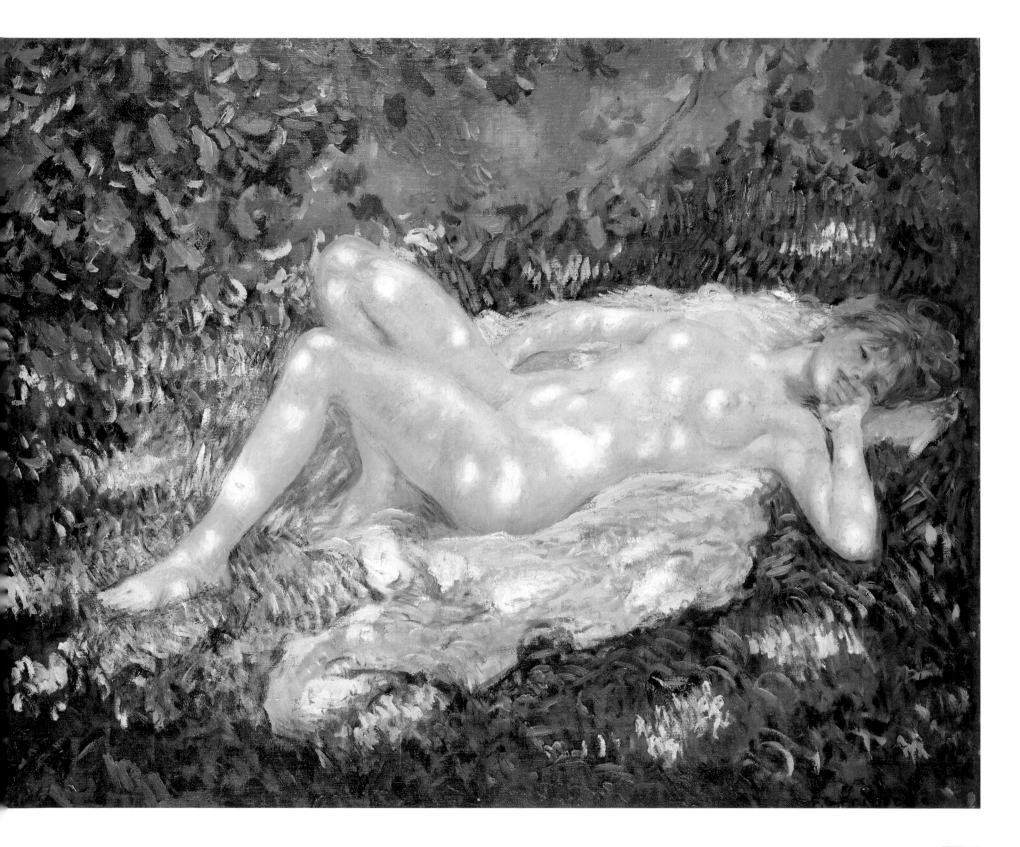

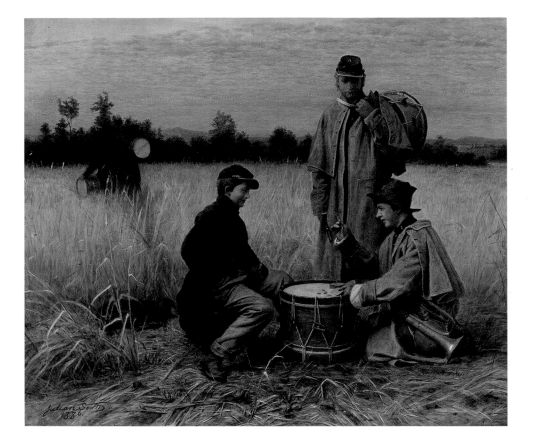

ABOVE

JULIAN SCOTT (1846–1901)
A Friendly Game, 1886

Oil on canvas, 20 x 24 inches
Inscribed lower right: Julian Scott 1886

RIGHT

CONSTANT MAYER (1831–1911)
Recognition, 1865

Oil on canvas, 68¼ x 93½ inches
Inscribed lower left: Constant Mayer 1865

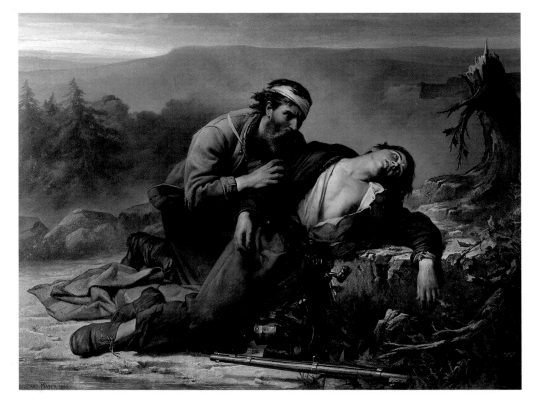

WINSLOW HOMER (1836–1910)
Sailboats off the Coast of Ten Pound Island, 1880

Watercolor on paper mounted on board,
9 ³/₈ x 13 ³/₈ inches
Inscribed: Winslow Homer
Collection of Mr. and Mrs. Jack Warner,
Tuscaloosa, Alabama

WINSLOW HOMER (1836–1910)
Picking Flowers, circa 1881

Watercolor, gouache, and pencil on paper,
10 x 16 ¹/₂ inches
Inscribed: Homer
Collection of Mr. and Mrs. Jack Warner,
Tuscaloosa, Alabama

ABOVE

WINSLOW HOMER (1836–1910)
A High Sea, 1894

Charcoal on paper, 14 ³/₄ x 23 ¹/₄ inches
Inscribed: Winslow Homer
Collection of Mr. and Mrs. Jack Warner, Tuscaloosa, Alabama

RIGHT

WINSLOW HOMER (1836–1910)
The Backrush, circa 1895

Oil on canvas, 22 x 29 inches
Collection of Mr. and Mrs. Jack Warner, Tuscaloosa, Alabama

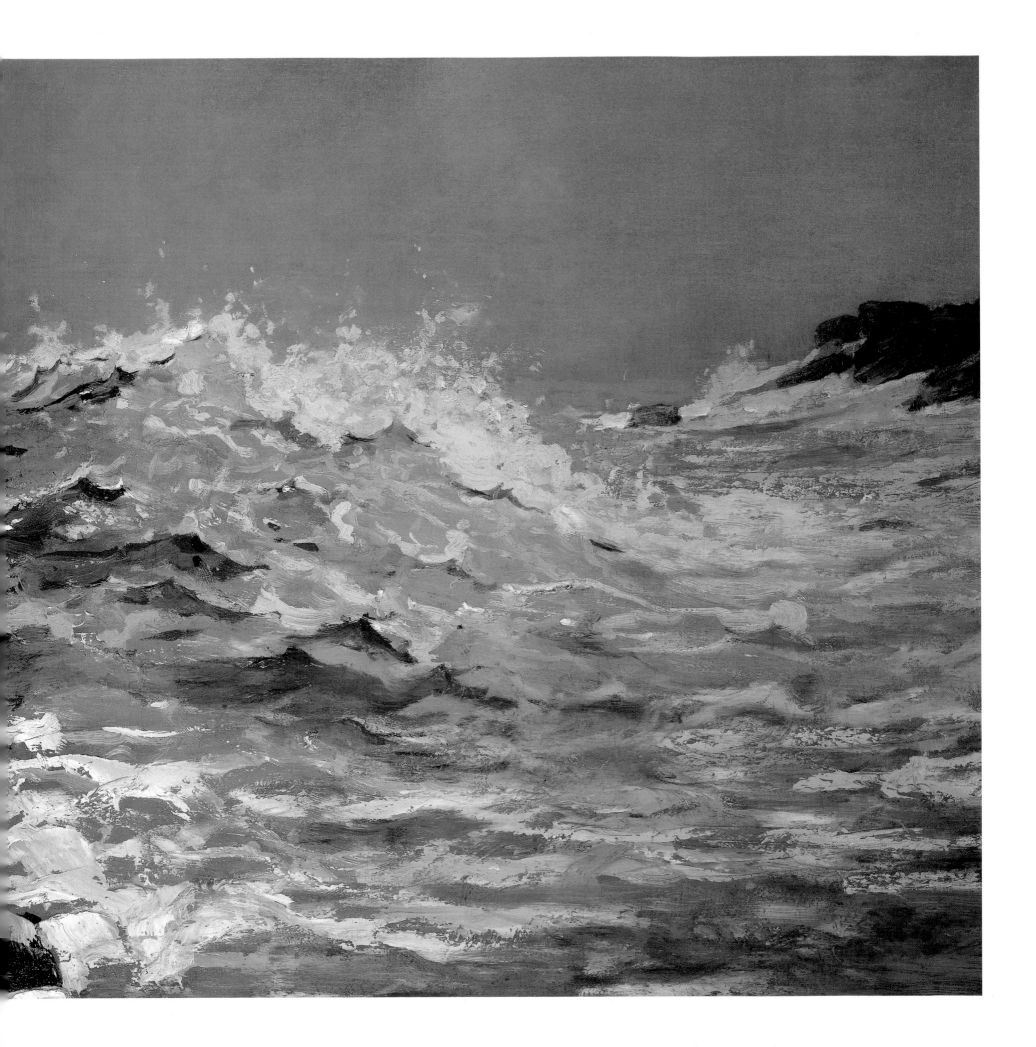

WILLIAM AIKEN WALKER (1839–1921)
Plantation Economy in the Old South,
circa 1876

Oil on canvas, 22 x 42 inches
Inscribed lower left: W A Walker

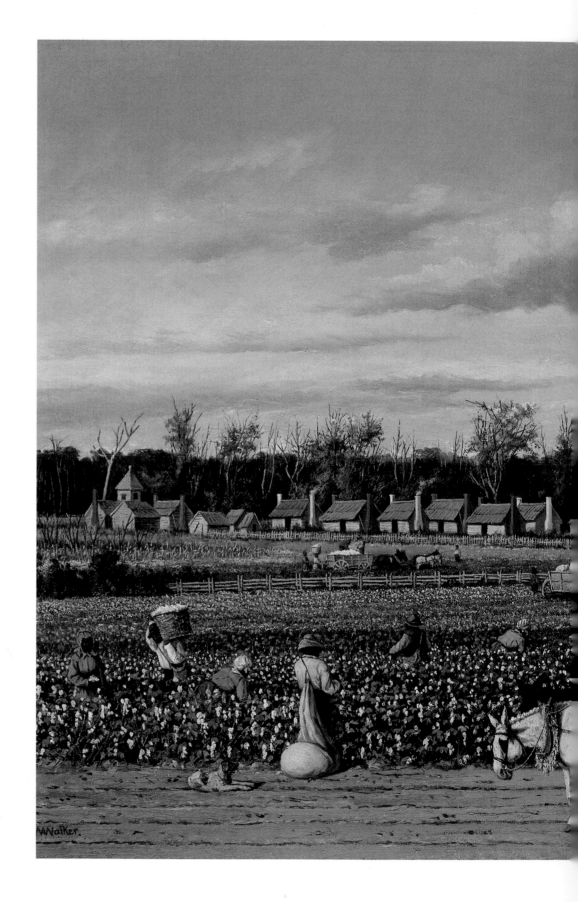

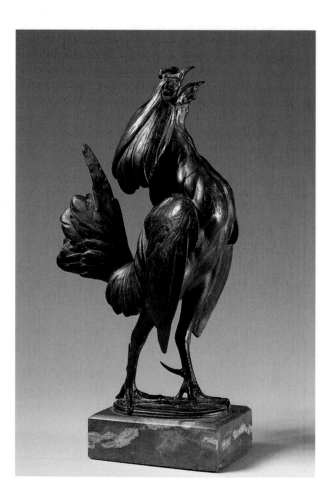

ABOVE

ALFRED LAESSLE (1877–1954)
Chanticleer, 1912

Bronze, 16 x 8 ¼ x 5 ¾ inches
Inscribed: ALFRED LAESSLE 1912 PHILA.

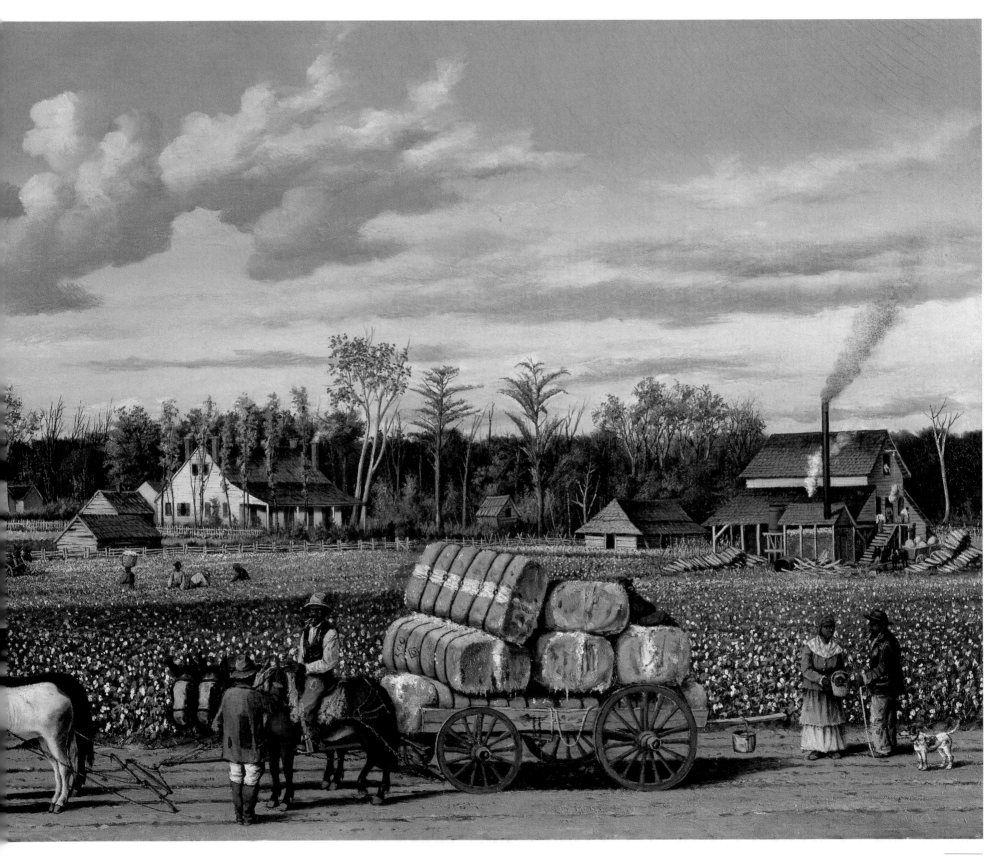

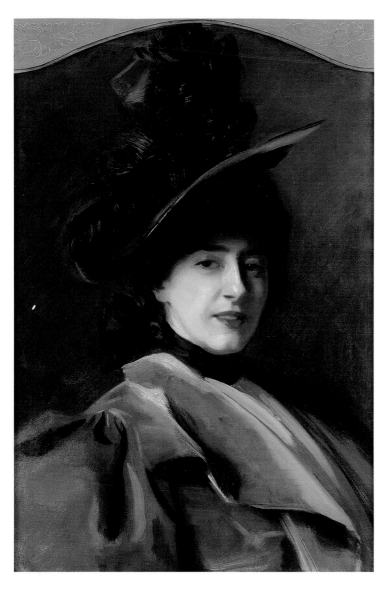

ABOVE

JOHN SINGER SARGENT (1856–1925)
Portrait of Mme. Flora Reyntiens, circa 1895

Oil on canvas, 29 x 20 inches
Inscribed upper left: Mme Reyntiens
Inscribed upper right: John S Sargent

RIGHT

ROBERT HENRI (1865–1929)
Marjorie in a Yellow Shawl, 1909

Oil on canvas, 77 x 38 inches
Inscribed lower left: Robert Henri

The subject is the artist's wife. The painting was included in the Exhibition of Independent Artists in New York City in 1910.

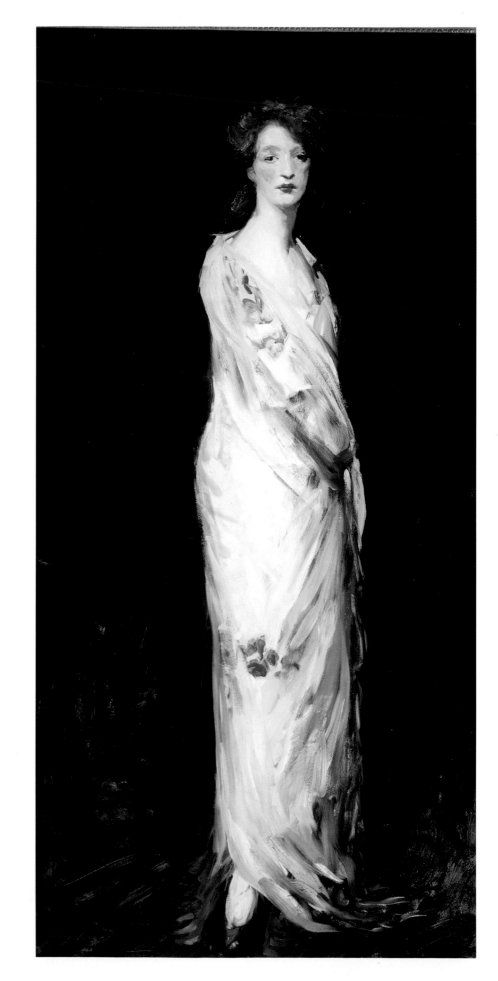

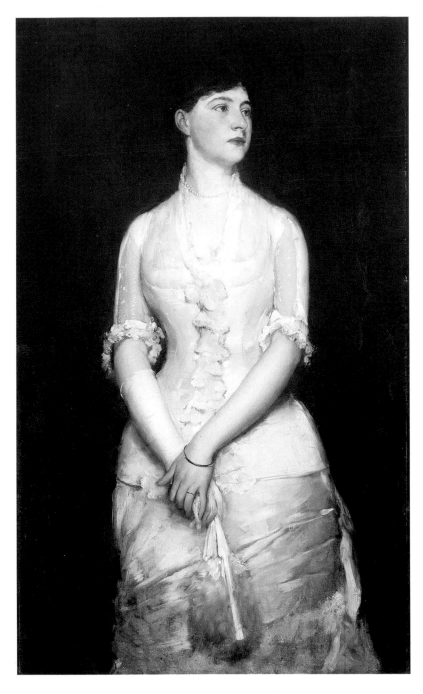

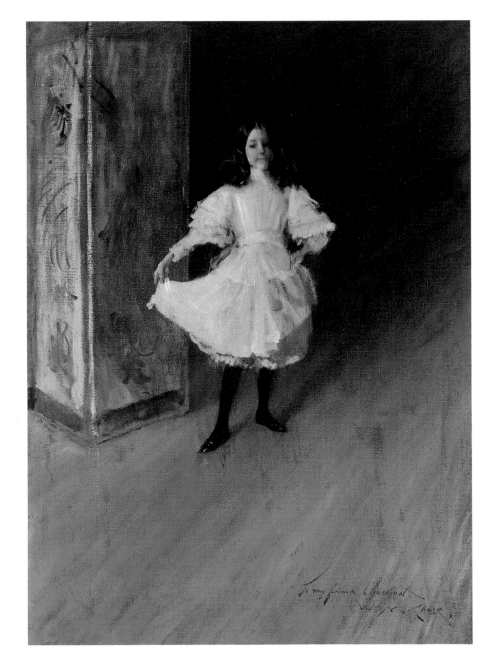

ABOVE

FRANK DUVENECK (1848–1919)
Miss Blood, 1880

Oil on canvas, 48 x 28 inches
Inscribed upper left: F D
Inscribed upper right: Venice 1880

RIGHT

WILLIAM MERRITT CHASE (1849–1916)
Portrait of the Artist's Daughter, Dorothy, circa 1897

Oil on canvas, 35 ¹/₂ x 25 ¹/₂ inches
Inscribed lower right: To my friend Klinedienst, Wm M Chase

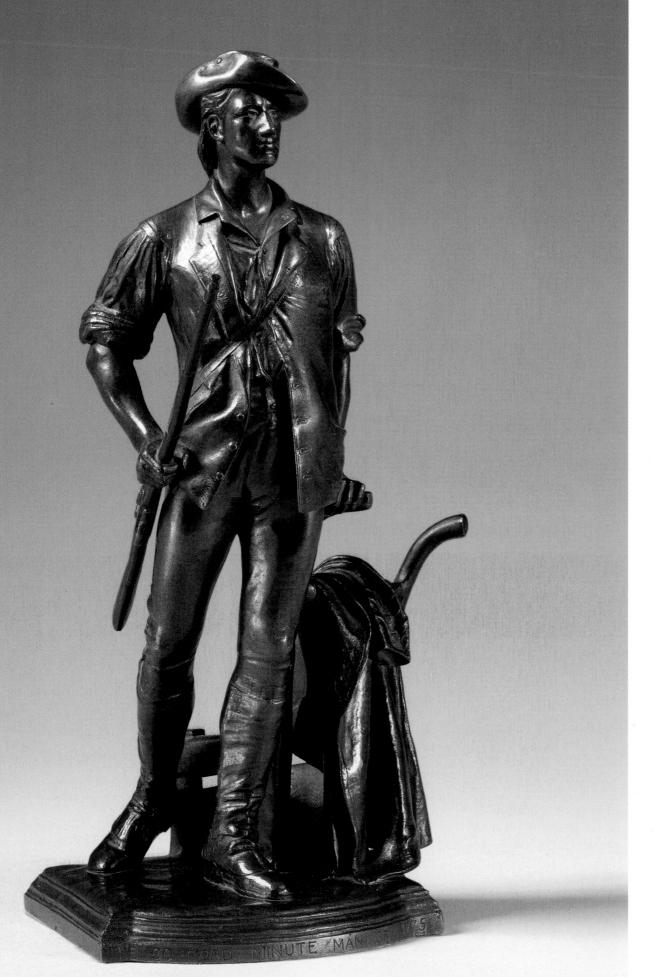

DANIEL CHESTER FRENCH
(1850–1931)
Minute Man, 1889

Bronze, 13 ¹/₂ x 7 x 7 ¹/₂ inches
Inscribed base, rear right: Gorham Co
Founders GACQ500
Inscribed base, front: The Concord
Minute Man of 1776

HERMON ATKINS MACNEIL
(1866–1947)
The Sun Vow, circa 1898

Bronze, 35 ¹/₂ x 25 x 16 inches
Inscribed base, front right: The Sun Vow
Inscribed base, rear left: Bureau Bros
Bronze Founders
Inscribed base, rear right: H A MacNeil

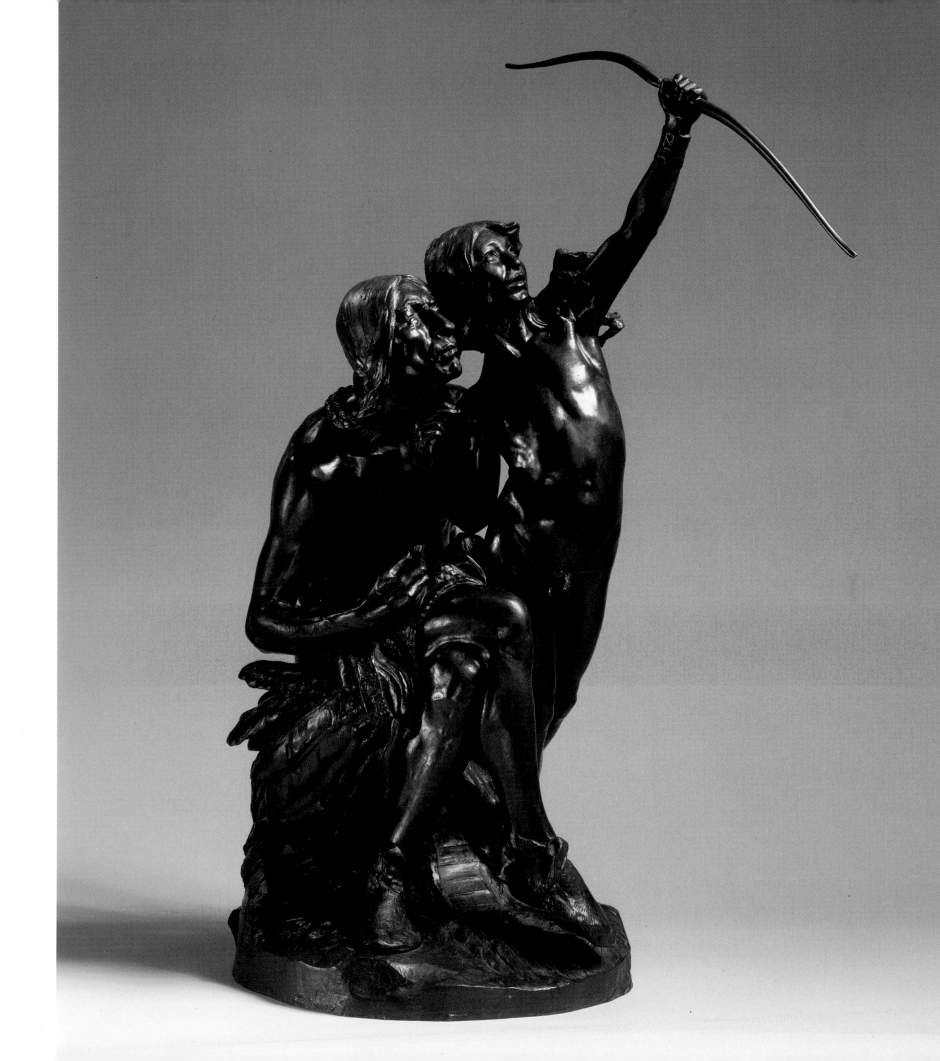

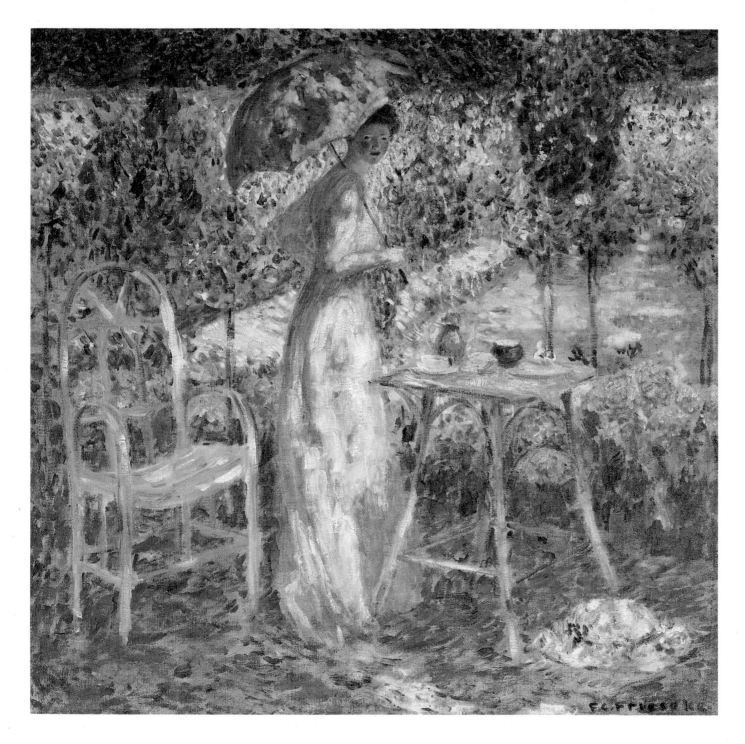

FREDERICK C. FRIESEKE
(1874–1939)
The Green Parasol, 1915

Oil on canvas, 31 ³/₄ x 32 inches
Inscribed: F C Frieseke
Collection of Mr. and Mrs. Jack Warner,
Tuscaloosa, Alabama

CHILDE HASSAM (1859–1935)
Ten Pound Island, 1896

Oil on canvas, 32 ¹/₈ x 32 ¹/₄ inches
Inscribed lower right: Childe Hassam,
1896

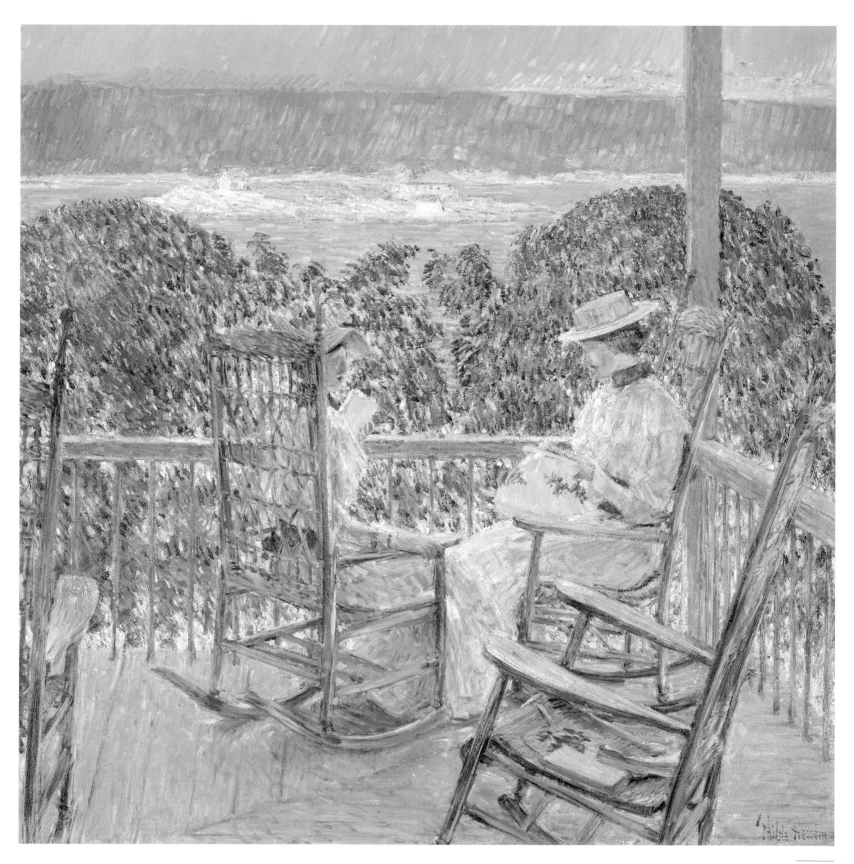

WILLARD METCALF (1858–1925)
Passing Glory, 1907

Oil on canvas, 36 x 36 inches
Inscribed lower right: W L Metcalf 07

EDWARD HENRY POTTHAST (1857–1927)
Children Playing at the Beach, circa 1910

Oil on canvas, 30 x 40 inches
Inscribed lower right: E Potthast

OPPOSITE

JOHN TWACHTMAN (1853–1902)
Snowbound Stream, 1890

Oil on canvas, 30 x 30 inches
Inscribed lower left: Twachtman Sale
(estate stamp)

JOHN SINGER SARGENT
(1856–1925)
Corner of a Garden,
circa 1910

Oil on cradled panel,
14 x 10 inches
Inscribed lower left: to my
friend . . . John S Sargent

ABOVE

THEODORE ROBINSON (1852–96)
The Farmer's Daughter, circa 1890

Oil on canvas, 25 ½ x 21 ½ inches

LEFT

CHILDE HASSAM (1859–1935)
Celia Thaxter's Garden, circa 1890

Oil on canvas, 13 x 9 ⁷/₁₆ inches
Inscribed lower left: Childe Hassam

LEFT

WILLIAM GLACKENS (1870–1938)
The Breakfast Porch, 1920

Oil on canvas, 20 x 24 inches
Inscribed lower left: W Glackens

OPPOSITE

DANIEL GARBER (1880–1958)
Tanis, 1915

Oil on canvas, 60 x 46 ¼ inches
Inscribed lower left: Daniel Garber

Neoclassicism in the New Republic

Amy Coes

A proud American, Jack Warner has assembled with patriotic fervor a collection of decorative arts of national importance; the primary focus is the arts of the Federal period, the era of the new republic and Warner's hero, George Washington. The decorative arts of those times were fashioned in the Federal style, a neoclassical style with European origins that became popular in America in the decades following the Revolution. In assembling a collection from this historically significant period, Jack appears to have followed the Gulf States Paper Corporation motto, "Quality Counts." Like many great collectors before him, he has relied on a philosophy emphasizing quality and comprehensiveness, with a particular concentration on rarity, condition, and provenance.[1] The result is a collection of masterpieces as well as a representative collection of makers, regions, forms, and materials incorporating the symbolism and creative spirit of the new nation.

As commander of the Continental Army and first president of the United States, George Washington is represented on fine and decorative arts throughout the collection. An outstanding example with a figural likeness of Washington is the gilt-brass and enamel mantel clock made by Jean-Baptiste Dubuc in Paris, 1815–17. Dubuc was *maitre-horloger* to the Compte d'Artois, brother of Louis XVI, and although he is recorded working in Paris only until 1798, a DuBuc *l'aine*, a *pendulier*, occupied several premises in the neighborhood of St. Martin-des-Champs, an area favored by bronze workers; from 1806 to 1807 DuBuc *l'aine* is found in rue Michel-le-Comte. Dubuc made this clock for the American market, portraying Washington in military regalia with an American eagle and a drapery swag inscribed with Henry Lee's famous words, "Washington, first in war, first in peace, first in the hearts of his countrymen."

Two other founding fathers represented in the collection are Benjamin Franklin and Gouverneur Morris; they are depicted on a pair of enamel knobs made in England

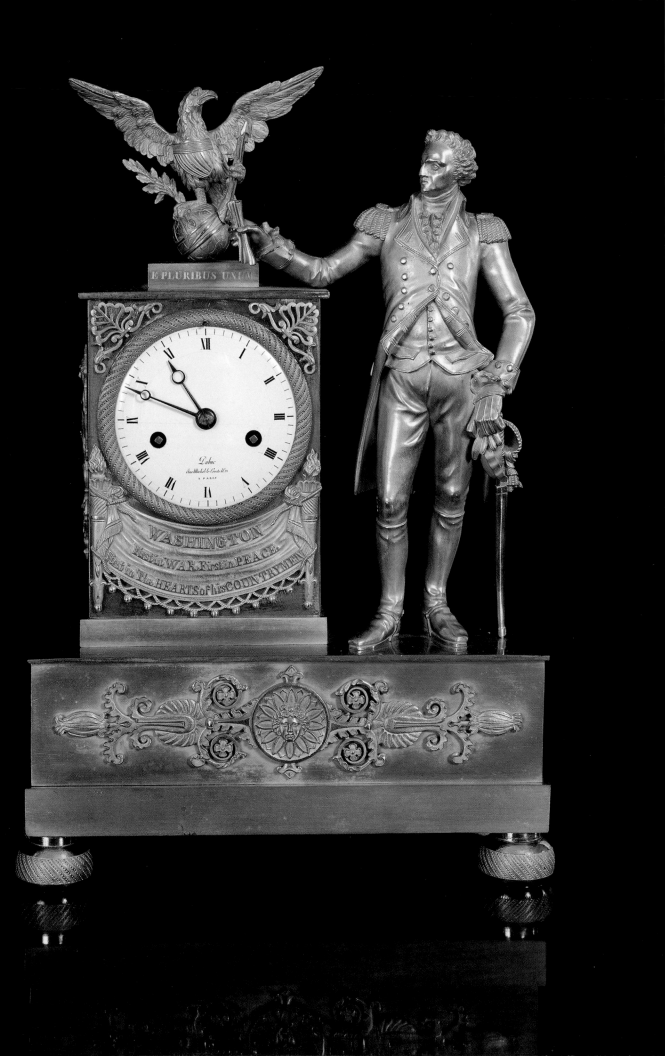

JEAN-BAPTISTE DUBUC, French (active 1790–1819)
Mantel clock with figure of George Washington
Paris, 1815–17

Gilt-brass and enamel,
16 x 10 ½ x 4 ½ inches

around 1785 as supports for a mirror. An American statesman with unparalleled achievements, Benjamin Franklin was a signer of the Declaration of Independence and the Federal Constitution as well as a scientist, inventor, philosopher, politician, editor, printer, and diplomat of world renown who achieved significant fame for identifying the properties of electricity. Gouverneur Morris, also a signer of the Constitution, was a successful lawyer before serving his country as a member of the New York Provincial Congress, a member of the Continental Congress, a delegate to the Constitutional Convention, United States minister to France, and United States senator. Both men were friends of George Washington and served as Pennsylvania delegates to the Constitutional Convention in 1787–88.

According to tradition, Gouverneur Morris once owned the marble fireplace surround in the Mildred Warner House parlor. Originally built in 1697, the Morrisania, New York, family estate was purchased by Gouverneur Morris after he finished serving as a delegate to the Constitutional Convention, and he returned there to live in 1788. He was soon called away on business to Europe, where he remained until 1798. When he returned to his manor house, he found it "leaky and

Pair of mirror knobs
England, late eighteenth century

Enamel, each 2 x 1 ½ inches

ruinous" and set about building a new house on the foundation of the old one. The fireplace surround was probably installed in the house at this time. Made in England around 1798, it displays a central relief depicting Aegis of Pallas Athena, the peacemaker, flanked by Mother England and a Native American binding up the instruments of war, especially appropriate iconography for a founding father of the new republic.

As the symbol of the new republic, the bald eagle was by far the most popular motif of the Federal period. Although utilized earlier as a heraldic device, this noble bird did not reflect an American connotation until 1782, when it was incorporated into the Great Seal of the United States. The Continental Congress passed a resolution regarding the selection of an official symbol of sovereignty after the Declaration of Independence was adopted on July 4, 1776; it rejected designs proposed by two committees before appointing another committee in May 1782.[2] The eagle was proposed as a symbol of the new nation by this third committee and approved as the national bird of America on June 20, 1782, when the Continental Congress adopted a design consisting of a spread-winged eagle with a shield, olive branch, and bundle of arrows for the Great Seal. Described by the committee as "the symbol of supreme power and authority," the eagle embodied the spirit of the American republic and quickly became a dominant emblem in the fine and decorative arts in an age of patriotic sentiment.

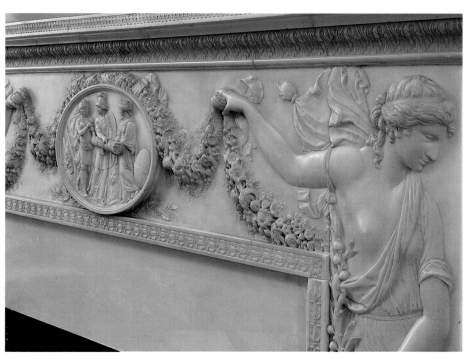

Jack Warner's collection contains numerous representations of the eagle. A faithful reproduction of the Great Seal is found on a porcelain vase made in France, which depicts a spread-winged eagle bearing a shield with arrows in its left talon, an olive branch in its right, a constellation of stars above, and the motto "E Pluribus Unum." Another interpretation on a candlestand made in New York is a less accurate representation in which the eagle is perched upon an olive branch bearing a shield with thirteen stripes and holding in its beak a scroll with sixteen stars, surrounded by sixteen inlaid stars. The inlaid decoration may commemorate Tennessee, which became the sixteenth state of the nation in 1796. A giltwood eagle by Samuel McIntire, the noted architect and carver of Salem, Massachusetts, is masterfully rendered in an upright stance with wings outspread and talons grasping a large supporting ball. Splendidly carved eagles also serve as finials on a pair of American giltwood girandole mirrors possibly made in Salem in 1800–1810 and as supports on a rare pair of gilt-pine eagle brackets made in America or England in 1810–30.

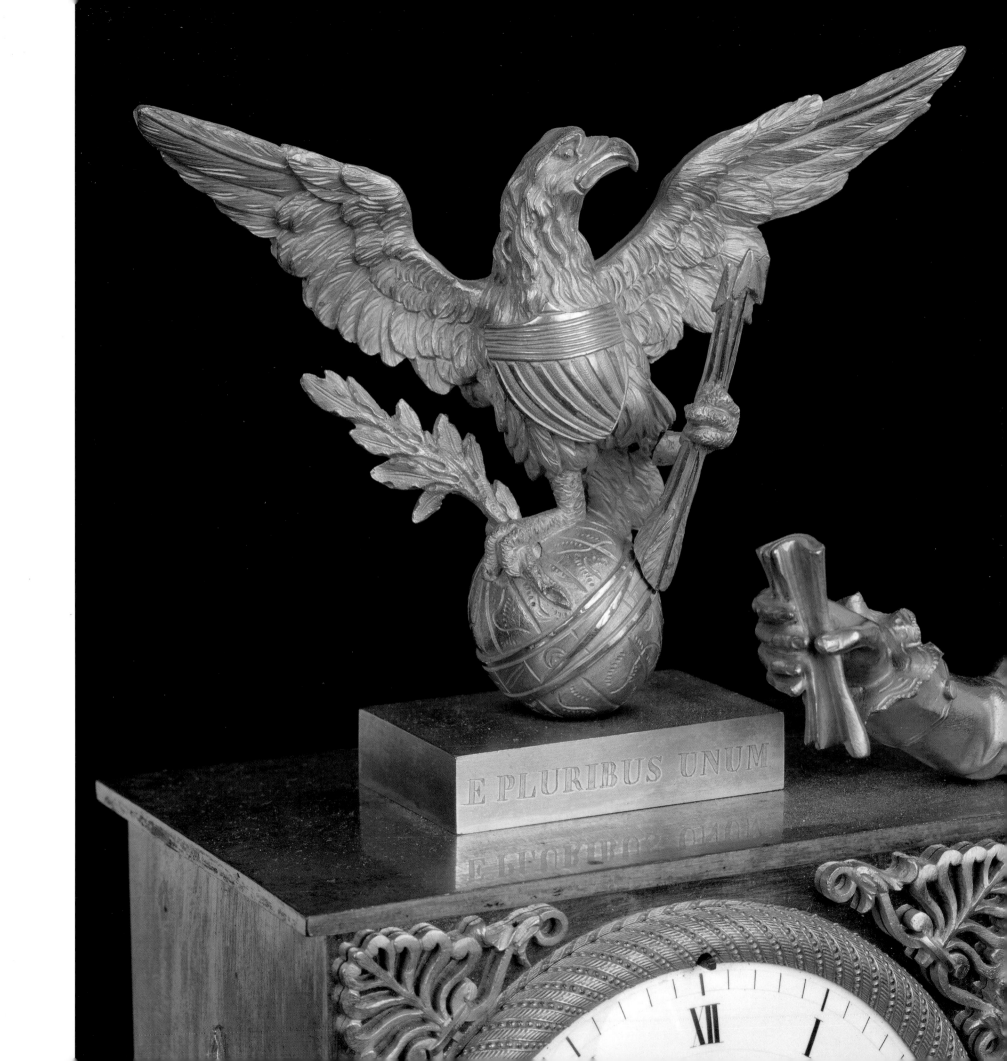

E PLURIBUS UNUM

OPPOSITE

SAMUEL MCINTIRE (1757–1811)
Eagle
Salem, Massachusetts, 1804–5

Giltwood, 18 ½ x 14 ¼ x 11 ½ inches

The eagle is in the foyer of the Mildred Warner House along with a pair of mahogany armchairs attributed to Joseph B. Barry (1759/60–1838) that were made in Philadelphia circa 1810. The armchairs feature doghead terminals similar to those on a sofa made for Louis Chapier of Philadelphia, for whom Joseph B. Barry made a pier table between 1812 and 1816. Above the right-hand chair is Pushmataha (the Sapling is Ready for Him), a Choctaw Chief, 1824, by Charles Bird King (1785–1862). Pushmataha was a chieftain of the Choctaws, an Indian tribe from the Tuscaloosa area that fought for the United States Army during the War of 1812 at the Battle of New Orleans. As senior delegate of the 1824 Choctaw delegation from Mississippi, Pushmataha traveled to Washington, where he died during negotiations over a land dispute. He was given a military funeral and buried at Congressional Cemetery.

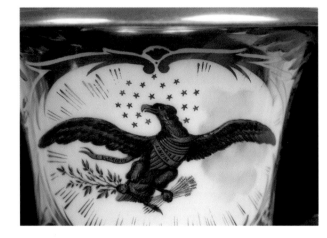

TOP LEFT

Giltwood girandole mirror with eagle finial, one of a pair, detail
American, possibly Salem, 1800–1810

LEFT

Porcelain vase with eagle, detail
France, circa 1825

The most dynamic motif represented in the collection from the late Federal period is the winged caryatid, a classically derived sculptural figure fashioned as a support on tables made in New York. Figural supports of this type were the innovation and trademark of Charles-Honoré Lannuier, who specialized in French-style winged caryatids inspired by ancient Greek and Egyptian design sources. Superbly carved and partially gilded, the winged caryatids in the Warner collection include supports on a pair of mahogany card tables in the Mildred Warner House foyer and on a pair of rosewood card tables in the sitting room.

**Parcel-gilt mahogany sofa
with dolphin support,** detail
New York, circa 1820

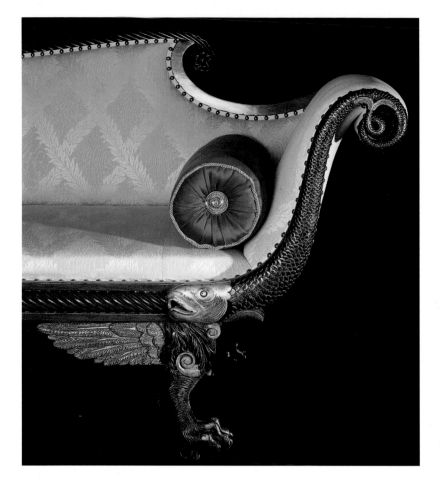

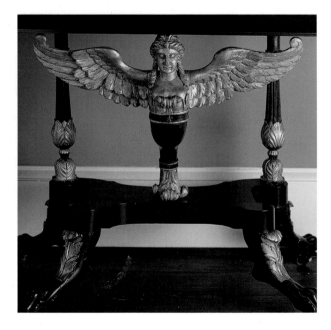

ABOVE

School of CHARLES-HONORÉ LANNUIER
(1779–1819)
**Mahogany card table with gilded winged caryatid,
one of a pair,** detail
New York, 1815–20

Also favored during the late Federal period, particularly in New York City and Philadelphia, was the dolphin, a symbol of Venus, the goddess of love, who was borne out of the sea and carried to land on a scallop shell, accompanied by dolphins. Often articulated with rounded bulbous heads and snub noses, the dolphin motif may have been inspired by the fantastical creatures found in classical mosaics, Minoan pottery, and French Empire furniture. Represented in the Warner collection as a visually appealing support on a mahogany sofa made in New York around 1820, the dolphin also served as a support on tables, seating furniture, and beds.

An American gilded white pine mirror possibly made in Philadelphia around 1820 is boldly carved with a creative mixture of popular Federal period motifs. The trophies surmounting the mirror symbolize victory and the strength of America. The richly carved cornucopia tails, foliage, fruit, and sheaves of wheat evoke abundance and plenitude, while the central supports represent the rays of light displayed in the Great Seal of the United States. The Prince of Wales feathers and the lion heads, symbols of British sovereignty, are rendered in a subordinate manner to underscore the mirror's theme of the strength and tremendous resources of the new nation.

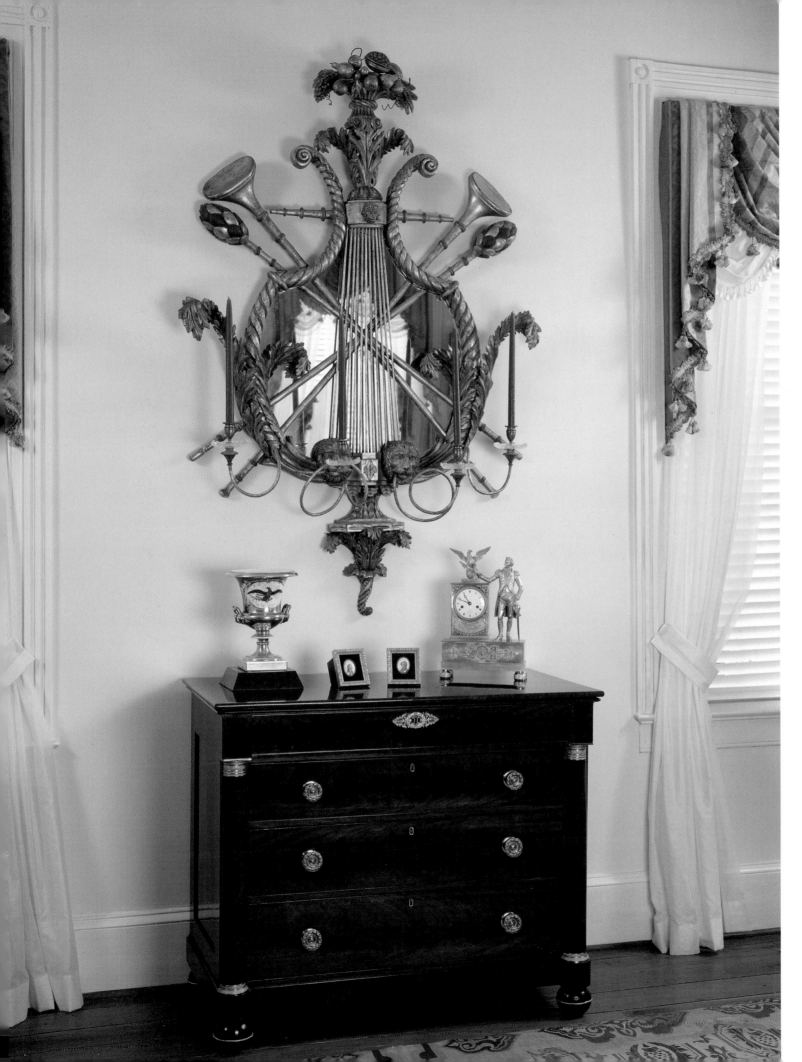

Mirror

American, possibly Philadelphia, circa 1820

Gilded white pine, 72 x 46 inches

The mirror is in the parlor of the Mildred Warner House over a mahogany chest of drawers (Boston, circa 1820).

169

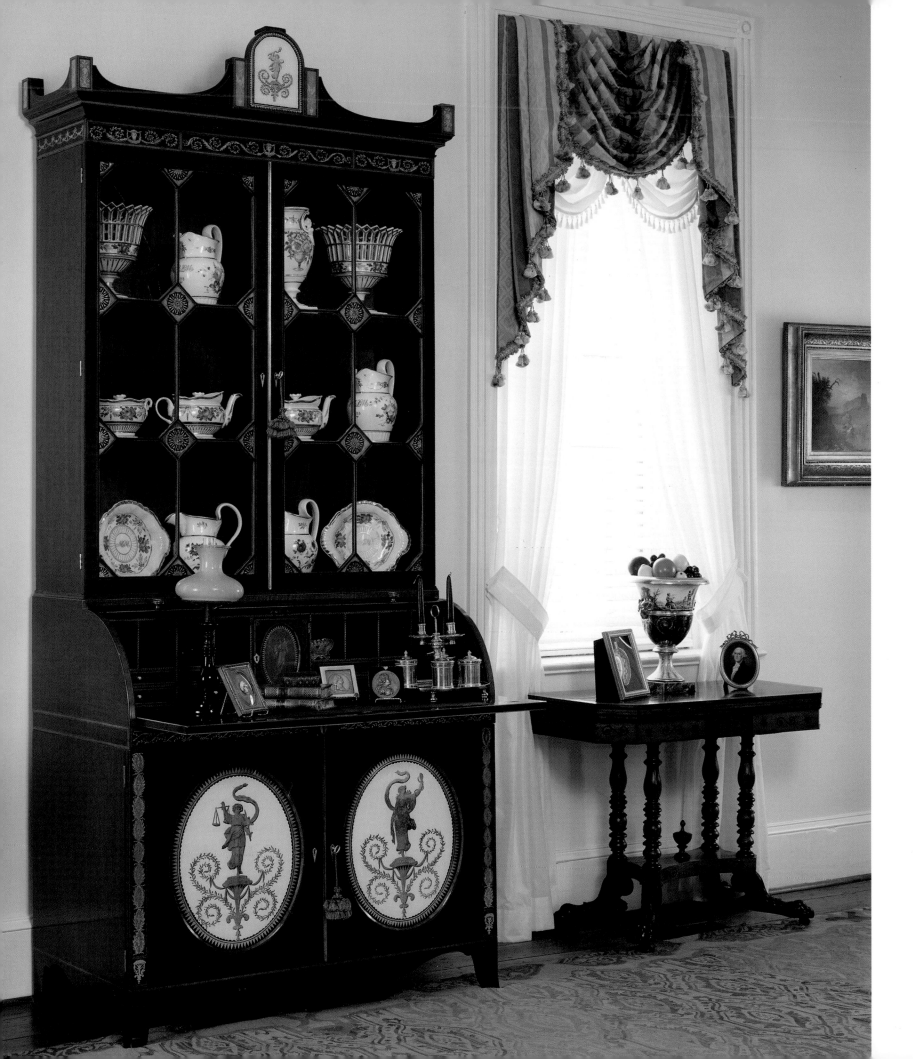

An extraordinary masterpiece of American furniture in the collection and, incidentally, Jack Warner's favorite piece is the elaborate and monumental desk-and-bookcase that was made around 1800 in Philadelphia, then the largest city in America as well as an important cabinetmaking center.[3] Patterned after plate twenty-six of *The Cabinet-Maker and Upholsterer's Drawing Book* by Thomas Sheraton, published in London in 1793, the desk is clearly the work of a master craftsman. It stands nearly nine feet tall and is made of the finest mahogany veneers, trimmed in satinwood, and ornamented with forty-seven *verre églomisé* (reverse painting on glass) panels painted with popular Federal period motifs. Gilded masks entwined with vines on a blue ground adorn the pediment, while the clear glass panes of the bookcase doors below are enlivened with twenty-four panels painted with gilded sunbursts on a black and pink ground. A golden female figure in Greek dress playing a lyre on a salmon-colored ground enhances the prospect door. Allegorical figures of Justice carrying a set of scales and a sword and Truth peering into a hand-held mirror are featured on the lower case doors, which are bordered by panels painted with sheaves of golden wheat on a pale green ground.

The history of the desk is unknown until 1988, when a used-furniture dealer purchased it out of a barn on a private ranch in Argentina and sold it as an English apothecary cabinet to two antiques dealers in Acassuso, Argentina. After storing the desk for five years, the dealers prepared it for a Buenos Aires antiques show in 1993, at which time they discovered it was an American piece. A New Hampshire antiques dealer vacationing in Buenos Aires in September 1994 came upon the desk and, recognizing its importance, made arrangements for it to be exhibited at the Winter Antiques Show, held in New York City in January 1995. Jack Warner acquired the desk there; he surmises it traveled to Argentina soon after the Civil War, when Confederate expatriates sought refuge in South America rather than live under Yankee rule.[4] At the same time he spontaneously acquired the elegant pair of New York card tables that flanked the desk at the Winter Antiques Show; the assemblage is displayed in the same arrangement in the parlor of the Mildred Warner House.

The exceptional andirons in the fireplace of the Mildred Warner House parlor were also made in Philadelphia, dating to around the time of the Revolution. They have distinctive features associated with the work of Daniel King, a master brazier who manufactured high-quality andirons and other wares from 1760 to the late 1700s at a foundry on South Front Street. In 1764 he supplied William Wharton with a pair of brass andirons in exchange for family hats, and from 1768 to 1776 he had an

Desk-and-bookcase
Philadelphia, circa 1800

Mahogany, satinwood, and églomisé, 102 x 43 x 25 inches

The desk-and-bookcase is in the parlor of the Mildred Warner House between a pair of ebony-inlaid satinwood and mahogany swivel-top card tables (New York, circa 1815).

Mahogany and satinwood desk-and-bookcase,
detail
Philadelphia, circa 1800

Attributed to DANIEL KING (1731–1806)
Pair of andirons
Philadelphia, 1775–85

Cast brass and wrought iron, 28 x 13 x 22 inches

Attributed to EDWARD PRIESTLEY (1778–1837)
Pier table, one of a pair
Baltimore, 1825–35

Mahogany with original King of Prussia marble top,
44 ¹/₂ x 59 ¹/₂ x 25 inches
University of Alabama, gift of Mr. and Mrs. Jack Warner

account with the local cabinetmaker Benjamin Randolph, presumably for furniture hardware. In 1770 he billed General John Cadwalader for six pairs of andirons, the most costly of which were itemized on the invoice as "to one Pare of the Best Rote fier Dogs With Corinthen Coloms £25; to a Pare of the Best Fluted Do with Counter Fluts £10."[5]

With their urn-form tops, engraved swags, tapered columnar supports with meandering vines, ram's heads, raised shells, and claw feet, the andirons in the Mildred Warner House are among the more elaborate examples attributed to Daniel King and may represent the highest level of sophistication for the form. Similar stylistic details are found on a pair of andirons in the collection of the Dietrich Americana Foundation that have been attributed to King on the basis of a marked pair at the Henry Francis du Pont Winterthur Museum.[6]

Ranking among the finest examples of Philadelphia furniture in the late Federal style in the collection is the chest of drawers in the Mildred Warner House sitting room ascribed to Joseph B. Barry. Dublin-born and London-trained, Barry emigrated to Philadelphia by 1794 and worked in a series of short-lived partnerships before establishing a successful business on South Third Street in 1797. He sold his furniture in Savannah, Georgia, in 1798 and Baltimore, Maryland, in 1803 and opened a manufactory at 132 South Second Street in 1804, moving to 134 South Second Street in 1805. By 1810 Joseph B. Barry & Son advertised "most fashionable Cabinet Furniture, superbly finished in the rich Egyptian and Gothic style."

On March 30, 1815, Barry advertised for sale in the *Aurora General Advertiser* "3 pair Eliptic Bureaus, Columns and Egyptian figures," chests like the one in the Warner collection with a bow front and Egyptian-style term supports, or tapered square columns with human heads and feet. These unusual supports were listed as "tapered therms with mummy heads and feet" in *The New York Book of Prices for Manufacturing Cabinet and Chair Work* of 1817 and may have been inspired by furniture designs published in *The Cabinet-Maker, Upholsterer and General Artist's Encyclopaedia* of 1807 by Thomas Sheraton and *A Collection of Designs for Household Furniture and Interior Decoration* of 1808 by George Smith.[7]

Similar term supports are found on the magnificent pair of pier tables with original King of Prussia marble tops in the dining room of the President's Mansion at the University of Alabama. Here the human heads are represented as male with mustaches and Turkish tasseled headdresses patterned after "Indian or Bearded Bacchus" designs illustrated in plate fifty-seven of Thomas Hope's *Household Furniture and Interior Decoration*, published in London in 1807. Nearly identical heads are found on a marble-top pier table made for the Talbot County, Maryland, planter Edward Lloyd VI by Edward Priestley, the proprietor of one of the largest and most successful cabinetmaking shops in Baltimore during the early nineteenth century. Born in

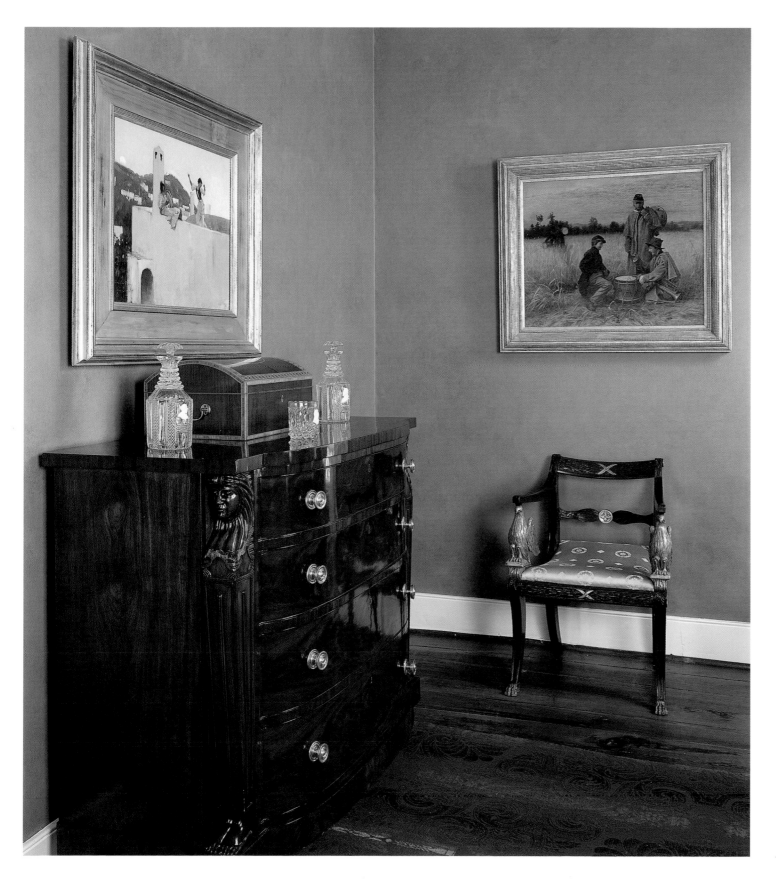

Attributed to JOSEPH B. BARRY
(1759/60–1838)
Chest of drawers
Philadelphia, 1815–25

Mahogany, 42 x 47 ³/₄ x 23 inches

*The chest is in the sitting room of
the Mildred Warner House beside
a parcel-gilt mahogany armchair
with eagle supports (Philadelphia, circa
1815), also attributed to
Joseph B. Barry.*

Annapolis in 1778, Priestley arrived in Baltimore in 1790, a time when the city was experiencing rapid growth and prosperity in the decades following the Revolution. Priestley built a flourishing cabinetmaking business in this atmosphere in addition to training apprentices such as John Needles and investing in lumber, real estate, railroad stock, nail manufacturing, and wharf and ship construction. He was known to have had on hand an "elegant assortment of furniture," which he supplied to prominent patrons from Maryland and the District of Columbia, including President and Mrs. James Madison.[8]

Also from Baltimore and among the supreme masterpieces in the Warner collection are two card tables dating to around 1825 that are attributed to Hugh Finlay, a leading manufacturer of "fancy" furniture, painted furniture based on English prototypes of the 1780s and 1790s. Hugh worked with his brother John from 1803 to 1816 at a shop on North Gay Street, producing painted furniture, window and bed cornices, and other upholstered goods. From 1816 to 1830, Hugh ran the shop alone, focusing primarily on chairmaking and export. John took over the firm after Hugh died in 1830 and ran it until it closed in the late 1830s.[9]

The card tables are superior examples of fancy furniture in the "archaeological" phase of the late Federal style, which promoted an archaeologically accurate revival of classical antiquity. The painted decoration simulates rosewood, while the stenciled motifs are meant to resemble ormolu mounts. Nearly identical stenciled motifs are found on furniture made by Hugh Finlay in 1819 and circa 1825 for the local shipping merchant James Wilson.[10]

One of America's largest cities during the Federal period, Boston supported a number of highly skilled cabinetmakers and related craftsmen who manufactured furniture in the latest styles to meet the demands of a growing population. The elegant demilune commode in the parlor of the President's Mansion at the University of Alabama may have been made by the celebrated cabinetmakers John and Thomas Seymour, whose furniture epitomizes the height of workmanship in Boston during the Federal period. Born in England and trained in Axminster, Devon, John Seymour emigrated to America in 1785, settling first in Portland, Maine, and then moving to Boston and opening a cabinet shop on Creek Street in 1794, which he ran until about 1813. He trained his son Thomas, who assisted with the business from 1794 until 1804, when he opened a furniture warehouse on Common Street and shifted his focus from manufacturing to retailing.

Indicative of the furniture produced in the Seymour shop, the commode in the President's Mansion reflects the influence of English design sources. It is finely crafted with attention to detail, delicately proportioned, and richly finished with vibrant

OPPOSITE

Attributed to HUGH FINLAY (1781–1830)
Card table, one of a pair
Baltimore, circa 1825

Painted, parcel-gilt, and ormolu-mounted faux rosewood,
30 ¹/₂ x 35 ³/₄ x 35 ¹/₂ inches

ABOVE

Attributed to JOHN SEYMOUR (circa 1738–1818)
and/or **THOMAS SEYMOUR** (1771–1848)
Demilune commode
Boston, circa 1810

Mahogany, 38 ³/₄ x 47 ³/₄ inches
University of Alabama, gift of Mr. and Mrs. Jack Warner

mahogany veneers enhanced by original brass lion's-head hardware. Its pleasing form and subdued ornamentation emphasize the preference of early-nineteenth-century Bostonians for well-made functional furniture decorated with restrained elegance.

One of the rarest clocks in the Warner collection is the lighthouse clock made by the Boston area's most prominent and innovative clockmakers, Simon Willard and Son. Born in Grafton, Massachusetts, on April 3, 1753, Simon Willard Sr. received his early training from the English-born Grafton clockmaker John Morris before working locally for his older brother Benjamin Willard. By 1784 he was working at a shop in Roxbury, where he trained his sons Simon Jr. and Benjamin in the trade as well as Daniel Munroe Jr. and Levi and Abel Hutchins, among others, before retiring in 1839. Also an inventor, Simon received a patent in 1802 for his "Improved Patent Timepiece," the banjo clock for which he became famous. Simon Jr. worked in his father's shop from around 1824 to 1826 and then spent several years in New York learning how to make chronometers. He returned to Boston in 1828 and established a business on Congress Street, where he continued to work until the 1870s.

Simon Sr. received a patent for the lighthouse clock in 1819, stating in the application that "the whole plan of the clock I claim as my invention."[11] Initially constructed as an alarm clock with a hammer that struck the case instead of a bell, the clock went through several incarnations before evolving into its final form, which was designed solely as a timepiece with an exposed movement covered by a glass dome. It is a rare form; only about twenty-five clocks of this type were made.[12] The Warner example is exceptional, with an ebonized mahogany case ornamented with vertical reeds, sophisticated ormolu mounts, and leaf-and-ball feet. The magnificent ormolu lyre finial surmounting the dial has been described as the most elaborate known on the Willards' work.[13]

The case of the clock may have been made by William Fisk, a Boston cabinetmaker who purportedly made cases for Simon Willard from about 1800 to 1838.[14] He was born in Watertown, Massachusetts, on December 20, 1770, the younger brother of Samuel Fisk, a cabinetmaker by trade who worked for a time as a journeyman in the shop of Stephen Badlam. In 1792 William and Samuel opened a cabinet shop in Roxbury; about 1794 they moved to a shop in Boston on Washington Street, a major thoroughfare between Boston and Roxbury where most furniture-related tradesmen worked. After Samuel's death in 1797, William continued alone in the business, which was described in 1798 as "a lot of land, 30,000 square feet with a shop thereon . . . next to Aaron Willard."[15]

The lighthouse clock is displayed in the music room of the Mildred Warner House on a work table with Fisk's label "WM. FISK/Cabinet Maker/Washington St./BOSTON" stenciled on the second drawer. Popularized by Thomas Sheraton, the unusual form of such work tables served during the early nineteenth century as sewing

Simon Willard (1753–1848)
and Son (active 1824–26)
Lighthouse clock,
the "Alarum Timepiece"
Roxbury, Massachusetts, 1824–26

Ebonized mahogany, verdigris, bronze,
brass, and glass, 29 inches high
Inscribed on dial: Simon Willard & Son

WILLIAM FISK (FISKE) (1770–1844)
Work table
Boston, circa 1820

Mahogany, 29 ⁵/₈ x 20 x 19 ⁵/₁₆ inches
Marked on label in second drawer: WM. FISK/Cabinet
Maker/Washington St./BOSTON
Inscribed inside top drawer: Mrs. Chase/27 Beacon

BELOW

WILLIAM FISK (FISKE) (1770–1844)
Label on mahogany work table
Boston, circa 1820

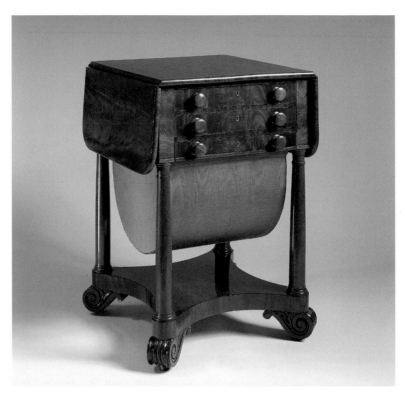

OPPOSITE
Work table
Boston, circa 1815

Brass-inlaid rosewood,
29 ¹/₈ x 20 ⁵/₁₆ x 17 ⁵/₈ inches

tables and storage bins for needlework supplies. This example is made of a highly figured mahogany and fitted with a bag, to emphasize its function. Although boldly articulated and crisply carved, the work table is relatively plain; uncommon scroll and tulip feet are the extent of its carved decoration.

A work table made in Boston around the same time is an extraordinary example of the form in the Greco-Roman taste, a phase of the late Federal style characterized by an eclectic combination of references to antiquity. The supports in the shape of lyres, the most common classical motif used in Boston, symbolize Apollo, the patron of music and god of the sun. The moths ornamenting the sides of the work table may refer to the moths that pulled the chariot of Apollo when he traveled across the sky as the god of truth and light. The anthemia are of Grecian inspiration, while the hairy paw feet are in the Roman taste. Also known during the period as pouch tables, in reference to their fabric bags, work tables represented a woman's leisure and refined needleworking skills. Made of rosewood, inlaid with brass, and decorated with ormolu mounts, this one was a costly production fashioned by a craftsman of considerable talent.

One of the highest achievements of American clockmaking in the Warner collection is the girandole clock made around 1815 by Lemuel Curtis of Concord, Massachusetts. This master clockmaker was born in Boston on July 3, 1790, and apprenticed to Simon Willard, brother of his uncle by marriage, Aaron Willard. In 1812 he

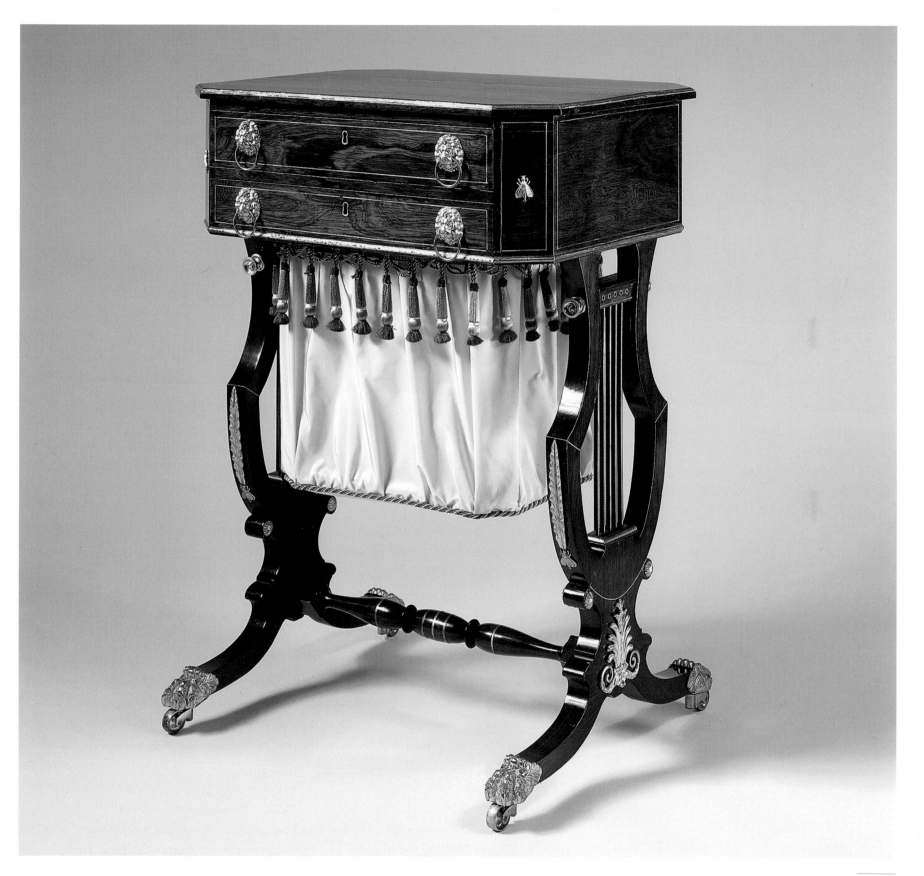

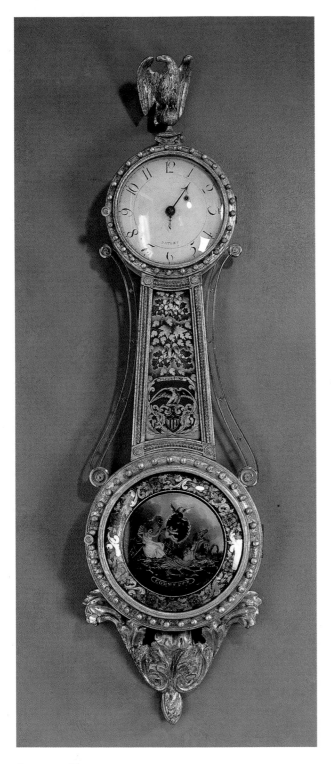

LEMUEL CURTIS (1790–1857)
Girandole clock
Concord, Massachusetts, circa 1815

Giltwood and églomisé, 48 x 14 x 4 ¼ inches

opened a shop in Concord near the courthouse, where he made clocks and watches and sold jewelry, silver, and other items until about 1818, when he moved to Burlington, Vermont. On July 12, 1816, he received a patent for an "improved timepiece," presumably his girandole clock, a variation of the popular banjo clock patented by Simon Willard in 1802. Characteristic of Curtis's finest work, this example has an eight-day movement set in an elaborate giltwood case surmounted by an original spread-winged American eagle and decorated with beautifully painted églomisé panels.

While Lemuel Curtis designed and made the movements for his clocks, other craftsmen supplied the cases and églomisé decoration, including his brother Samuel, who made the iron dials, and his brother Benjamin, who executed many of the églomisé panels. Benjamin may have made this clock's panels, which are adorned with historical and mythological scenes as well as scrolls, shields, flowers, oak leaves, and acorns. The waist panel is painted with an American eagle, with "L. Curtis" inscribed on the banner above. The painting on the lower glass panel, entitled *Commerce*, is a representation of Aurora, with Phoebus carrying the American flag while driving the seahorse-drawn chariot of the sun. This scene appears to include a paddle wheel, which may symbolize the expansion of commerce that resulted from the transportation revolution created by Robert Fulton's development in 1807 of the first successful steamboat, the *Clermont*.

After the Revolution, New York City experienced significant growth and prosperity and by 1815 had replaced Philadelphia as the largest city in the new nation and the center of commerce. By the early nineteenth century, the city had become the major center of fine cabinetmaking in America as well, by 1805 supporting more than one hundred furniture makers and related craftsmen.[16] Foremost among them were Charles-Honoré Lannuier and Duncan Phyfe, two renowned master cabinetmakers whose work is prominently represented in the Warner collection.

A magnificent part-ebonized, parcel-gilt, and brass-inlaid rosewood card table in the collection bears the French-style *estampille* of Charles-Honoré Lannuier, the French émigré cabinetmaker working on Broad Street in New York from 1803 to 1819. The cabinetmaker of choice for furniture in the latest styles for many wealthy New Yorkers, Lannuier was born in 1779 in Chantilly, France, and probably received his early training from his brother Nicholas, a successful *ébéniste* in pre-Revolution Paris. He emigrated to America in 1803, announcing his arrival in an advertisement in the *New-York Evening Post*, and established a workshop and wareroom at 60 Broad Street, where he practiced his trade until he died in 1819, only forty years old. Lannuier often labeled his finished work with a stamp or paper label, and as a result, more than 125 pieces of furniture can be documented or firmly attributed to him today.[17]

A superb signed example of Lannuier's late Federal style, the rosewood card table features a tripod support arrangement above a four-footed base that may derive from

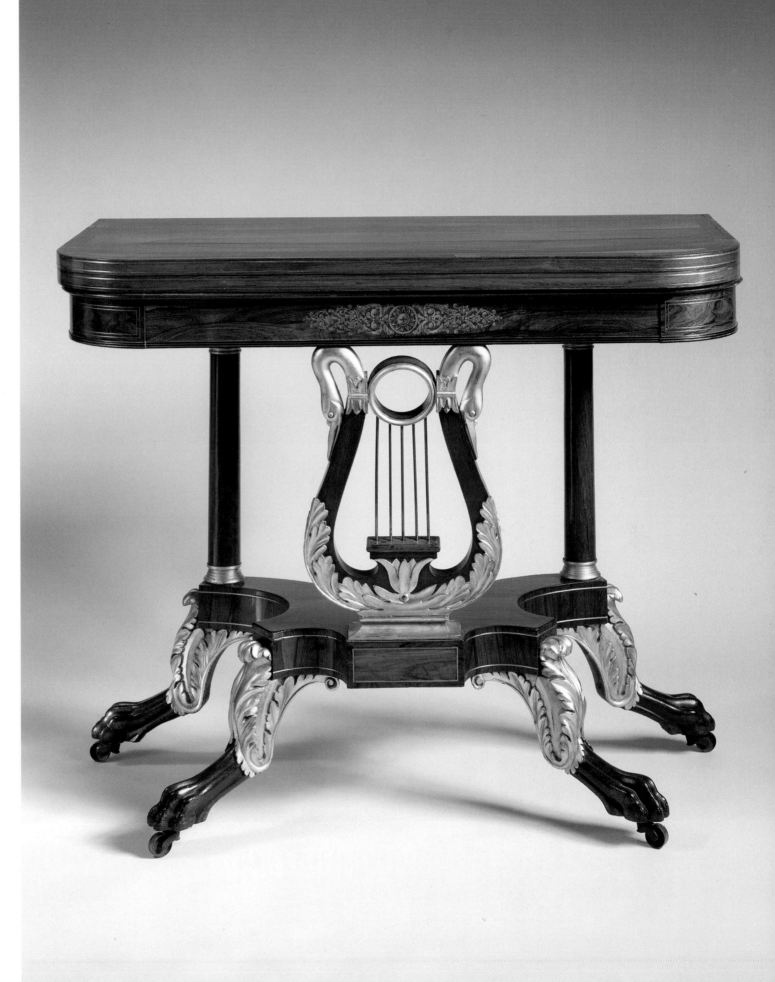

**CHARLES-HONORÉ
LANNUIER** (1779–1819)
Card table
New York, 1810–19

Part-ebonized, parcel-gilt,
and brass-inlaid rosewood,
30 1/8 x 35 3/4 x 18 inches
Stamped four times:
H. LANNUIER,/NEW-YORK

designs illustrated in the 1802 edition of Pierre de la Mésangère's *Collection des Meubles et Objets de Goût*. The French-inspired lyre and swan motifs symbolize mythological gods and goddesses. Lyres are often associated with Apollo, patron of music and god of the sun, as are swans, which, according to myth, sing before their own death. Swans also pull the chariot of Venus, the goddess of love. As the personal symbol of Empress Josephine, the swan was also integrated into French Empire-style furniture made for the empress by Percier and Fontaine.

Also represented in Jack Warner's collection is the work of Duncan Phyfe, the leading New York cabinetmaker who achieved a remarkable level of celebrity during his lifetime. Born in Loch Fannich, Scotland, in 1768, Phyfe emigrated to America in 1783, settling with his family in Albany, New York. After training in his father's cabinet shop, Phyfe moved to New York City around 1792 and established a successful workshop on Broad Street. In 1795 he relocated to a larger workshop on Partition Street (later Fulton Street), where he worked until his retirement in 1847. Described as "the largest and most fashionable establishment in the country," Phyfe's shop was known for its stylish furniture and elite New York clientele.

An armchair, six side chairs, and a wardrobe in the music room of the Mildred Warner House are part of an important set of furniture made by Duncan Phyfe for Luman Reed, a wealthy New York merchant and art patron. In March 1833, Reed paid Phyfe for a large quantity of furniture, including an armchair *en gondole*, mahogany side chairs, work table, bedstead, wardrobe, and footstools, for which the 1833 bill of sale for a total of $910 signed by Phyfe survives. Reed undoubtedly purchased the furniture for his new house at 13 Greenwich Street, which was designed by Alexander Jackson Davis and completed in 1833.

The upholstered armchair was likely included in Phyfe's bill, although it was not itemized, and may be the "1 Arm chair with cover . . . 25" listed in the first-floor office in the inventory of Reed's property taken at his death in 1836. It was fashioned in the French Restauration style, with a design based on a *fauteuil de salon* illustrated in plate 667 of the 1829 issue of La Mésangère's *Collection des Meubles et Objets de Goût*. The scrolled arms rest on supports carved with Egyptian lotus leaves, an exotic motif that came into use in France after Napoleon's campaign into Egypt in 1798 and the publication of Baron Vivant Denon's *Voyage dans la Basse et la Haute Égypte* in 1802.

The mahogany wardrobe descended in Luman Reed's family with its documented history of manufacture by Duncan Phyfe. Characteristic of Phyfe's work, the wardrobe displays highly figured mahogany veneers, handsome cross banding, and waterleaf and animal paw feet. Three other armoires made by Phyfe are known; one descended in the family of his daughter, Eliza Phyfe Vail, and two others were made for James Lefferts Brinckerhoff and documented by an 1816 bill of sale.[18] The wardrobe form was listed as "A French Press" with "two flat paneled doors, with two

Sofa
New York, circa 1820

Parcel-gilt mahogany,
36 x 91 x 26 ⁵/₈ inches

Along with this sofa, which has dolphin supports, the foyer of the Mildred Warner House contains a pair of gilt-pine eagle brackets (American or English, 1810–30) as well as George Washington, *painted from life at Mount Vernon in 1785 by Robert Edge Pine.*

Attributed to JOSEPH B. BARRY (1759/60–1838)
Armchair
Philadelphia, circa 1815

Parcel-gilt mahogany, 32 x 23 inches

Similar eagles appear on a tall case clock signed J. Barry and on a pier table attributed to Barry in the collection of the Henry Francis du Pont Winterthur Museum, Delaware.

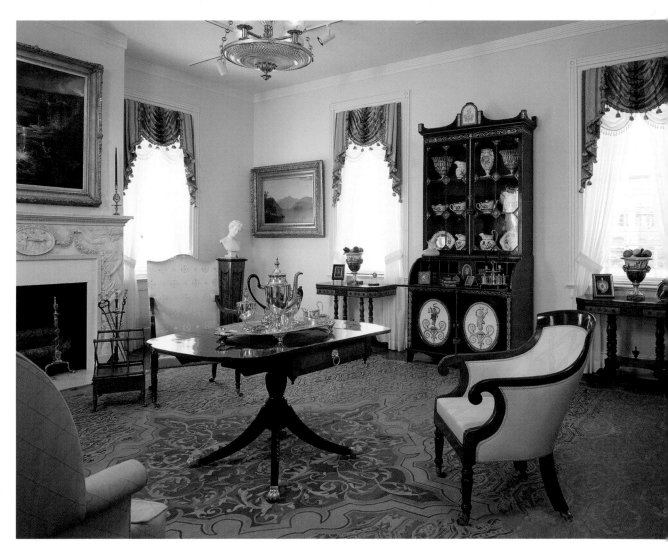

LEFT

Sofa

New York, circa 1820

Mahogany, 37 x 97 x 27 inches

A pair of giltwood brackets with Prince of Wales feather supports (American or English, circa 1815) and Sunset in the Shawangunk Mountains, 1854, by Sanford Gifford are above the sofa in the parlor of the Mildred Warner House.

ABOVE

Desk-and-bookcase

Philadelphia, circa 1800

Mahogany, satinwood, and églomisé, 102 x 43 x 25 inches

In the parlor of the Mildred Warner House are the large desk-and-bookcase, a pair of ebony-inlaid satinwood and mahogany swivel-top card tables (New York, circa 1815), a mahogany breakfast table (New York, 1810–20), an assembled collection of silver, and a mahogany armchair (New York, circa 1815).

Attributed to GEORGE HENDEL (died 1842)
Coffeepot
Carlisle, Pennsylvania, 1790–1800

Silver, 15 ¼ inches high
Marked four time on base: GH in oval
Inscribed on foot: Wedding Gift to Rebecca Crawford &
Thomas Foster married November 24th 1778. Inherited by
Josephine Castor, wife of Alfred H. Foster. Inherited by Jesse
C. Foster Furness, on her death given to her brother Thomas
C. Foster July 12, 1907
Inscribed on side: TRF, the monogram of Thomas and
Rebecca Foster

George Hendel also made a three-piece tea service
for Thomas Foster, a local innkeeper; it is now in the
collection of the Cumberland County Historical Society.

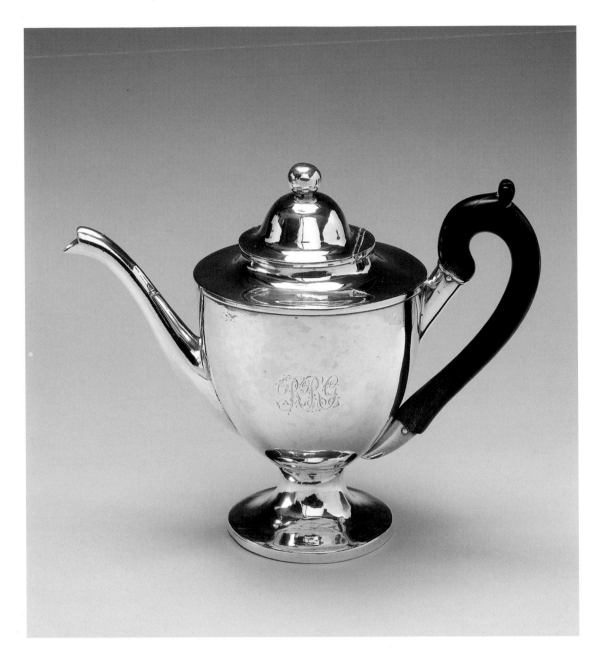

PAUL REVERE, JR. (1735–1818)
Teapot
Boston, circa 1797

Silver, 8 inches high
Marked on rim of foot: REVERE
Inscribed on side: RRG and SPG

Made by the Boston patriot and silversmith
Paul Revere Jr., this teapot bears the monograms
of Rebecca Russell Gardner and Samuel Pickering
Gardner, who married in 1797.

PAUL REVERE, JR. (1735–1818)
The Bloody Massacre Perpetrated in King Street
Boston on March 5, 1770, 1770

Copperplate engraving, hand colored, 10 ¼ x 9 ¹/₁₆ inches
Inscribed lower right of image: Engrav'd Printed & Sold
by PAUL REVERE BOSTON

This political broadside depicts the Boston Massacre of
March 5, 1770, an image derived from the engraving
The Fruits of Arbitrary Power, *or* The Bloody
Massacre *by Henry Pelham.*

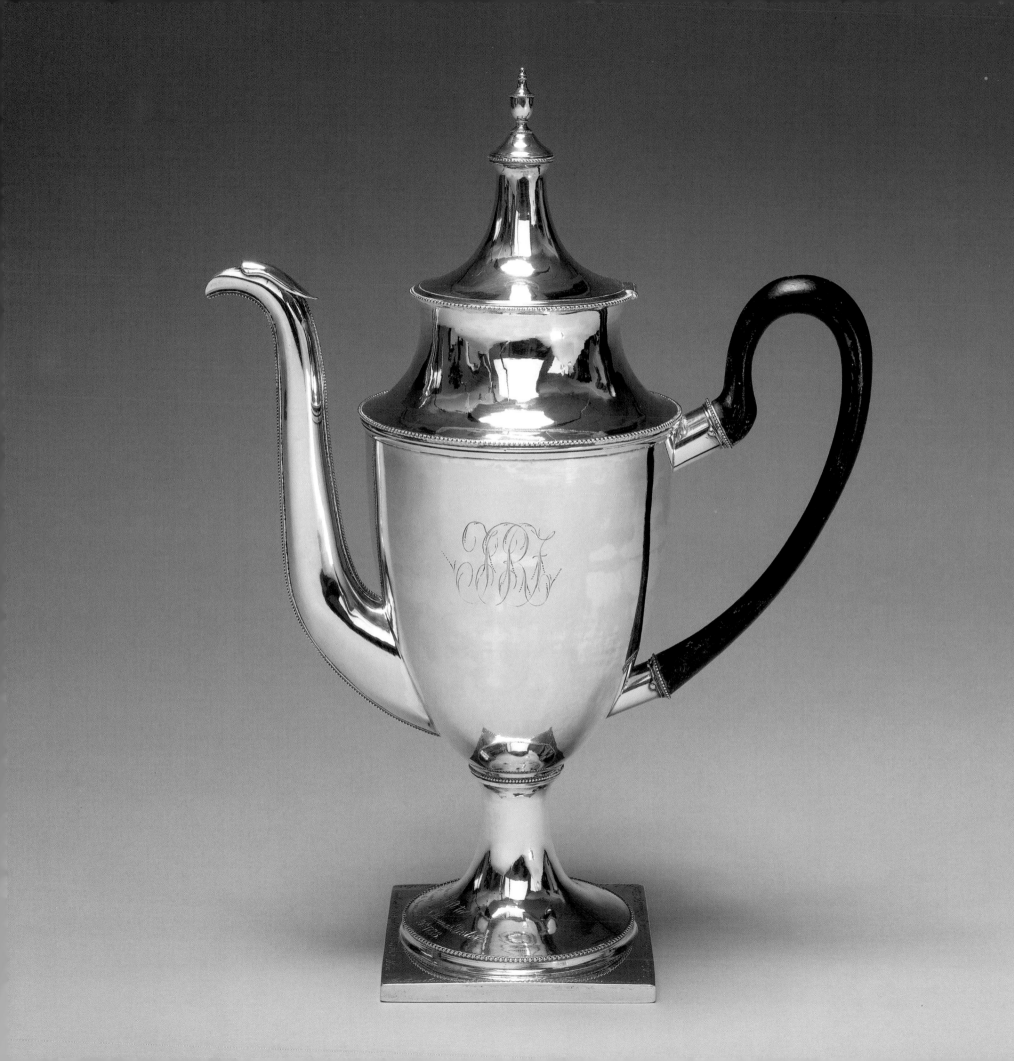

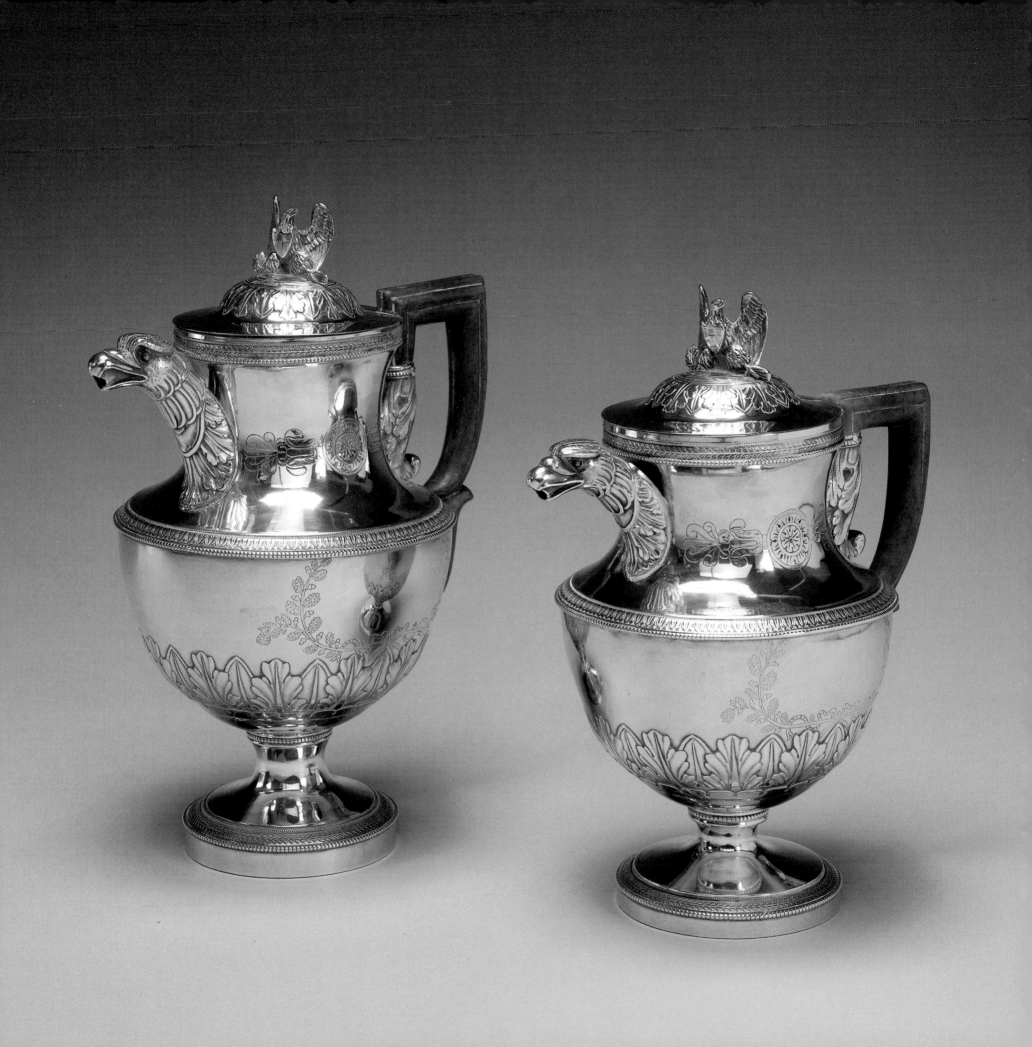

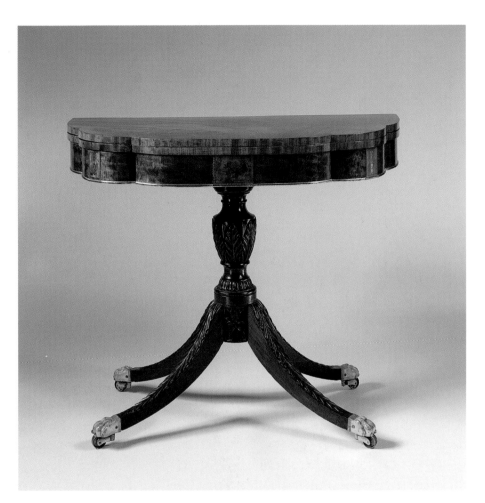

LEFT

Attributed to CHARLES-HONORÉ LANNUIER
(1779–1819)
Card table, one of a pair
New York, 1810–19

Mahogany with brass inlay, 30 x 35 ¼ x 35 ¾ inches

*Abraham Berry, a prominent Brooklyn physician
and surgeon general of the Second Army Corps
in the Civil War, once owned this pair of tables.*

BELOW

Swivel-top card table, one of a pair
New York, circa 1815

Ebony-inlaid satinwood, mahogany, rosewood,
and maple, 29 x 36 x 35 ¾ inches

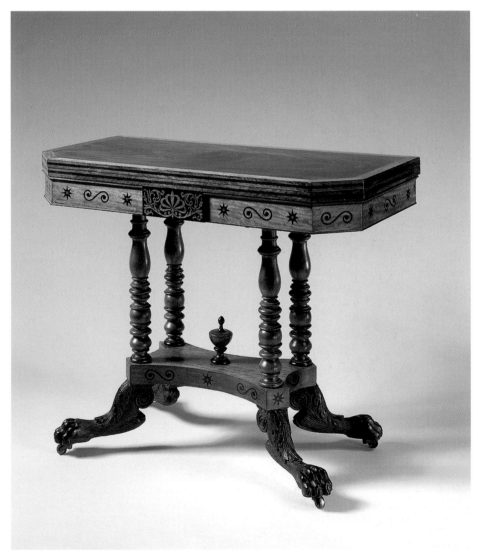

OPPOSITE

Attributed to ANTHONY RASCH (active 1807–57)
Coffeepot and teapot
Philadelphia, circa 1820

Silver, coffeepot 11 ½ inches high, teapot 10 inches high

*The eagle iconography suggests this coffeepot and teapot
were made as presentation pieces, presumably to honor
a hero of national service. Though unmarked, they are
attributed to Anthony Rasch on the basis of a nearly
identical service marked by Rasch in the collection of
the North Carolina Museum of Art, Raleigh.*

WILLIAM ELLIS TUCKER and JOHN HULME
(active 1828)
Pitcher, one of a pair
Philadelphia, 1828

Porcelain, 9 ¹/₂ inches high

In 1826 William Ellis Tucker established the first success-
ful porcelain manufactory in the United States on the site
of the old waterworks in Philadelphia. The pitcher was
made during his one-year partnership with John Hulme
in 1828; the reticulated compote was fabricated sometime
between 1826 and 1838, during one of Tucker's partner-
ships or by a successor.

BELOW

Attributed to WORCESTER PORCELAIN FACTORY
Cake plate with view of Baltimore Harbor
England, circa 1840

Porcelain, 2 ¹/₁₆ x 12 ¹/₁₆ x 9 ⁷/₁₆ inches
Inscribed on base: Baltimore

This cake plate, once part of a large dessert service, depicts
Baltimore with views of Fort McHenry and the
Washington Monument.

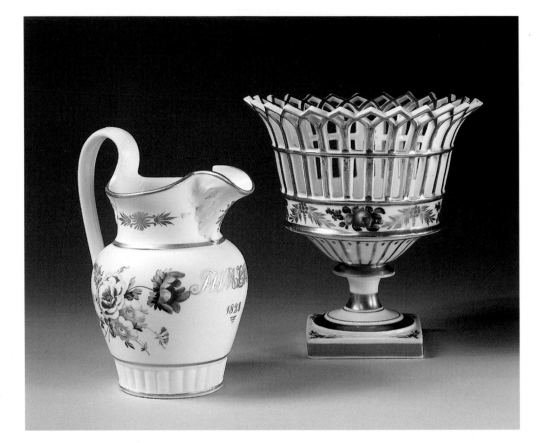

OPPOSITE

Vase with view of Schuylkill River and
old Philadelphia waterworks
France, circa 1830

Porcelain, 15 ⁹/₁₆ inches high

During the 1820s and 1830s, French and English
porcelain made for the American market was often
decorated with transfer-printed views of American cities.
This vase depicts a view of the old Philadelphia water-
works, which was leased by William Ellis Tucker for
his porcelain manufactory from 1826 to 1831.

Attributed to MONSIEUR CHOPIN, French
(active early nineteenth century)
Argand lamp, one of a pair
Paris, circa 1820

Japanned tôle, 28 ½ inches high

FRANÇOIS-JOSEPH BOURGOIN, French
(active 1762–1817)
Family Group in a New York Interior, 1807

Oil on canvas, 30 x 42 inches
Inscribed lower right: J Bourgoin pt / New York-1807

*Japanned-tôle Argand lamps are represented
in this painting of a stylish Federal New York City
interior by François-Joseph Bourgoin, a French artist
from the West Indies.*

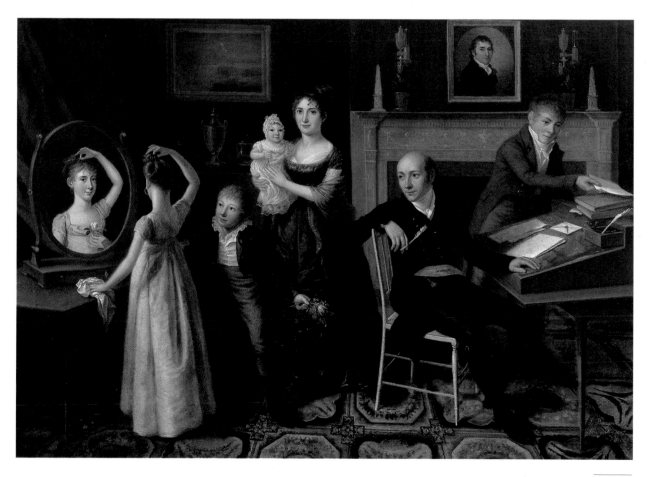

JOHNSTON BROOKES & CO.
Argand lamp, one of a pair
London, circa 1820

Glass and gilt-brass, 14 inches high

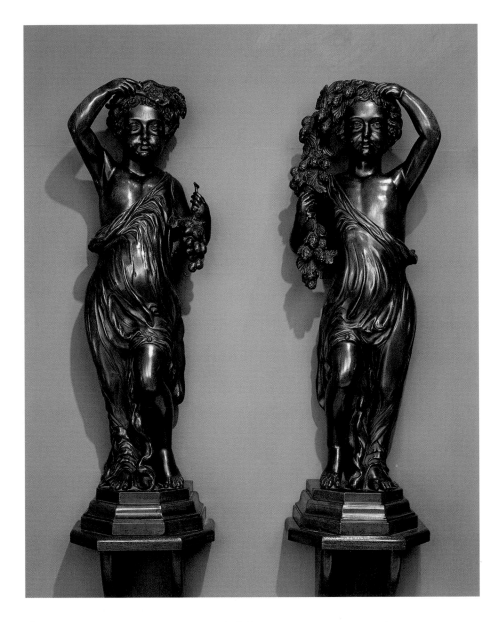
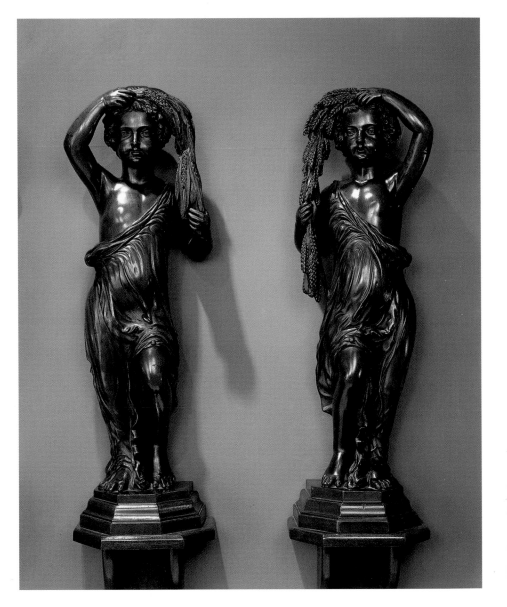

ANONYMOUS ARTIST, American or English
Allegories of the Four Seasons, 1790–1820

Mahogany, each 27 ³/₄ inches high

Probably the work of an English master carver,
these allegories of the four seasons feature sophisticated
modeling and superior understanding of the figure.

LEFT

**Upholstered armchair,
one of a pair**
New York, circa 1825

Mahogany, 36 ¹/₂ inches high

*According to tradition, Stephen
Van Rensselaer III (1764–1839)
originally owned the pair of chairs.*

ABOVE RIGHT

Thomas Constantine and Company (active 1815–39)
Armchair, one of a pair
New York, circa 1820

Mahogany, 27 x 17 ¹/₂ x 25 inches
Marked on front castors: BIRMINGHAM PATENT
Marked on back castors: T. CONSTANT. LOVE. N. YORK

*Until 1994, the pair of chairs served as pulpit furniture at Christ and
St. Stephen's Church in New York City. They were made by Thomas
Constantine and Company, a New York City firm working at 157 Fulton
Street from 1817 to 1824 and at 538 Greenwich Street in 1825. From
1826 to 1839 the firm operated a mahogany yard at 503 Pearl Street.*

LEFT

Pair of candlestands
New Hampshire, circa 1820

Cherry, 27 ³/₄ x 20 x 14 ⁶/₁₆ inches

*Gifts from Jonathan Clough of Canterbury, New Hampshire, to his twin
sons, Joseph (1804–60) and Benjamin (1804–36), these candlestands
descended in their families until 1935 and were reunited in 1994.
They feature broken-pilaster inlay similar to that on a card table labeled
by Levi Bartlett (1784–1864) of Concord, New Hampshire.*

LEFT

REVEREND DANIEL F. SCHROTH Painted Room from Winemiller House, detail, circa 1880

Reverend Schroth, a minister of the German Evangelistic Reform Church, painted the panels now in the apartment sitting room of the Mildred Warner House for the house of Mrs. Winemiller, one of his four daughters, in Randolph County, West Virginia. The imagery suggests a fanciful reminiscence of Schroth's European background.

OPPOSITE

REVEREND DANIEL F. SCHROTH Painted Room from Winemiller House, detail, circa 1880

Additional Schroth panels are installed in the breakfast room of the Mildred Warner House. Also in the breakfast room is a rosewood work table (Boston, circa 1815) as well as a silver tea machine (English, late eighteenth or early nineteenth century) and one of a pair of mahogany side chairs (Boston, circa 1810).

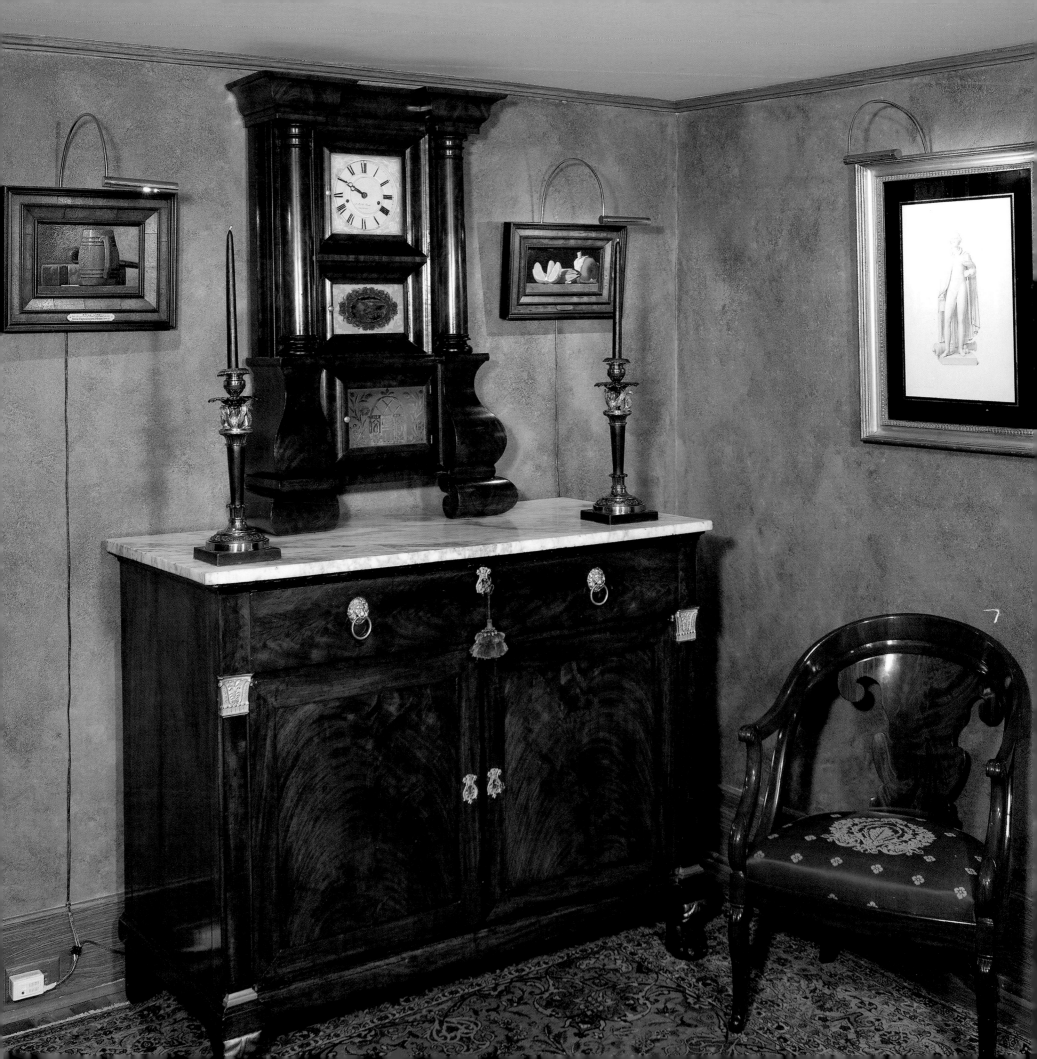

CHARLES-HONORÉ LANNUIER (1779–1819)
French bureau
New York, 1805–15

Mahogany, gilt-brass, gilt-gesso, and verdigris,
39 ¼ x 47 ¾ x 24 inches
Marked on top of each stile:
H. LANNUIER NEW-YORK

*According to tradition, the bureau descended in the
family of Rufus King, signer of the Constitution and
minister to Great Britain, who either owned it himself
or presented it as a wedding gift to his son, James
Gore King, on the occasion of his marriage to Sarah
Gracie in 1813.*

Attributed to DUNCAN PHYFE (1768–1854)
Cellarette
New York, circa 1815

Part-ebonized and parcel-gilt rosewood,
25 ½ x 23 ¼ x 23 inches

*A cellarette, or wine cooler, was used during
the Federal period to chill and store spirits.*

LEFT

Campeachy armchair
New York, circa 1820

Rosewood

The form of American "campeachy" armchairs was derived from chairs imported to New Orleans from Campeche, Mexico, in the early nineteenth century. Also in the bedroom of the Mildred Warner House is a rosewood-veneered secrétaire à abattant (New York, 1815–20) together with a rosewood work table (Boston, circa 1815) and Girl in Landscape with Two Lambs, 1875, by Eastman Johnson.

BELOW

School of CHARLES-HONORÉ LANNUIER
(1779–1819) or **DUNCAN PHYFE** (1768–1854)
Mahogany bedstead with giltwood finial, detail
New York, circa 1815

OPPOSITE

School of CHARLES-HONORÉ LANNUIER (1779–1819)
or **DUNCAN PHYFE** (1768–1854)
Bedstead
New York, circa 1815

Mahogany, 117 x 88 ¹/₂ x 62 inches

In the bedroom of the Mildred Warner House are a pair of giltwood cornucopia wall brackets (American, circa 1820) and a pair of hurricane candle lamps (English, circa 1825).

LEFT

School of CHARLES-HONORÉ LANNUIER (1779–1819)
Card table, one of a pair
New York, 1815–20

Parcel-gilt veneered rosewood, 29 ½ x 36 ¼ x 18 ⅛ inches

*Among the furniture in the sitting room of the Mildred Warner House
is the card table, as well as Lemuel Curtis's giltwood and églomisé girandole
clock (Concord, Massachusetts, circa 1815) and a pair of mahogany armchairs
(New York, circa 1825).*

BELOW

Secrétaire à abattant
Philadelphia, circa 1820

Mahogany and bird's eye maple, 61 ½ x 36 ¼ x 23 inches

*Inspired by designs published by Pierre de la Mésangère in Collection des
Meubles et Objets de Goût (Paris, 1796–1830), the American secrétaire
à abattant, or fall-front secretary, illustrates the taste for French-style furniture
in early-nineteenth-century America, particularly in New York and Philadelphia.
The secrétaire is in the sitting room of the Mildred Warner House along with a
mahogany side chair (New York, circa 1815), a mahogany and satinwood work
table (New York, circa 1810) attributed to Duncan Phyfe, Noon Recess,
1873, by Winslow Homer, and La Muleteria or Spanish Stable, circa 1910,
by John Singer Sargent.*

OPPOSITE

School of CHARLES-HONORÉ LANNUIER (1779–1819)
**Rosewood veneered card table with gilded winged
caryatids, one of a pair,** detail
New York, 1815–20

*Classically derived winged figural supports were
the trademark of Charles-Honoré Lannuier,
although other New York makers used them as well.*

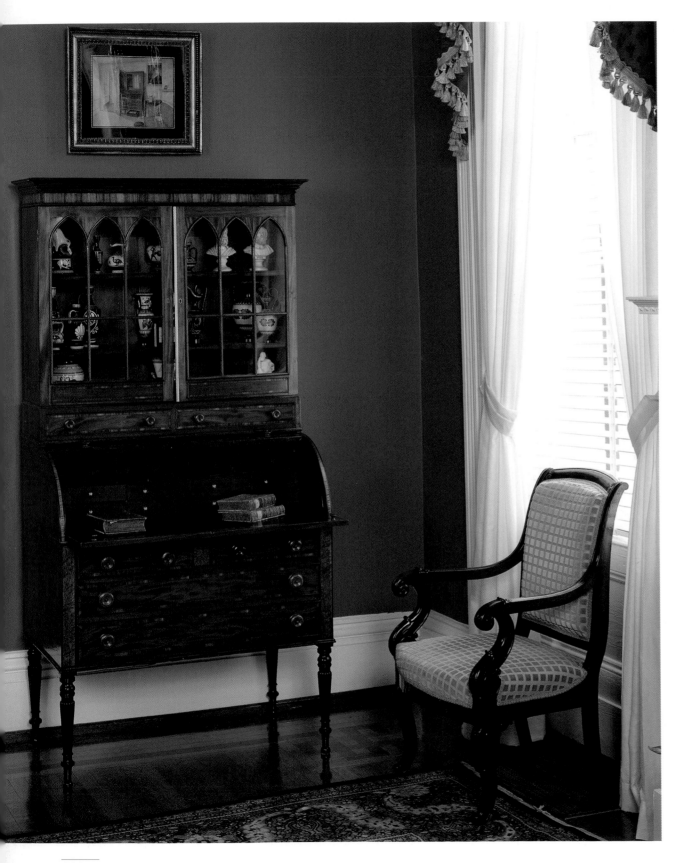

LEFT

Cylinder desk-and-bookcase
Eastern Massachusetts, circa 1810

Mahogany and maple, 74 ½ x 36 x 21 ½ inches
University of Alabama, gift of Mr. and Mrs. Jack Warner

*The cylinder desk-and-bookcase is in the parlor of
the President's Mansion at the University of Alabama
along with a mahogany armchair (New York, circa 1820)
and a watercolor painted by an anonymous American
artist, circa 1810, depicting a similar desk-and-bookcase.*

BELOW

ANONYMOUS ARTIST
Interior Showing Cylinder Desk-and-Bookcase,
circa 1810

Watercolor on paper, 9 ½ x 11 ½ inches
University of Alabama, gift of Mr. and Mrs. Jack Warner

OPPOSITE

Linen press
Boston, circa 1820

Mahogany, 97 x 55 ¼ x 24 ½ inches
University of Alabama, gift of Mr. and Mrs. Jack Warner

*The linen press is in the dining room of the President's
Mansion at the University of Alabama beside one of a pair
of mahogany marble-top pier tables attributed to Edward
Priestley (1778–1837) made in Baltimore circa 1825–35.*

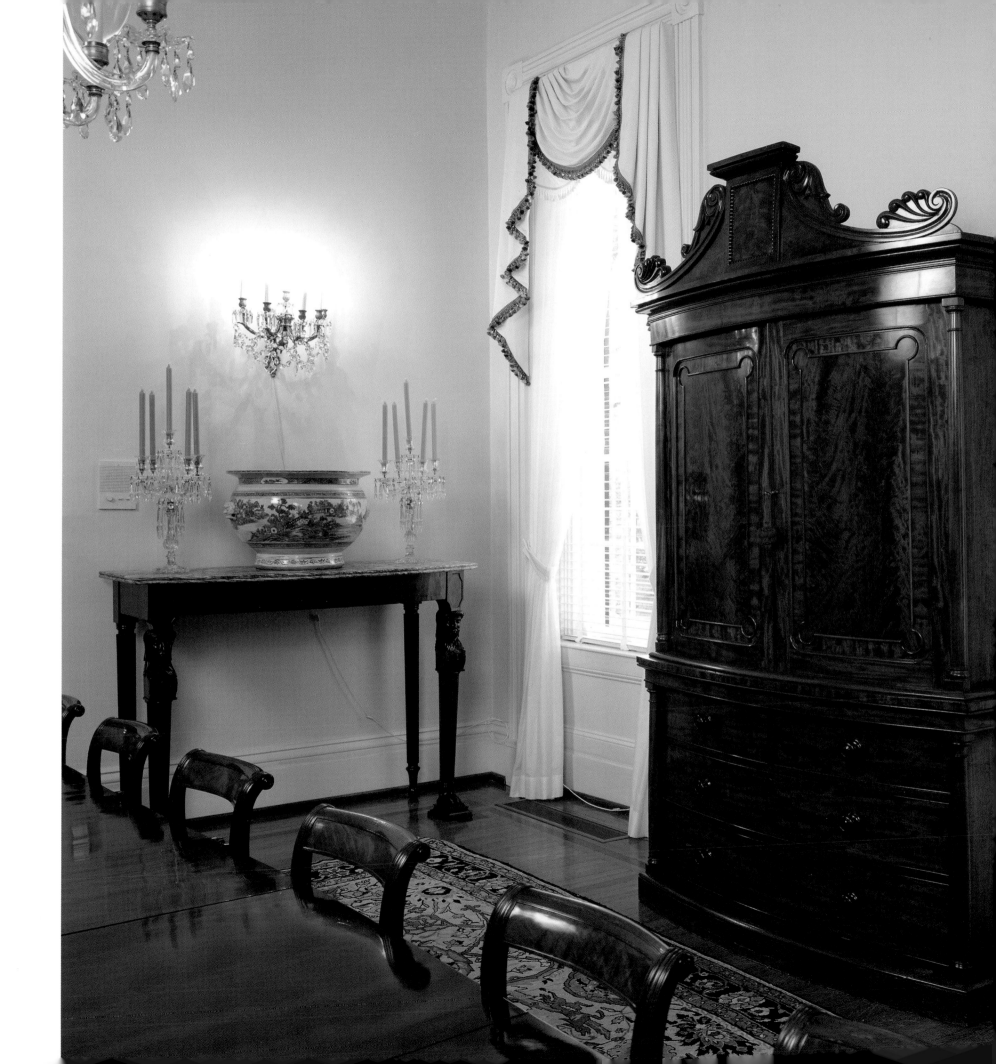

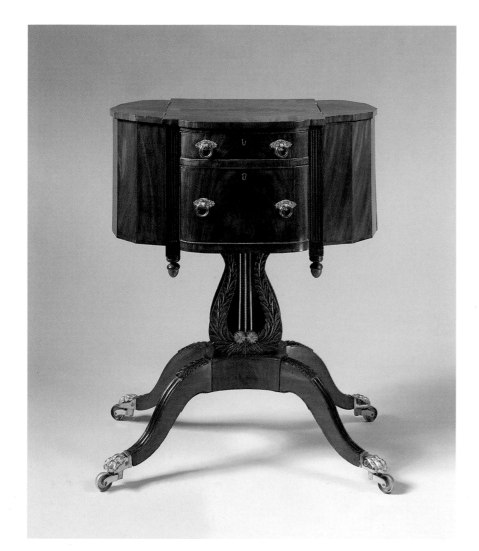

ABOVE

Work table
Philadelphia, circa 1810

Mahogany, 32 x 25 ½ x 15 ½ inches

RIGHT

Attributed to DUNCAN PHYFE (1768–1854)
Work table
New York, circa 1810

Mahogany and satinwood, 29 ½ x 22 ½ x 16 ¼ inches

OPPOSITE

Girandole mirror
American or English, 1810–15

Part-ebonized gilt-pine, 43 x 36 inches

This mirror is one of a pair that descended in the family of Elias Hasket Derby (1739–99), a prominent merchant and patron from Salem, Massachusetts. The other mirror is in the collection of the Portland Museum of Art, Maine.

AN AMERICAN SPIRIT

WENDELL GARRETT

There is a history in all men's lives.

—William Shakespeare, *King Henry the Fourth*, 1598

'L arger than life" is the possibly hackneyed, though appropriate, phrase needed to encapsulate the ebullient, dynamic, generous, and generously gifted Jack Warner. He is a man of rare charm and gentle strength, of humor, fidelity, and patriotism, self-effacing in manner but tenacious in conviction—a consummate southern gentleman of cultivation and style. He is broad in his sympathy and profound in his understanding and deeply emotional in his attachments. A man of diverse interests and great achievements, he stands for what President Charles William Eliot of Harvard used to call "the durable values and satisfactions of life." He has a calm, persistent way of being loyal to his family and friends, his region, his work, his college, and to all the institutions with which he is associated. Jack is a collector of taste, wit, and warmth whose keen eye for beauty is matched by an ear just as finely tuned to the nuances of language. This indomitable zest for life springs from the integrity of spirit that underlies his dazzling versatility of talent—a patriotic love of country rare in this corrupt age.

In 1802, when the American continent was still largely unmapped and its resources still largely undiminished, President Thomas Jefferson, sensing the need for a written record, encouraged Meriwether Lewis to make notes and gather materials during his continental trek. During the first two generations of the American republic, interest in science grew into a national concern and American scientists devoted their primary efforts to discovering, exploring, charting, collecting, describing, and classifying the natural resources of the virgin continent. The study and description of the thousands of previously unknown species that abounded in America provided artistic naturalists with the irresistible opportunity to draw, paint, or otherwise repre-

TERRY MATHEWS, English (b. 1931)
Tuska, 2000

Bronze, 24 feet high

Modeled and cast at the Pangolin
Editions Foundry, Chalford,
Gloucestershire, England

*During the spring and summer
of 2000, Jack Warner sometimes
seemed preoccupied and occasionally
made obscure references to
"the elephant." His latest project
was the acquisition and installation
of a monumental elephant he had
commissioned from the English artist
Terry Mathews, a renowned wildlife
sculptor who has worked as a profes-
sional big game hunter. Several years
earlier, works by Mathews that had
interested Warner were withdrawn
from an auction in London. So Jack
obtained Mathews's telephone number
in Africa and began a friendship and
acquisition of work directly from the
artist. Love of elephants combined with
admiration for an accomplished artist
would not, in most cases, result in a
life-size, seven-ton work, but somehow
for Jack it seems a natural conclusion
of his high-spirited enthusiasm.
The elephant was shipped from
England through the port of Mobile
and installed at the entrance to the
NorthRiver Golf Club in time for
the first home football game at the
University of Alabama in fall 2000,
where for inexplicable reasons,
the mascot is an elephant.*

sent the exotic novelties of America. This was most beautifully true of John James Audubon, whose stunning elephantine edition *Birds of America* was published over a ten-year period beginning in 1827—the object of Jack Warner's earliest collecting interest.

In Audubon's lone prowling through the unmapped backwoods and across the prairies of the Ohio and Mississippi Valleys—"My knapsack, my gun, and my dog, were all I had for baggage and company," he reported—the self-taught artist and gifted ornithologist frequently referred to himself as a "stranger" in the abundant, untouched landscape. What resulted from those travels were not only the famous illustrations of birds and small mammals but, equally important, the chronicle of a solitary pioneer in "the dark recesses of the woods" who felt himself a marauder inevitably disrupting the virgin land, violating his intimacy with nature even as he sought to preserve it. What Audubon experienced was a disturbing ambivalence in the face of nature's bounty. He was plagued by the attempt to reconcile the conflicting impulses that motivated the frontier woodsman, "felling and squaring the giant trees," and the frontier naturalist, killing his beloved birds in order to capture them for posterity, in pen and ink.

Unable to resolve what is still a central concern in the American psyche—the sense of guilt aroused by the conflict between the pastoral longing to view nature as bountiful and the impulse to dominate and possess the landscape—Audubon attempted to stop time altogether and preserve the static continuity of soaring bird and untamed landscape "before population had greatly advanced." Alexis de Tocqueville in the 1830s observed a paradoxical melancholy, anxiety, and restlessness among Americans "in the midst of their prosperity." Rolling back the western frontier, Americans soon discovered that notions of "rugged individualism," "the

SANFORD GIFFORD (1823–80)
Morning in the Adirondacks, 1854

Oil on canvas, 40 ⅞ x 36 inches
Inscribed lower center: S R Gifford 1854

214

course of empire," and "manifest destiny" masked the other side of progress: the destruction of the wilderness. Abundance had encouraged the myth of inexhaustibility, but too soon eroded prairie and deforested hills stood in silent judgment of the world Americans had lost. The florid optimism of nineteenth-century America could not altogether mask a strain of misgiving about the threatened wilderness. In the 1830s Audubon mourned that "Nature herself seems perishing" as he detailed the dwindled herds of buffalo and deer and the disease-ridden Indian tribes. Thomas Cole was enraged to see the "ravages of the axe" on the unprotected landscape, and in a speech in 1835 he implored Americans to remember that "We are still in Eden; the wall that shuts us out of the garden is our own ignorance and folly."

As the frontier moved westward, so did a stream of artists in quest of the unspoiled grandeur and overpowering beauty of the American continent. Reflecting the benign chauvinism and bumptiousness of Jacksonian democracy, Americans were clamoring for an art of their own—large, luminous canvases full of meticulous detail that would suggest the wide horizons and towering mountains of their landscape. The land became so supportive of the arts that one Irish visitor wrote in the late 1830s: "While in America I was struck by the manner in which the imaginative talent of the people had thrown itself forth into painting; the country seemed to swarm with painters."

The nation was steeped in its own image, and with these sweeping landscapes it may be said that its artists rediscovered America with mystical reverence. "The painter of American scenery has indeed privileges superior to any other: all nature here is new to art," wrote the English-born Thomas Cole, who became the ablest landscape painter of his time. This obscure and impoverished immigrant from the smoky pall of industrial Lancashire viewed the awe-

SANFORD GIFFORD (1823–80)
Sunset in the Shawangunk Mountains, 1854

Oil on canvas, 40 ⅞ x 36 inches
Inscribed lower center: S R Gifford 1854

215

some majesty of nature passionately, finding it a holy place full of meaning and symbol. Cole's paintings, infused with a sense of the supernatural, reflect his exploration of the Hudson River and the vistas of the Catskill Mountains; in his grandeur of conception and moral passion he was closer to the heart of romanticism than any of his contemporaries.

By midcentury the continent had been crossed and the frontier had reached the Pacific. It is both sad and ironic that by the time of Cole's premature death in 1848 and that of Audubon in 1851 there were no more virgin landscapes left upon which to project the literary and pictorial image of America as Eden, the idyllic garden of innocence and material ease. The United States census of 1890 signaled both that the wilderness no longer existed and that its human symbol—the Indian—was largely exterminated. For Frederick Jackson Turner, who in 1893 proclaimed the end of the frontier, the risks and rewards of westward expansion had uniquely shaped the national character. But here was an irresolvable contradiction: the ideal American society needed continuous regeneration through contact with nature, while nature everywhere was receding before that society. Yet even by the end of the nineteenth century few Americans understood Henry David Thoreau's eccentric plea: "In wildness is the preservation of the world." Untroubled American assumptions of cultural progress and technological advancement still combined to encourage plowing the virgin land, laying railroad track in the wake of Lewis and Clark's expedition up the pastoral Missouri River and on to the Pacific, and scarring the landscape with factories. Only too late did thoughtful Americans come to recognize with Marcel Proust that "The only true paradise is the paradise we have lost."

The land, the limitless wilderness that was to be America, held a promise that challenged the imagination and daring of those who pledged their lives, fortunes, and sacred honor to settling the remarkable continent. The English clergyman-poet John Donne would intone in 1633:

> Oh my America! My new-found land,
> My kingdom safeliest when with one man mann'd
> My mine of precious stones, my Empiree
> How blest am I in this discovering thee.

In the centuries that followed, America has continued to be envisioned in terms of promise, but the promise was to the diligent rather than to the adventuresome. And the land itself was the New World's greatest attribute: the rich virgin soil only wanting men and women willing to plant and reap; the dense woods offering firewood for the household, lumber for buildings and furniture, and timber and naval stores for ships; food, furs, and pelts both for clothing and as a commodity for export.

But was it only the rich endowment of natural resources that made the United States or was it the peculiar quality of the people? It took human ingenuity to convert the features of the land into a quality of life never before experienced by a large group of people. Here there was to be more personal freedom, more security, more self-determination, more access to knowledge, and more equality before the law than anywhere else on earth. Nothing in all history had ever succeeded like America, and every American knew it. America was the land of the future; and some of the most learned and perspicacious observers thought that America held the key to the past as well, that the newest of nations would reveal the history of the oldest. "I confess," wrote the incomparable Tocqueville, "that in America I saw more than America; I sought the image of democracy itself, with its inclinations, its character, its prejudices, and its passions, in order to learn what we have to fear from its progress." He added, "The question here discussed is interesting not only to the United States but to the whole world; it concerns not a nation, but all mankind."

What a country! It had a radical constitution couched in philosophical terms and a political system based on two basic principles: first, that all government derives from the people; second, that all government is limited. It lacked a reigning house and a landed aristocracy. It was the product of harebrained theory, political instability, a tarnished record of mob violence, and defiance of decent custom. It invited dissension; it welcomed the discontented to its shores and then passed the oppressive Alien and Sedition Acts. It was a country boiling with odd, revolutionary notions about law, language, literature, art, education, land holding, rights of man, representative government, and the disestablishment of religion. The Americans were a menace to the intellectual world of Descartes and Newton, to the polite world of Chesterfield and Marie Antoinette, to the cosmopolitan world of Gibbon and Voltaire, and to the international world of well-bred society. American currency was so bad that the phrase "not worth a Continental" passed into the common language as a synonym for utter worthlessness.

Yet the American navy defeated English vessels in spirited combat during the War of 1812, and Jackson's raw frontiersmen slaughtered Sir Edward Packenham's seasoned veterans before New Orleans in January 1815. Then, in the 1840s the infant republic reached the Pacific with an expansion of speed and effectiveness unprecedented in history. The nation's moment of greatest triumph, however, was also the moment of its greatest danger, given the disruptive and intractable nature of slavery. Was it, finally, to be one nation or many? The grave fears about the permanence of the federal union raised by the Civil War were finally settled at Appomattox. After that few doubted that the United States of America was here to stay. The Europeanized Henry James, writing from London at the end of the nineteenth century, observed that the United States had undergone "immense uninterrupted material development" and was, in comparison to all other nations and empires that ever existed, a county bathed in "broad morning sunshine."

While still the youngest of great countries, America is in many respects very old. It is, of major nations, the oldest republic, the oldest democracy, the oldest federal system; it boasts the oldest written constitution and the oldest of genuine political parties. Americans were—and still are—a puzzle and a power in the world of ideas, politics, and social history. To understand how swift and how effective was the process of Americanization depends ultimately on an understanding of all those intangible factors that make up what is called national character. And it is to that grand theme that hundreds of commentators, both foreign and domestic, before and since Tocqueville, have returned, in indignation, in enthusiasm, and in wonder.

What remarkable men and women they were, these Americans! Such curiosity they had, such courage, such versatility, such imagination. They emancipated themselves from the classical past; they interested themselves in all but the next world. On the world about them they imposed new classifications and comparisons, and they began a mighty effort to report, reassess, and reorder the arts and sciences. There was a prodigality and foolhardiness about them: they recognized no bounds to their curiosity, no barriers to their thought, no limits to their activities or even their authority. They sailed and mapped the seven seas. They probed deep into the earth and explored the expanse of the cosmos. They found new families of man and unveiled hidden continents, and what they did not find they imagined, for their imaginations teemed with utopias.

Americans were incurable optimists. Progress was not to the American a philosophical idea but a commonplace of experience; the present was viewed through the eye of the future: not the straggling, dusty town but the shining city; not the shabby shop but the throbbing factory; not the rutted roads but the gleaming rails. All this tended to give a quantitative cast to American thinking and led to a quantitative valuation established for almost everything. Michel de Crèvecoeur had observed of the newcomer to America that "Two hundred miles formerly appeared a very great distance, now it is but a trifle; he no sooner breathes our air than he forms schemes, and embarks on designs he never would have thought of in his own country"; and what was true of recent immigrants was even more true of hard-bitten Americans.

The Americans of the early nineteenth century looked at the years ahead with magnificent self-assurance. They knew who they were, where they had come from, and what they intended to do with the future. And indeed Americans had the best of both worlds—the world of Newton without the weight of a past full of ignorance, credulity, and superstition; the world of the *Federalist Papers*, which made law of Enlightenment principles, crystallized them into institutions, and put them to work. These Americans searched the past, explored the present, and imagined the future, discussing and disputing all the while. They sought the good and the true; they were enraptured with the sublime and the beautiful; they cherished virtue and pursued happiness. The Enlightenment mind, library, and arts posed the great questions of a

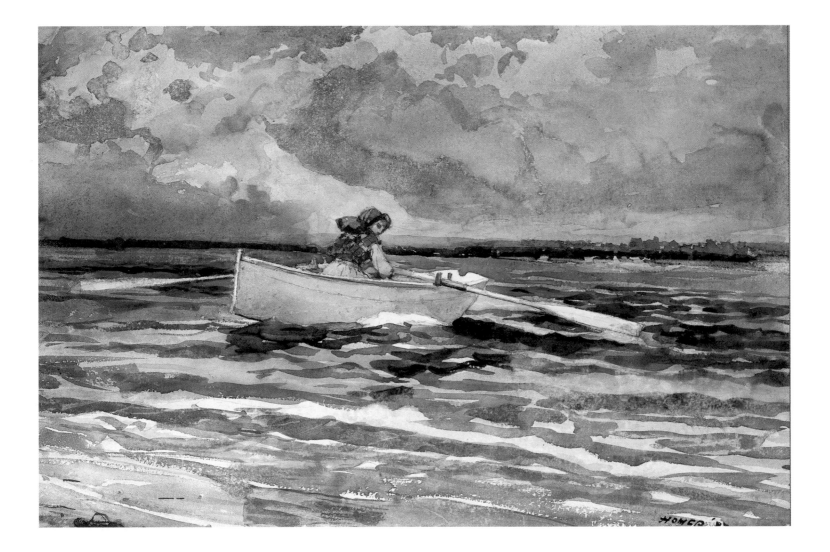

moral, intellectual, and aesthetic world, which has somehow been lost or betrayed. That contemporary Americans should attempt to retrieve something of that world is a worthy ambition; with unswerving devotion Jack Warner has made this the aspiration of his collecting odyssey.

One of Jack's most endearing characteristics is the immense kick he gets out of life, which suggests the following lines by Robert Louis Stevenson:

> That man is a success who has lived well, laughed often and loved much; who has gained the respect of intelligent men, and the love of children; who has filled his niche, and accomplished his task; who leaves the world better than he found it— whether by an improved poppy, a perfect poem [in this case, "collection"], or a rescued soul; who never lacked appreciation for earth's beauty, or failed to express it; who looked for the best in others, and gave the best he had.

For those who know him best, that man is Jonathan Westervelt Warner.

WINSLOW HOMER (1836–1910)
Rowing at Prouts Neck, 1887

Watercolor on paper mounted on board,
14 1/4 x 20 1/4 inches
Inscribed: Homer
Collection of Mr. and Mrs. Jack Warner,
Tuscaloosa, Alabama

ACKNOWLEDGMENTS

The enthusiasm and generosity of Jack Warner made this book possible. With his characteristic good humor and his sense that we might satisfy his need for constant activity and provide a hint of mischief, Jack gave us total freedom to interpret his life in the context of presenting the Warner collection of American fine and decorative arts of the Gulf States Paper Corporation. He kept a watchful eye as he observed from the sidelines; his remarks indicated he hoped we were up to the challenge. We would not have been without Charles Hilburn, fine arts manager, and Candy Grant, fine arts secretary. Charles devotes his boundless energies to Jack and his endeavors. His remarkable understanding of our needs and his critical review of our manuscript and catalog entries were invaluable. Candy's inventory records, her ability to spot mistakes, and her always amiable disposition contributed to making us as accurate as possible. Without them . . . no book.

Amy Coes and Ella Foshay have brought thoughtful and personal insight to the Warner collection in their essays. We are grateful for their knowledgeable approaches to the difficult task of identifying the aesthetic and thematic nature of a private collection.

The photographers who are recognized on the title page spent a collective time of almost one month photographing in Tuscaloosa. Their work with objects and views of interiors and exteriors was assisted by Michael Andrews, his brother Lee, and Lee's son-in-law, Travis White, all members of a family team that operates a framing and fine arts business. It was a pleasure to discover that Michael is an artist, and his drawing for the endpapers adds another dimension to our presentation of the Warner collection.

Elizabeth and Jack Warner's benevolence is an essential part of their character, expressed in their generosity to the President's Mansion at the University of Alabama, the First Presbyterian Church, Tuscaloosa, and Washington and Lee University, Lexington, Virginia. At the President's Mansion, repeated visits to photograph, check dimensions, and record facts were cheerfully welcomed by President and Mrs. Andrew Sorensen, and keen observations by Dot Bates and Peggy Richey were always helpful. James Whitehead, former treasurer and secretary of Washington and Lee University and former director of the Reeves Center of Antique Porcelain at the university, provided a general background of the Warners' association with Washington and Lee, and Farris Hotchkiss, senior assistant to the president, detailed the Warners' repeated generosity to the university. In Tuscaloosa, my unannounced

arrival at the First Presbyterian Church, photographer in tow, was disconcerting, but William Pool, church administrator, guided us to important locations after we met and explained ourselves to Joel Gregory, the organist.

Certainly our most helpful archival resource was *Progress: Gulf States Paper Corporation, Our First Hundred Years*, published by Gulf States Paper Corporation in 1984. In our biographical research, factual information was graciously provided by Joanna Smith, communications manager of the United States Equestrian Team, Gladstone, New Jersey, and her associate John Fritz, as well as Dennis Murphy, Longview Farms, Vandiver, Alabama. In the organization of the book, Janice Conner and Joel Rosenkranz, of Conner•Rosenkranz in New York City, encouraged me to treat sculpture with the same attention as painting and guided me with their knowledge of the subject. Research on Jack Warner's extensive collection of material related to George Washington was greatly assisted by Carol Borchert, curator at Mount Vernon. Hugo Ramirez of Hugo Ltd. Fine Lighting and Decorative Arts was extremely helpful in identifying the lighting in the Mildred Warner House.

Through the hospitality of Christopher Clark, general manager of NorthRiver, we became informed about various aspects of this recreational complex. Our understanding of the design and building of Gulf States Paper headquarters was expanded through the insights of Cecil Alexander, architect of the building, formerly a partner in the firm of Finch, Alexander, Barnes, Rothschild and Paschal, Architects, Atlanta, and now associated with the successor firm Alexander, Weiner, Architects. Dennis Piermont, principal of Landgarden, Landscape Architects, New York, interpreted the design of the interior Japanese garden by landscape architect David Harris Engel, associated with the firm for many years. He described Engel's particular talents and shared great admiration for his distinguished partner, who now lives primarily in Korea.

One of the most memorable helpers in our tasks was Willie Cleveland, caretaker of the Mildred Warner House. Willie was intrigued by our northern ways and constantly inquired about our adaptation to Tuscaloosa cuisine, especially the menu at Dreamland, an internationally known roadhouse that serves only beer, white bread, and barbecued ribs. Willie's knowledge of the collections of the Mildred Warner House and his care for them provided an engaging background to our Tuscaloosa experience.

My colleagues at Sotheby's have kindly assisted our efforts with expert advice concerning various aspects of the Warner collection. I am particularly grateful to Wendell Garrett, senior vice president, Americana, who has followed this project from the beginning and has helped me immeasurably, always with an expression of confidence and encouragement. Wendell is a long-time friend whose knowledge and eloquence are legendary. It was an honor to share this endeavor with such an illustrious collaborator.

This book presents an odyssey—the story of a family and the art that reflects their American heritage. Making it was also an adventure and we are forever grateful to all who helped. — T.A.

WILLIAM MERRITT CHASE (1849–1916)
Keying Up (The Court Jester), circa 1875

Oil on panel, 15 x 8 ⅛ inches
Inscribed lower right: Wm Chase

HENRY F. FARNY
(1847–1916)
The Return to Camp,
1903

Gouache on paper,
12 ¹/₂ x 8 inches

ILLUSTRATION CREDITS

Numbers refer to page numbers.

Deloye Burrell: 68, 71, 213

Lynn Diane DeMarco: 6–7, 9, 17, 38, 39, 40, 41, 43, 44, 45, 48, 49, 60, 88, 90 top, 101 bottom right, 108, 109, 116, 117 left, 146, 150, 151, 161, 172 top, 174, 178, 179, 181, 188 bottom, 190, 191, 192, 193, 194, 195, 196, 199, 203, 210

Gulf States Paper Corporation: 10, 12, 62, 113, 114 bottom, 142 bottom, 143 bottom, 148 right

Mr. and Mrs. John McCoubrey: 101 left

Bonnie Morrison: 4, 11, 32, 35, 37, 56, 57 bottom, 59, 86, 95 bottom, 103, 112, 119, 124, 129, 131, 133, 135, 136, 138, 139, 141, 143 top, 144, 145, 149, 152, 153, 154, 155, 156, 157 left, 158, 219, 224

Paul Rocheleau: 1, 2–3, 13, 14, 15, 16, 18, 19, 20, 21, 22, 23, 24, 25, 26–27, 29, 30, 31, 33, 34, 47, 51, 52, 53, 54, 55, 57 top, 58, 61, 63, 64, 65, 66, 67, 69, 70, 72, 73, 75, 76–77, 78, 79, 80, 81, 82, 83, 85, 87, 90 bottom, 91, 93, 94, 95 top, 97, 98, 100, 101 top right, 104–5, 106, 107, 110, 111, 114 top, 115, 117 right, 118, 120, 121, 122, 123, 125, 126, 127, 130, 134, 137, 140, 142 top, 147, 148 left, 157 right, 159, 162, 163, 164, 165, 166, 167, 168, 169, 170, 171, 172 bottom, 173, 175, 177, 180, 183, 184, 186, 187, 188 top, 189, 197, 198, 200, 201, 202, 204, 205, 206, 207, 208, 209, 211, 214, 215, 221

University of Alabama: 74

Virginia Museum of Fine Arts: 89, 99

Washington and Lee University: 50

Yale University Art Gallery: 42

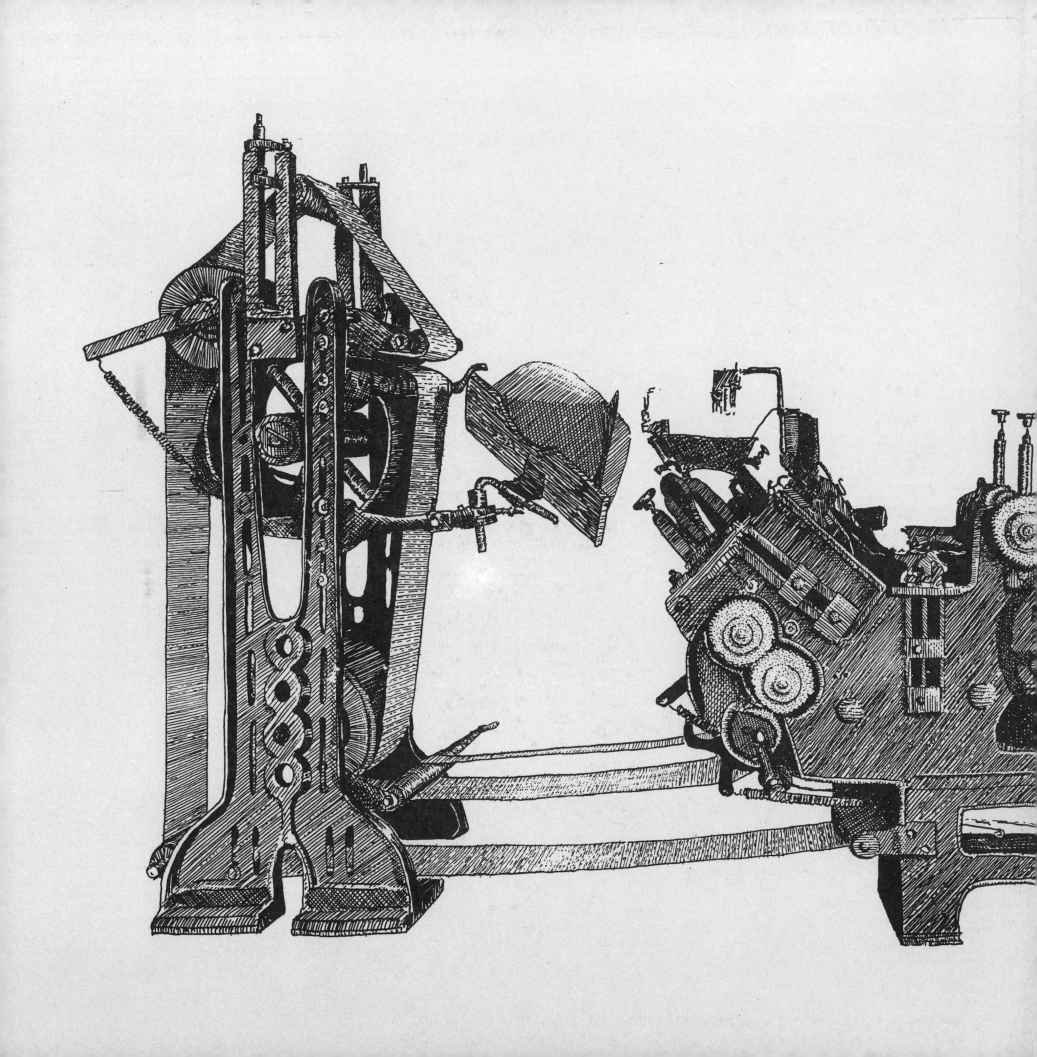